# ARTWORDS

## A Glossary of Contemporary Art Theory

### THOMAS PATIN and
### JENNIFER McLERRAN

**GREENWOOD PRESS**

Westport, Connecticut

**Library of Congress Cataloging-in-Publication Data**

Patin, Thomas, 1958–
    Artwords : a glossary of contemporary art theory / Thomas Patin
and Jennifer McLerran.
      p.     cm.
    Includes bibliographical references and index.
    ISBN 0–313–29272–8 (alk. paper)
    1. Art—Philosophy—History—20th century—Terminology.
I. McLerran, Jennifer.  II. Title.
N71.P32   1997
701′.09045—dc20        96–29274

British Library Cataloguing in Publication Data is available.

Library of Congress Catalog Card Number: 96–29274
ISBN: 0–313–29272–8

First published in 1997

Greenwood Press, 88 Post Road West, Westport, CT 06881
An imprint of Greenwood Publishing Group, Inc.

Printed in the United States of America

The paper used in this book complies with the
Permanent Paper Standard issued by the National
Information Standards Organization (Z39.48–1984).

10 9 8 7 6 5 4 3 2

# CONTENTS

# PREFACE

Since the early 1970s the vocabulary used to discuss visual art has expanded radically. Many teachers, students, artists, and critics have suddenly found themselves drowning in a sea of jargon that seems to have descended suddenly from outer space. A straightforward guide to specialized language is sorely needed. Without such a guide, readers of contemporary art history, theory, and criticism often choose either to spend a few years "playing catch-up," or to dismiss an important and fruitful discourse on contemporary culture.

This glossary is intended to be a guide into the frontier of current theory and criticism of visual art and culture. It includes over four hundred terms or phrases that have recently entered the discourse on the visual arts. Many of the terms in this glossary are not especially new to the art world. In fact, some terms have been widely used in discussions on the visual arts or in other cultural contexts for many years, but have been adapted for use in the contemporary art world with specific or specialized applications. Where possible and appropriate, we attempt to cite or demonstrate the application of theoretical terms and phrases to works of art or some aspect of visual culture. In doing so, we hope to clarify both the specific definitions and the general connotations of many of the entries and to avoid the repetition or synthesis of many glossaries that specialize in contemporary literary theory.

While there are a number of dictionaries and glossaries covering the terminology in the fields of literary criticism, philosophy, and related areas, no such reference book exists for the visual arts. Robert Atkins' *Artspeak* and *Artspoke* come closest to our glossary, but Atkins concentrates on artistic production in the visual arts—artistic movements, styles, and names—and falls short, in our opinion, in his explanations of more theoretical terminology. While our glos-

sary rarely deals directly with art movements and personalities (Atkins does an admirable job in that regard), it does seek to be a handbook for anyone studying the recent visual arts and visual culture in general.

Due to the interdisciplinary nature of recent art criticism, this glossary includes terms from many interrelated discourses: feminist theory, film and photographic theory, literary theory, queer theory, discourse analysis, postcolonial and multiculturalist discourse, cultural studies, revisionist art history or new historicism, Marxist criticism, modernist art theory, postmodernist art and architecture, structuralist and poststructuralist semiotics (including deconstruction), psychoanalytic criticism, abjection, as well as a number of key terms from the writings of Gilles Deleuze and Félix Guattari.

In researching this glossary, we found valuable information in many other glossaries, dictionaries, and anthologies. Among these are Chris Baldick's, *The Concise Oxford Dictionary of Literary Terms*, Terry Eagleton's *Literary Theory: An Introduction*, Jeremy Howthorn's *A Concise Glossary of Contemporary Literary Theory*, Maggie Humm's *The Dictionary of Feminist Theory*, Frank Lentricchia and Thomas McLaughlin's (editors) *Critical Terms for Literary Study*, Irena R. Makaryk's (editor) *Encyclopedia of Contemporary Literary Theory: Approaches, Scholars, Terms*, Madan Sarup's *An Introductory Guide to Post-structuralism and Postmodernism*, Raman Selden's *A Reader's Guide to Contemporary Literary Theory*, and Raymond Williams' *Key Words: A Vocabulary of Culture and Society*. (Full citations can be found in the bibliography.) These are all excellent works but they do not deal with the visual arts in particular.

Readers may approach this glossary in one of two ways. As they come across theoretical terms in reading other texts, they can check those terms in this glossary, much as they would in any dictionary. In addition, readers may wish to access the terms thematically, as they are listed by topic in the front matter. Of course, the contents of this glossary are cross-referenced: we have indicated when a term appears elsewhere by putting the term in small CAPS.

# ACKNOWLEDGMENTS

The entries for this glossary were selected through years of research as students and years of work as professors teaching graduate and undergraduate courses in contemporary art history, theory, and criticism. In the mid-1980s Professor E. Ann Kaplan at the State University of New York at Stony Brook provided one of the authors with a brief and informal glossary of terms specific to film studies. That class handout sparked the idea for a full-blown glossary for the visual arts in general. Students at Pacific Lutheran University (Tacoma, Washington), Cornish College (Seattle, Washington), Western Washington University (Bellingham, Washington), the University of Washington (Seattle, Washington), and Ohio University (Athens, Ohio) received abbreviated trial runs of this glossary from one or the other of us. We began collecting terms in the form of lists or note cards years ago, but filed them away for some vaguely envisioned future project. In 1992 Marilyn Brownstein, an editor at Greenwood Press, gently declined a proposal from one of us for an anthology of recent approaches to the visual arts which included a glossary. However, she suggested that the glossary itself had some potential for publication. We thank her for her vision and confidence. Alicia Merritt, who took over the editorial supervision of our project after Ms. Brownstein's retirement, has provided insightful guidance and advice. Jason Azze, our production editor, has been instrumental in guiding us through the publication process.

Thomas Patin would like to acknowledge the support of the College Art Association through the Professional Development Program in American Art. Jennifer McLerran would also like to acknowledge the support of the College Art Association through the Professional Development Program in American Art.

# ENTRIES BY TOPIC

**Abjection:**
abject, bassesse, Bakhtinian dialogics, carnival, classical body, dialogic/dialogism, grotesque, grotesque body, grotesque realism, informe, material bodily principle, transgression.

**Cultural Studies:**
Birmingham School, communication, critical theory, cultural materialism, cultural studies, culture, elite, Frankfurt School, gatekeeping, hegemony, *ideologiekritik,* ideology, interdisciplinary, legitimacy, media studies, negotiation, overdetermination, popular, popular culture.

**Deleuze and Guattari:**
arborescent, body without organs, BWO, D&G, Deleuze/Deleuzian, desiring machines, Guattari/Guattarian, nomadology, nomads, plateau, postmodern warfare, rhizomatic and arborescent, rhizome, schizoanalysis.

**Discourse Analysis:**
archaeology of knowledge, author, author function, bio-power, counter-memory, death of the author, discourse, discourse analysis, discursive formation, discursive practices, discursive regime, dispositif, docile body, *episteme*, epistemic break, Foucault/Foucauldian/Foucaultian, genealogy, heterotopia, intelligible body, naturalizing/naturalization, normalizing discourse/normalization, panoptic/panopticon, power, practical body, surveillance, useful body.

**Film and Photographic Theory:**
acoustic mirror, active desire, A-film, B-film, apparatus, auteur theory, cinema, cinema vérité, classical cinema, continuity, desire, direct cinema, female gaze, feminine desire, feminist film theory, fetish/fetishism, film theory, gaze, gen-

dered spectatorship, male gaze, masculine desire, object of desire, pornography, scopophilia, screen theory, spectacle, specular, specularization, studio era, suture, tableau space, voyeurism.

## Gender Theory:
body, central void aesthetic, cultural feminism, drag performance, *écriture féminine*, essentialism, Female Gaze, feminine desire, feminine masquerade, femininity as masquerade, feminism, feminist activist art, first-generation feminism, gender, gender theory, gendered spectatorship, gendered subjectivity, gyn-ecology, gynocentric, gynocritic, heterosexist, heterosexual desire, homosexual desire, identity politics, Imaginary, imaginary body/imaginary anatomy, *jouissance*, liberal feminism, Marxist/socialist feminism, masculine desire, masquerade, mastery, Nature/Culture debate, objectification, object of desire, Other, parody/parodic, passing performance, patriarchy, *peinture feminine*, performance/performative/performativity/performativity of gender, phallic/phallus, pornoglossia, pornography, positionality, postfeminism, psychoanalytic feminism, radical feminism, second-generation feminism, sex/gender distinction, sexuality/sexual identity, spiritual feminism, straight-jacket style, subject/subjectivity, transgression, transgressive strategy, vaginal iconography, voyeurism.

## Literary Theory:
allegory, descriptive, diegesis, exegesis, fiction, free-floating, genre, intertextuality, lacunae, linguistic paradigm, literary theory and criticism, master narrative, metacriticism, metafiction, metalanguage, metanarrative, metaphor, metonymy, mimesis, misprision, misreading, narration, narrative, plot, prescribe/prescriptive, reader, reader-response criticism, readerly and writerly texts, reception theory, representation, subtext, trope, writerly.

## Marxist Theory and Criticism:
Althusser/Althusserian, apparatus, base and superstructure, class, commodification, dialectical, Ideological State Apparatus (ISA), interpellation, Marxist literary theory and criticism, Marxist/socialist feminism, materialism, problematic, Repressive State Apparatus (RSA).

## Modernist Art Theory:
abstract, aesthetic emotion, anti-art, art for art's sake, autonomy, avant-garde, central core imagery, central void aesthetic, content, expression, expressionist, form, formalism, genre, goddess art, instrumentalism, modernism, objecthood, originality, performance art, self-reference, self-reflexive, self-sufficiency, significant form, theatricality, work.

## Postcolonial Discourse/Multiculturalism:
alterity, colonial(ism)/colonialized, diversity, dominant culture, ethnicity, Eurocentric, hegemony, hybridization/hybridity, hybrid poetics, imperialism,

# A

**ABJECT** The specific idea of the abject explored in recent art practice has been that theorized by French psychoanalyst Julia Kristeva; (born in Bulgaria in 1941, educated in Paris under Barthes, Lacan, and others beginning in 1965), especially in her book *Powers of Horror: An Essay on Abjection*, 1980 (translated in 1982). Kristeva is interested in the abject as a cultural category that distinguishes self from OTHER on the level of individual IDENTITY and, on the cultural level, the undesirable from that which is culturally privileged. She describes the abject as that which disturbs IDENTITY and order and does not respect borders or rules. Kristeva concerns herself with distinctions between the BODY's outside and inside as establishing distinct boundaries between subject and object. SUBJECTIVITY is dependent upon a discrete sense of the limits of the BODY. Any violation of the boundaries of the BODY is perceived as a threat to the self. She explains that the individual attempts to retain a sense of selfhood by rejecting those things in the environment that are considered impure. Because the BODY itself (especially the female BODY) produces matter deemed socially impure, the sense of a discrete, pure self is constantly threatened. SUBJECTIVITY or self-identity is consequently also constantly threatened. What Kristeva calls the experience of abjection arises from the individual's awareness that the BODY is never impermeable and the self is thus never fixed and stable. Objects and substances that cross the body's boundaries, such as tears, feces, menstrual blood, urine, and so on, produce abjection. The abject defines the space between the SUBJECT and the object as a space of both danger and DESIRE. Kristeva draws heavily on the ideas of anthropologist Mary Douglas regarding the importance of concepts of the pure and impure in cultural practices and social distinctions.

Building on Kristeva's ideas, film theorist Barbara Creed has further explored the realm of the abject. Creed concerns herself with Kristeva's exploration of how abjection, through evoking horror, functions in patriarchal CULTURES (see PATRIARCHY) to separate the human from the nonhuman, separates the SUBJECT that is fully constituted from the SUBJECT that is partially formed. Creed's greatest concerns are with how SUBJECTIVITY is structured through the processes of abjection as they occur in religious and cultural contexts through

ritual and language and with how the conception of the monstrous as conceived in the horror TEXT finds its basis in such contexts in the ancient world. Creed explains that horror films illustrate abjection in three ways: (1) through an abundance of images of abjection; (2) through the function of a border that is threatened; and (3) through maternal FIGURES constructed as abject.

Philosopher Judith Butler has also recently explored the category of the abject. Butler explores how homosexuality comes to be positioned as abject through the workings of a normative heterosexuality (see HOMOSEXUAL DESIRE and HETEROSEXUAL DESIRE). She explains that those practices of exclusion through which individual SUBJECTS are formed simultaneously require the production of a category of abject beings who are "not yet 'subjects,' but who form the constitutive outside to the domain of the subject." In such a cultural CONTEXT, the category of the abject serves to define those social positions and spaces that are regarded as unlivable and uninhabitable and to mark those "whose living under the SIGN of the 'unlivable' is required to circumscribe the domain of the abject" (Butler, *Bodies that Matter*, p. 3). Butler goes on to explain that GENDER equals the social significance that SEX assumes in a CULTURE. SEX is replaced by the social meanings it takes on. It is replaced (displaced) by GENDER. Gendering is necessary to the formation of the self: "The 'I' neither precedes nor follows the process of this gendering, but emerges only within and as the matrix of GENDER relations themselves" (p. 7). The matrix of GENDER relations is necessary to (prior to) human will and agency. The contention among radical social constructivists that everything is discursively constructed refuses the abject as a constitutive force.

Butler proposes a return to the idea of matter "as a process of materialization that stabilizes over time to produce the effect of boundary, fixity, and surface we call matter" (p. 9). The construction of a sexed self takes place over time through a process or repetition and reiteration of norms. But this process of reiteration also offers the possibility for the opening up of gaps and fissures formed by that which exceeds or escapes the norm, as that which cannot be accommodated by the repetition of the norm. This instability is where we may find what Butler terms a "*de*constituting possibility." Butler explains that to refer to that which cannot be signified requires prior delimitation of the extra-discursive. The extra-discursive is formed by the DISCOURSE from which it attempts to free itself. This process of SIGNIFICATION (or delimitation) can construct only by erasing. The disruptive return of the excluded is necessary to call into question the BINARY HETEROSEXUAL MATRIX.

By way of an explanation of her own project, Butler tells how recent artists and theorists have attempted to harness the abject's potential for TRANSGRESION for political ends. She suggests that "the contentious practices of 'queerness' might be understood. . . as a specific reworking of abjection into political agency. . . . The public assertion of 'queerness' enacts PERFORMATIVITY as citationality for the purposes of resignifying the abjection of HOMOSEXUALITY into defiance and LEGITIMACY" (p. 21; see PERFORMATIVE). She further explains that this politicization of the abject constitutes an effort to "rewrite the history of the term, and to force it into a demanding resignification" (p. 21).

Examples of abjection can be found in the contemporary WORK of performance artist Karen Finley and photographers Cindy Sherman and Andres Serrano, and in numerous horror films, such as *Aliens*. Finley explores the abject

through smearing her body's orifices with foods and other materials that replicate bodily fluids. Cindy Sherman immerses herself in the abject in a series of self-portraits in which her form appears in an advanced state of decay, nearly engulfed by the earth. Andres Serrano employs bodily fluids in acts of defilement of religious images. An example can be found in his highly controversial work *Piss Christ*, a photograph of a crucifix bearing a figure of Christ and immersed in a pool of Serrano's urine.

**ABSENCE** The problem of absence has become important to THEORY and criticism only recently, especially since the work of Jacques DERRIDA and other POSTSTRUCTURALISTS. According to DERRIDA, absence has usually been ignored in the history of Western philosophy in favor of PRESENCE. Gaps, pauses, rests, emptiness, and what is not found or depicted in a WORK are all examples of absences. A POSTSTRUCTURALIST approach to TEXTS, however, shows that seemingly stable arguments or categories are actually dependent upon certain exclusion, or absences, for their stability. Louis ALTHUSSER and other critics operating in a more explicitly political mode argue that what is left out of a TEXT points to otherwise hidden IDEOLOGIES.

**ABSTRACT** For all practical purposes synonymous with "non-objective," this term is widely used in the visual arts of MODERNISM to refer to an intentional abandoning of mimetic REPRESENTATION. The early twentieth century saw the birth of abstract art. Extreme abstraction is found in the mature work of Vassily Kandinsky, a Russian painter who is often cited as the first producer of truly abstract art. Less extreme abstraction is found in the WORK of Spanish painter Pablo Picasso, whose Cubist abstractions retained reference to FIGURES and objects. This strategy offers two advantages. The first is that it enables the artist to paint those things that are of ultimate importance but are invisible. The WORK becomes a SYMBOLIC REPRESENTATION or a parallel of the SUBJECT. Examples range from the Constructivists to the Abstract Expressionists. The second advantage is that this mode of working allows the artist to focus on the physical and material properties of the medium being used. Such a formalist position was exemplified by critics like Clement Greenberg.

**ACOUSTIC MIRROR** Drawing on the ideas of Guy Rosaloto, Kaja Silverman uses the idea of an acoustic mirror extensively in her 1994 analysis of contemporary film. The acoustic mirror refers to the mirroring effect created when one hears oneself talk. The speaker's VOICE is simultaneously emitted and received by him/herself. Because the VOICE so conceived can be internalized and externalized at the same time, it carries the potential to destabilize individual SUBJECTIVITY.

**ACTIVE DESIRE** In their explorations of representations of women in film, Laura Mulvey and Marianne Doane use the term "active desire" to refer to a type of DESIRE that involves an active, rather than a passive, SUBJECT position (see FEMINIST FILM THEORY). They pose this form of DESIRE as opposite to the passive DESIRE in which they believe women film viewers typically engage. In her 1975 essay "Visual Pleasure and Narrative Cinema," Mulvey theorizes that Hollywood conventions of cinematic practice construct the GAZE as male.

The female BODY in classical NARRATIVE cinema is the "SITE of sight." A male spectator is constructed both within the film and the audience. The female BODY acts as the FETISHIZED object of the MALE GAZE, and those in the audience necessarily take on the role of masculine VOYEUR. Further, the combination of NARRATIVE and SPECTACLE (the functions of telling and showing) reflects a system of SEXUAL imbalance in which the male is the active SUBJECT and the female is the passive object. Since within her framework women can only function as the objects of SPECTACLE, not as spectators, Mulvey's THEORIES leave little room for nonobjectifying representations of women or for expression of feminine as opposed to MASCULINE DESIRE. Feminist DISCOURSE subsequent to Mulvey's "seminal" article calls for exploration of the development of forms of REPRESENTATION that can embody and convey women's DESIRE.

In *The Desire to Desire: The Woman's Film of the 1940s*, Doane extends Mulvey's THEORIES, asserting that the female viewer as constructed in classical Hollywood film can only "desire to desire." She explains how the filmic image operates as a shop window for the female viewer: "The cinematic image for the woman is both shop window and mirror, the one simply a means of access to the other. The mirror/window takes on then the aspect of a trap whereby her SUBJECTIVITY becomes synonymous with her subjectification" (Doane, *The Desire to Desire*, p. 33).

The path of resistance to the subjugation of women thus produced—as Mulvey and Doane see it—involves development of forms of film and other visual media that offer women the active instead of the passive role. Contemporary artist Mary Kelly explores the possibility for development of active DESIRE by women in Western commodity culture in a mixed-media installation, *Interim*. Kelly proposes that an examination of hysteria might lead us to new formulations of possible alternative SUBJECT positions for women. According to PSYCHOANALYTIC THEORY, the female hysteric is characterized by an excess of identification with the male VOYEUR's DESIRE. Through her process of identification with the masculine VOYEUR, she comes to DESIRE to be the object that the male spectator desires her to be, and postures herself in a sort of THEATRICAL REPRESENTATION of that object. Kelly utilizes in her installation heterogeneous and ANICONIC imagery (REPRESENTATION not based on resemblance or analogy) because, she tells us "it can have the effect of displacing the female spectator's 'hysterical' identification with the male VOYEUR." (Kelly, *Interim*, p. ?) The hysteric's inability to DESIRE is paradigmatic of the inability to DESIRE by women in general. If women cannot actively DESIRE, they can only DESIRE to DESIRE. As Doane says, "In female spectatorship, it is a capitulation to the image, an overinvestment in and overidentification with the story and its character. Unable to negotiate the distance which is a prerequisite to DESIRE and its displacements, the female spectator is always, in some sense, constituted as a hysteric" (Doane, *The Desire to Desire*, p. 67)

**AESTHETIC EMOTION** According to Clive Bell, it is the distinction of art that it is able to produce this particular emotion. Aesthetic emotion is the result of Significant Form, which is in turn produced by a certain use of the elements of design. There is no particular combination of formal elements that is required to produce Significant Form. Any combination that moves the viewer

aesthetically will qualify as Significant Form. The elements of design, according to Bell, work on viewers via "certain unknown and mysterious laws" (see Clive Bell, "The Aesthetic Hypothesis.") It is the job of the critic to point out how particular works of art do or do not produce aesthetic emotion.

**A-FILM** A term from the American STUDIO ERA, signifying a major production, usually with important stars and a generous budget. A-Films were usually shown as the main feature on double bills.

**ALLEGORY** In the usual sense, the second, hidden, or "merely rhetorical" meaning of a TEXT or visual image, as opposed to any literal or apparent meaning. Techniques of allegory include personification, METAPHOR, and SYMBOLISM. In the visual arts, Craig Owens, in his article "The Allegorical Impulse," argues that modernist formalist art THEORY and production suspended the allegorical possibilities of visual REPRESENTATION in favor of Kantian SELF-REFERENCE. This FICTION, as Owens refers to it, could not be maintained after Minimalism. POSTMODERNIST art works to problematize the activity of pictorial reference not to proclaim the AUTONOMY and SELF-SUFFICIENCY of art, but to point out art's contingency partly through the use of ambiguously allegorical imagery.

**ALTERITY** Alterity describes the condition of an individual who, due to race, class, gender, age, and so on, is marginalized, and placed in the position of OTHER (see MARGINALITY, OTHER, and RADICAL ALTERITY).

**ALTHUSSER/ALTHUSSERIAN** Having similarities to the writings of French social theorist Louis Althusser, especially a concern with INTERPELLATION, SUBJECTIVITY, and REPRESSIVE and IDEOLOGICAL STATE APPARATUSES.

**ALWAYS ALREADY** A phrase used by Jacques DERRIDA and many subsequent writers of literature and art to describe an imminent and immanent contradiction in a TEXT. This contradiction is made more obvious through DECONSTRUCTION, but is not brought to a TEXT from the outside. It is already there, and has always been there, lurking in the TEXT.

**AMBIGUITY** The quality that allows a WORK to have different interpretations. This is achieved, intentionally or not, through a use of visual, spoken, or written language that has an uncertain significance. While such a condition has traditionally been considered a flaw of a TEXT, it has been seen in more recent art as an important rhetorical device that makes the processes of SIGNIFICATION more readily apparent.

**ANICONIC** A kind of REPRESENTATION that does not include a resemblance to a REFERENT. In some recent FEMINIST art and THEORY, aniconic REPRESENTATION has been exemplified by an avoidance of pictorial REPRESENTATION of the female BODY. The advantage of this type of reference is in allowing "woman" to be represented without being identified with the female BODY, which has often been taken as the definition and limit of "woman."

**ANTI-AESTHETIC**  As Hal Foster explains in *The Anti-Aesthetic: Essays on Postmodern Culture*, this term refers to the general shift from MODERNISM to POSTMODERNISM. Foster indicates two ways in which "anti-aesthetic" can be understood to describe this shift. First, the anti-aesthetic can be seen as a critique that destructures the order of REPRESENTATIONS in order to reinscribe them. Second, the anti-aesthetic can be understood as an extreme doubt and skepticism of the notion of the aesthetic, especially of the idea that the aesthetic exists "apart," almost beyond historical and social specificities. The anti-aesthetic, however, is not intended as a negation of art or REPRESENTATION, but rather as a refiguring and rethinking of REPRESENTATION and the aesthetic. Foster's understanding of the anti-aesthetic must be distinguished from the idea of ANTI-ART found in modernity.

**ANTI-ART**  This term is often linked to artists associated with Dada, because of their aggressive opposition to bourgeois cultural values, and their emphasis on chance, nonsense, and absurdity. Since such activities and attitudes have enraged some in the art world while inspiring others, the term has been used as both an epithet and an accolade.

**APORETIC(AL)**  Having the qualities of an APORIA.

**APORIA**  From the Greek meaning "impassable path," an aporia is a contradiction of the logic (or sense) and the RHETORIC in a TEXT. This should not be confused with a simple logical contradiction that may be found in an argument. The recognition of a contradiction of logic and RHETORIC is crucial to recognizing and understanding a DECONSTRUCTION.

**APPARATUS**  In film studies, the term "cinematic apparatus" or "filmic apparatus" refers to several interconnected aspects of the production and the viewing of film, including the technical components of film production, e.g., camera and projector; the conditions of film projection, e.g., the darkened room, seating that limits and directs the viewers' field of vision, light projected from the viewers' heads, and a SCREEN in front of the viewers; and the film itself, using various devices to create the impression of a continuous reality.

In Louis ALTHUSSER'S THEORY of state POWER, this term refers not only to a collection of the mechanical means of production in a society, but more generally to the means of producing cultural and social norms. They are of two types: Repressive State Apparatuses (RSAs) and Ideological State Apparatuses (ISAs). RSAs include governments, administrations, armies, police, courts, prisons, and so on. To ALTHUSSER, RSAs function ultimately (but not always) through the real or perceived threat of violence. Combining SEMIOTICS, LACANIAN PSYCHOANALYSIS, and, most of all, Marxist THEORY, ALTHUSSER describes ISAs, on the other hand, as functioning through IDEOLOGY by representing the "IMAGINARY relationship" of individuals to their "real conditions" of existence. ISAs are the means through which ideologies form individuals: religions, family, professions, schools, museums, courts, film and television, newspapers and magazines, advertising, and so on. They are typically the nonviolent, cultural, and often seductive means by which ideologies are distributed. IDEOLOGY consti-

tutes SUBJECTS within ISAs through INTERPELLATION or "hailing," that is, through the ways in which IDEOLOGY addresses itself directly to a SUBJECT. ISAs are the material systems of social practices that have effects upon individuals, providing them, for example, with their social identities and positions. Such workings of IDEOLOGY "naturalize" ARBITRARY DISCOURSE and social arrangements.

**APPROPRIATION** Influenced by THEORIES of both SEMIOTICS and SIMULATION, appropriation refers to the practice of reproducing or copying as accurately as possible in one WORK of art all or part of another WORK from a different CONTEXT (most commonly from art history or mass media). In MODERNISM and earlier periods, artists often incorporated "found objects" into artworks and also paid homage to the great artists of the past by borrowing images and compositions. This kind of activity was rarely a highly valued activity. In the late 1970s, however, shifts in art criticism allowed for more positive evaluations of appropriation. It has been viewed as a critical method on the part of some artists within POSTMODERNISM interested in questioning notions of ORIGINALITY and of progress of the history of art.

A second meaning of the term, with very different connotations, is found in more recent issues connected to multiculturalism. Here, to appropriate is akin to "stealing" some aspect of a CULTURE that has been put into a marginal position or a position of "OTHER." This sort of appropriation has met with a great deal of criticism, as it is seen as a form of colonization and cultural domination.

**ARBITRARY** In SEMIOTICS, the relationship of a SIGNIFIER to a SIGNIFIED and of a SIGN to a REFERENT is considered to be arbitrary. This indicates that semiotic relations are unmotivated, not necessary, not natural, in short, determined by CONVENTION.

**ARBORESCENT** See RHIZOMATIC AND ARBORESCENT.

**ARCHAEOLOGY OF KNOWLEDGE** This phrase is taken from the title of one of Michel FOUCAULT'S books, *The Archaeology of Knowledge*, originally published in France in 1969. (Later FOUCAULT added "The Discourse on Language" as an appendix to the main TEXT of the book.) In general usage, the phrase refers to any analysis of DISCOURSE that is concerned with the processes by which statements are generated and regulated within a system. More figuratively, the phrase is commonly used to refer to any layering of ideas upon other ideas, or to a historical search for the sources of ideas.

**ART FOR ART'S SAKE** A phrase used most commonly to refer to FORMALISM, a critical position on art that flourished within MODERNISM. From the formalist perspective, art is to be done and appreciated for its own sake, and not for any reason extraneous to the WORK of art, such as the imitation of nature, political purposes, or even expressive purposes. Art has an AUTONOMY that makes it valuable in and of itself.

**AUTEUR THEORY** A THEORY of film popularized by the French journal *Cahiers du Cinema* in the 1950s, primarily with reference to Hollywood. This

THEORY emphasizes the director as the major source of meaning. A strong director (an *auteur*, i.e., AUTHOR) stamps the material with his or her personal vision, characteristic themes, STRUCTURE, or style, even when working with an externally imposed script or GENRE, or other restrictions inherent in the studio system.

**AUTHOR**  Until relatively recently, the concept of the author was an untroubled one. With Roland BARTHES'S "The Death of the Author" (1977) and Michel FOUCAULT'S "What is an Author?" (1977), the idea of the author has become more PROBLEMATIC. BARTHES'S challenge of the idea of the author is part of his larger challenge of bourgeois values. The author and the living person who wrote the TEXT should not be seen as identical. A TEXT, to BARTHES, is not a collection of statements originating from a creative, godlike individual, but a collection of "quotations" from the wider CULTURE. The author then is not so much a PRESENCE as a location or an interstice. If the author is no longer the origin of a TEXT, the author no longer has control of the range of meanings of that TEXT. The author as usually understood is "dead," but at that same time the READER is "born," because without the author to limit the interpretation of the TEXT the READER can exert more control over the meanings of the TEXT. The TEXT becomes as much the product of a READER as of an author. We can certainly add to that combination all those others who work on texts but are not seen as authors: editors, publishers, friends, critics, students, and so on.
    FOUCAULT, consistent with his interests in DISCOURSE ANALYSIS and the POWER that accompanies INSTITUTIONS, sees the author not so much as the person who writes, but as a category of person who writes that which is deemed a special category of writing. Authors then perform a "classificatory function," allowing certain types of writing to be organized in some categories, while other forms of writing are placed into other categories. Grocery lists are not usually seen as having authors, but poetry is. Part of the function of an author is to provide a grounding for the distinction of different types of utterances, as well as different individuals. The usual idea of writing poetry is different from the notions we usually have about grocery shopping. To FOUCAULT, the historical rise of the author as an individual emerges together with the rise of modern concepts of the individual human being. Authors possess certain characteristics that are seen as important for authors in specific historical periods. For FOUCAULT, the rise of the author, together with shifts in his/her expected characteristics, demonstrates the artificial and contingent nature not only of authors but of all human SUBJECTS.

**AUTHOR FUNCTION**  See AUTHOR.

**AUTONOMY**  According to some of the more extreme positions of the FORMALIST THEORY of the arts, the WORK of art does or should exist in a separate sphere from that of everyday life. This allows art to develop to some degree independently from the pressures of the marketplace or politics. One way of achieving a position of autonomy is through complete abstraction, a strategy endorsed by Clement Greenberg and Theodor Adorno. This critical strategy goes by many other names: independence, self-criticism, SELF-SUFFICIENCY, SELF-REFERENCE, self-reflection. See also FORMALISM and ART FOR ART'S SAKE.

**AVANT-GARDE** The first use of the term was a military phrase in French strategic textbooks, meaning a scouting party that goes ahead of the main force, initiates a skirmish without taking part in a battle, and then reports back to the main column. The first use of the term in the arts was in 1825 by the utopian socialist Henri de Saint-Simone, who said of the arist Gustave Courbet and others, "it is you artists who will serve as our *Avant-Garde*" (Saint-Simon was using the term analogously to refer to the more general idea that it is the role of artist to lead society into a better future). The term was later adapted to indicate the "leading edge" or "advanced" developments in the arts, and eventually came to refer to anything new or unusual.

# B

**BAKHTINIAN DIALOGICS** See DIALOGIC/DIALOGISM.

**BARTHES/BARTHESIAN** Having similarities to the writings of French SEMIOLOGIST and literary critic Roland Barthes. He was especially concerned with the SEMIOTICS of a large range of cultural phenomena, from the visual arts to stripping and professional wrestling.

**BASE AND SUPERSTRUCTURE** According to Marxist cultural THEORY, the term "base" designates the means of industrial production and includes natural resources as well as the control of those resources by the ruling CLASS. The "superstructure" includes religion, philosophy, and cultural production such as literature, theatre, and visual art. Marxist theorists and critics are especially concerned with how superstructural activities produce IDEOLOGY that prevents workers from seeing the true conditions of their existence. Therefore, criticism of art is at the same time a criticism of IDEOLOGY and is an important social and political activity.

**BASSESSE** The French novelist, philosopher, and art critic Georges Bataille (1897—1962) has had an impact on recent CRITICAL THEORY through such writings as *The Accursed Share* (1949, trans. 1988), *The Tears of Eros* (1961, trans. 1989), and *Georges Bataille: Visions of Excess: Selected Writings, 1927—1939* (1988). Bataille regards the *INFORME* ("unformed"), which he likens to spit, as capable of subverting rational, categorical thinking. He further develops this concept through the idea of *bassesse* (baseness), the mechanism by which he believes the INFORME can be achieved.

One of the ways Bataille feels that formlessness can be achieved is by rotating the "proper" vertical axis of a human from the upright posture to the horizontal axis. He explores this baseness in his essay "The Big Toe" (1929), which was

accompanied by photographs of feet and toes produced by the French Surrealist Jacques-André Boiffard. Bataille offers the lowliest of all appendages, from which this essay derives its name, as that which connects us to the most base, the most earthly elements of human existence, since it is literally our connection to the earth. Positing two orders of seduction, the ideal and the base, Bataille presents the big toe as a reminder of the side of human existence which we, as humans, are drawn to but attempt to deny. Bataille says:

Since by its physical attitude the human race distances itself as much as it can from terrestrial mud—one can imagine that a toe, always more or less damaged and humiliating, is psychologically analogous to the brutal fall of a man—in other words, to death. The hideously cadaverous and at the same time loud and proud appearance of the big toe corresponds to this derision and gives a very shrill expression to the disorder of the human body, that product of the violent discord of the organs. (Bataille, *Visions of Excess*, p. 22)

Contemporary critic and art historian Rosalind Krauss asserts that Bataille's influence on surrealism resulted in "the production of images that do not decorate, but rather structure the basic mechanisms of thought" (Krauss, *L'Amour Fou*, p. 64). The concepts of the INFORME and *bassesse* are central to Bataille's concern with the structuring of these mechanisms. Bataille critiques the dependence on negativity of forms of thought which derive from the Hegelian dialectic. He views DIALECTICAL thinking as positing the master/slave relationship as fundamental to POWER STRUCTURES. The slave inhabits the negative pole of a relationship of BINARY OPPOSITION. In his desire to transcend such oppositional forms of thought, Bataille proposes that the oppressed, the "slave," effects an act of TRANSGRESSION through strategic employment of that regarded as most base, those characteristics of human existence which most closely resemble those of animal existence. Allan Stoekl explains: "the slave gains essential mastery over the master through his constructive use of the dead matter the master would fly above" (Stoekl, in *Georges Bataille, Visions of Excess*, p. xvi).

In a contemporary reworking of Boiffard's photographs of the same subject, John Coplans explores the bassesse in a series of photographs of his own feet and toes. These works form part of a larger body of work in which Coplans explores the TRANSGRESSIVE potential of display of the GROTESQUE BODY. (See GROTESQUE.)

**BAUDRILLARD/BAUDRILLARDIAN** Having similarities to the writings of French sociologist Jean Baudrillard, especially those concerned with SIMULATION, SIMULACRA, mass media, and the general spread of copies, duplicates and other SIGNS of the REAL that threaten to replace the REAL.

**B-FILM** A low-budget movie usually shown as the second feature during the American STUDIO ERA. B-films rarely included important stars and mostly took the form of POPULAR genres, like westerns, thrillers, horror films, and so on.

The major studios used them as testing ground for the "raw" talent under contract and as their filler product.

**BINARY DIFFERENCE** See BINARY OPPOSITION.

**BINARY OPPOSITION** Central to dialectic logic, a bringing together of two terms into exclusive oppositional relationship with one another. This arrangement of terms is common to the European traditions of philosophical and scientific discourses. Some prominent examples are positive and negative, male and female, good and evil, and mind and BODY. In SEMIOTICS, the binary opposition is one of the limits to the ARBITRARY relationship of SIGNIFIERS to SIGNIFIEDS and SIGNS to REFERENTS. At any one point in time, a SIGN signifies what it does because it does not signify something else. For example, the spoken word "hat" means what it does in part because, at the moment of its utterance, "hat" does not mean the same as the spoken word "boat."

**BIO-POWER** See DISCIPLINE.

**BIRMINGHAM SCHOOL** The Birmingham School of Cultural Studies, Birmingham, England, includes writers such as Stuart Hall. It is especially interested in studying mass media, GATEKEEPING, HEGEMONY, and elitism, and is generally influenced by, but not limited to, Marxist THEORY.

**BODY** DISCOURSE on the body as a SITE of regulation and control has comprised a significant portion of recent feminist THEORY. In contemporary CULTURE, the attributes of a normative femininity are conveyed predominantly through the visual CODES of the POPULAR media. The construction of individual feminine SUBJECTIVITY depends upon a visual presentation of the self that conforms to such CODES. The body, the SITE for presentation of this self, is thus of primary importance.

Much contemporary THEORY that deals with the BODY finds its source in the ideas of Michel FOUCAULT. As FOUCAULT writes in *A History of Sexuality, Volume 1: An Introduction*, the body in the modern CONTEXT is a primary SITE of regulation and control. In his discussion of how disciplinary POWER operates as a form of social control, FOUCAULT explains how the body is configured within disciplinary practices that make individuals both more powerful and more productive. Such practices, however, also make individuals more docile. Bodies constructed through disciplinary practices, "docile bodies," can, according to FOUCAULT, be broken down into two types: the INTELLIGIBLE and USEFUL BODIES. The INTELLIGIBLE BODY is constructed of our normative cultural conceptions of the body, how it is represented in the DISCOURSES of science, philosophy, and norms of beauty and health. Such REPRESENTATIONS serve to formulate a set of practices that function to regulate the body and produce USEFUL BODIES. USEFUL BODIES (also known as practical bodies) are well-adapted to their social function and, at the same time, ill-adapted to perform actions not

deemed socially useful or socially fit. These USEFUL BODIES are valued and deemed aesthetically pleasing because they are perceived as well-adapted to their function. The USEFUL BODY, which is not shaped or determined by nature, is culturally mediated. It produces meaning through real use and function. In contrast, the INTELLIGIBLE BODY produces meaning through *appearance* and *symbolic* function. Susan Bordo, a cultural theorist who has productively applied Foucault's conception of the body to a feminist critique of contemporary CULTURE, points out that the INTELLIGIBLE BODY and the USEFUL BODY grow out of the same DISCOURSE and are mutually supportive. She asserts that, if FEMINISM is to have any effect on women's lives, it must examine the connections between the INTELLIGIBLE BODY (the body as represented in culturally dominant discourses) and the USEFUL BODY (the body as it functions in practical terms in the everyday world) (See Bordo, "The Body and Reproduction of Femininity: A Feminist Appropriation of Foucault").

The work of a number of cultural theorists who focus on the body has had a particularly strong impact on the field of visual art. The influence of most major theorists, such as LACAN, Kristeva, FOUCAULT, and DERRIDA, has been for the most part indirect, exerted through writers of lesser stature who have interpreted their THEORIES and thus made them accessible and applicable to the work of visual artists. Such interpreters include Laura Mulvey, who has had a major impact on FEMINIST FILM THEORY through her application of Freudian and LACANIAN THEORY to film; Barbara Creed, whose THEORIES regarding the "monstrous feminine" have served to more widely disseminate the ideas of Julia Kristeva; Mary Russo, whose work on the female GROTESQUE has stimulated feminist theorists' interest in Mikhail Bakhtin's ideas regarding CARNIVAL and the GROTESQUE; Susan Bordo, who has productively applied FOUCAULT'S ideas to contemporary cultural phenomena, such as eating disorders like *anorexia nervosa*; Australian theorists Moira Gatens and Elizabeth Grosz, who have drawn on a wide range of cultural THEORY but have made perhaps their most significant contribution to FEMINIST understanding in their discussion and applications of PSYCHO-ANALYTIC THEORY; and Judith Butler, who has served as a major elucidator of the ideas of a number of cultural theorists, including FOUCAULT, LACAN, and the French feminist theorists Monique Wittig, Luce Irigaray, and Hélène Cixous.

**BODY WITHOUT ORGANS** Originating in the ideas of Gilles DELEUZE and Félix GUATTARI, the idea of a BODY WITHOUT ORGANS (BWO) is a BODY without "organization" and outside any determinate state. The lack of organization means that the BODY has regained its potentiality and is outside the socially articulated, disciplined, semiotized, and subjectified state in which BODIES have been in modernity. The BWO has become disarticulated, dismantled, and deterritorialized, and hence is able to be reconstructed in new ways. DELEUZE and GUATTARI'S articulation of the BWO includes the description of how some BWOs tend toward a more limited, organized, and disciplined state, and toward remaining in existence or a returning to existence. This tendency, or DESIRE, turns the BWO into a DESIRING MACHINE, constantly moving toward that which

it cannot fully possess or become. A DESIRING MACHINE, also called an assemblage at times by DELEUZE and GUATTARI, is both a tendency in humans and a machine. The BWO and the DESIRING MACHINE are parts of the larger movement in recent cultural thought that attempts to reconceive and reposition the human SUBJECT and SUBJECTIVITY in social, cultural, and historical contexts. See also NOMADOLOGY, and RHIZOMATIC and ARBORESCENT. (See DELEUZE AND GUATTARI, 1987.)

**BRICOLEUR** A term borrowed from the writings of French structuralist linguist Claude Levi-Strauss, *bricoleur* indicates one who makes do with whatever material odds and ends are available at any given time. What is constructed from these materials is a *bricolage*, or a kind of improvisational and makeshift handiwork slapped or collaged together from found materials. Levi-Strauss used the term to describe the processes by which primitive societies construct language and MYTH. Jacques DERRIDA widened the concept to include the activity of borrowing from one's own textual heritage whatever is needed to produce new and different TEXTS, with the emphasis on intertextual borrowing for the purposes of textual construction.

**BWO** See BODY WITHOUT ORGANS.

# C

**CANON** A canon is a "list" of great works or masterpieces. Literally, of course, there is no official single and unchanging list. Rather, a canon is a generally recognized set of works that are repeatedly discussed, taught, read, reproduced, or exhibited with regularity over a period of time. To locate a canon, one need only look at anthologies of literary works or art history survey textbooks. Canons are by necessity exclusive and confer value on some works and not others. In recent years, the processes by which canons have formed, as well as the socio-political effects on the contents of canons, have been the topic of great discussion and debate.

**CARNIVAL** Carnival figures prominently in the writings of Russian linguist Mikhail Bakhtin (1895–1975). Interested in folk CULTURE of the late medieval and early Renaissance periods of European history, Bakhtin makes the collective ritual of carnival the SUBJECT of much of his writing. He sees the imagery and ritual of carnival as characterized by a "MATERIAL BODILY PRINCIPLE," which finds expression in "GROTESQUE REALISM." In GROTESQUE REALISM all things bodily become grossly exaggerated, exceeding all normal and proper limits. In the carnival, the "high" and the "ideal" are lowered through laughter linked to the "bodily lower stratum" and lower bodily functions. GROTESQUE REALISM celebrates all those aspects of material existence that are commonly regarded in Western CULTURE as base or degraded.

Peter Stallybrass and Allon White use Bakhtin's *Rabelais and His World* (1940, trans. 1968 and 1984) to study carnival as a cultural DISCOURSE and as a SITE of TRANSGRESSION, from which political change may be effected through a rearrangement of the relations of "high" and "low" across a social STRUCTURE. The subversive potential of carnival is characterized by a diffuse and humorous heterogeneity, by all sorts of inversions, mockery, and degradation. Laughter figures prominently in the carnivalesque. Comedic reenactments of ritual SPECTACLE that PARODY such practices of high CULTURE, THEATRICAL verbal PLAY, and GROTESQUE display of the BODY make up the major components of carnival as conceived by Bakhtin. Such theatrics of carnivalesque PER-

FORMANCE are believed to produce a leveling of CLASS distinctions; as a conse-
quence, they are regarded as potentially subversive of the existing social order
with its established distinctions of high and low.

Stallybrass and White maintain that only those actions that challenge major
cultural SITES of DISCOURSE—acts of defiance that normally originate from
those occupying low or marginalized positions such as found in carnival—can
hold the TRANSGRESSIVE POWER necessary to effect true political transforma-
tion. They regard carnival as a DISCURSIVE FORMATION that provides a model
of resistance through its function as a SITE of TRANSGRESSION that derives its
subversive potential from the crossing of limits, the violation of boundaries, and
the joining of opposites. GROTESQUE display of the BODY, a significant ritual
element of carnival, transgresses the socially determined proper limits of the
BODY. In such display somatic SYMBOLS function as producers of social classi-
fication. Through employment of HYBRID forms that function as somatic
METAPHORS for such crossing of limits and joining of opposites, social limits
are transgressed and, at the same time, established.

Tracing the development of carnival from medieval to nineteenth-century Eu-
rope, Stallybrass and White maintain that the carnival came to signify for the
nineteenth-century European bourgeoisie "the culture of the other" (Stallybrass
and White, p. 178). The carnival carried, in SYMBOLIC FORM, all that members
of polite bourgeois society strove to eliminate from their lives. The breaking
down of boundaries and abandonment of social hierarchies in carnival violated
those distinctions between self and other that were necessary to the sense of a
discrete individual self. The GROTESQUE BODY as displayed in carnival, in its
corpulence and excess, threatened to overflow the limits of the discretely bounded
CLASSICAL BODY.

Stallybrass and White describe the ritual inversions of carnival as involving
degradation of those representing authority in the CULTURE (kings, government
officials, and so on.) through conferring GROTESQUE qualities upon them. Such
GROTESQUE attributes involve those features making up the bottom half of the
BODY (the toes, feet, buttocks, anus, and genitals), which are displayed in
comic, mocking fashion. The GROTESQUE BODY may thus be effective in
strategies of resistance, "may become a primary, highly-charged intersection and
mediation of social and political forces, a sort of intensifier and displacer in the
making of IDENTITY" (Stallybrass and White, p. 25).   Display of the
GROTESQUE BODY in carnival as discussed by Bakhtin can be "rediscovered as a
governing dynamic of the BODY, the household, the city, the nation-state—in-
deed a vast range of interconnected domains" (Stallybrass and White, p. 19).

The main weakness pointed out by various critics of Bakhtin's conception of
carnival as oppositional is that, as an officially sanctioned event, carnival may
serve as a controlled form of opposition. Such opposition, because contained,
may serve to consolidate rather than subvert the positions of those in POWER.
Literary critic Terry Eagleton voices this opinion, noting that carnival is "a *li-
censed* affair in every sense, a permissible RUPTURE of HEGEMONY, a contained
popular blow-off as disturbing and relatively ineffectual as a revolutionary work
of art" (Eagleton, *Walter Benjamin*, p. 148).

Mary Russo notes that anthropologists Mary Douglas and Victor Turner also
see rituals, such as carnival, that involve status reversals as basically conserva-
tive social forces. In their view, they reinforce existing social structures, thus

consolidating that which they oppose. Temporary loss of social differentiation and HIERARCHY found in carnival function as brief periods of collective disorder that, in invoking chaos and danger, cause the status quo to appear safe and desirable. Dissenting from this view, Russo argues for the subversive potential of carnival. She describes carnival as characterized by a diffuse heterogeneity, by "all manner of recombination, inversion, mockery, and degradation," and argues for the capacity of carnival to serve as the SITE of political change:

The political implications of this heterogeneity are obvious: it sets carnival apart from the merely oppositional and reactive; carnival and the carnivalesque suggest a redeployment or counterproduction of culture, knowledge, and pleasure. In its multivalent oppositional play, carnival refuses to surrender the critical and cultural tools of the dominant class, and in this sense, carnival can be seen above all as a site of insurgency, and not merely withdrawal (Russo, "Female Grotesques," p. 218).

Stallybrass and White believe that, although carnival may be a normally stable officially sanctioned ritual, in cases of already heightened political unrest it may function as both catalyst to and SITE of actual conflict (Stallybrass and White, p. 14). They point out that one can find many instances in European history when violent uprisings occurred during carnival.

Russo asserts that recent DISCOURSE on carnival, or the carnivalesque, has "translocated the issues of bodily exposure and containment, disguise and GENDER MASQUERADE, abjection and MARGINALITY, PARODY and excess, to the field of the social constituted as a SYMBOLIC system" (Russo, "Female Grotesques," p. 214). This DISCOURSE has led CULTURAL STUDIES to seek out models for transformation and social change in those phenomena operating symbolically at the margins of CULTURE. Asserting that one of the dominant concerns of recent FEMINISM has been to reestablish the BODY as a SITE of contestation within the political realm, Russo feels that, at this point, it would be productive to assess "how the relation between the SYMBOLIC and cultural constructs of femininity and Womanness and the experience of *women* (as variously identified and SUBJECT to multiple determinations) might be brought together toward a dynamic model of a new social SUBJECTIVITY."

In the contemporary CONTEXT, Bakhtin's conception of the carnivalesque is often applied to POPULAR CULTURE, to those "low" cultural forms that are excluded from the realm of "high" CULTURE. Consequently, carnival THEORY has played a central role in much recent CULTURAL STUDIES focusing on film, television, and other commercial forms. In addition, a number of contemporary artists have explored the realm of the carnivalesque in attempts to subvert the exclusionary practices of high CULTURE. One recent example is the "Bad Girls" exhibition held simultaneously at the Museum of Contemporary Art in New York and the UCLA Wight Art Gallery in Los Angeles in 1994. Curator Marcia Tucker acknowledges the carnivalesque as a basis for the exhibit's premise and the relevance of Bakhtin's THEORIES to recent artwork that deals with FEMINISM and GENDER issues. She finds the carnivalesque particularly relevant to those artists who are "trying to effect positive social change by being both transgressive and funny (hoping to kill more flies with honey than with the fly-swatter)" (Tucker, *Bad Girls*, p. 23). She sees the "Bad Girls" show as, like carnival, "characterized by an inordinate ability to mix disparate elements with wild abandon and to confound categories, social positions and hierarchies of space, lan-

guage and CLASS; to provide both a 'festive critique' and an extreme utopian vision of society at the same time; and to reconfigure the world through laughter" (p. 23).

**CENTER** In the STRUCTURALIST SEMIOTIC THEORY of Saussure, the center is that which governs and limits the arbitrariness of SIGNIFICATION, but that is at the same time outside REPRESENTATION. As part of his development of DECONSTRUCTION, Jacques DERRIDA criticized such a notion of the center by arguing that it cannot be represented—that is, posed as a fundamental component of a THEORY of REPRESENTATION—and at the same time exist outside REPRESENTATION.

**CENTRAL CORE IMAGERY**  See CENTRAL VOID AESTHETIC.

**CENTRAL VOID AESTHETIC**  Art critic Lucy Lippard was perhaps the most vocal proponent of what has become known as first-generation FEMINIST art. Writing about such WORK in the early 1970s, Lippard described it as characterized by a number of features that she believed expressed an innate feminine aesthetic sense. Such features include soft veils of color, high tactility, and a composition structured around a central void. The centralized void she described, which had been previously labeled by artists Judy Chicago and Miriam Schapiro as "CENTRAL CORE IMAGERY" and by others as "VAGINAL ICONOGRAPHY," became the object of much debate. Some believed such imagery was the product of women's bodily experience, of their sense of the vaginal orifice and womb as an empty bodily space located at the core of their physical being. In the catalog essay that accompanied the 1973 exhibition "Women Choose Women," Lippard describes how she has observed in women's art "a uniform density, or overall texture, often sensuously tactile and repetitive to the point of obsession; the preponderance of circular forms and central focus (sometimes contradicting the first aspect). . . a new fondness for the pinks and pastels and the ephemeral cloud-colors that used to be taboo unless a woman wanted to be 'accused' of making 'feminine' art" (Lippard, "A Note on the Politics and Aesthetics of a Women's Show, pp. 6–7).

**CINEMA VÉRITÉ**  (French, literally "cinema truth".)  A style of filmmaking that claims that its methods do not interfere with the way events take place in "reality." *Cinema vérité* depends upon lightweight equipment (hand-held camera and portable sound APPARATUS) and usually involves very small (two-person) crews. Originally associated with the work of the French ethnographer Jean Rouch (late 1940s, 1950s), *cinema vérité* inspired the American movement of "direct cinema," which became the dominant style of documentary in the early 1960s.

**CLASS**  Most commonly, a class refers to a particular economic group. The term comes out of MARXIST THEORY and has been used to designate those parts of a society that are, or may eventually be, locked in a struggle with one another over the control of the means of production. More recently Pierre Bourdieu has extended the economic conception of class to develop his idea of "social habitus." One's habitus or position is determined by income, but also by education,

taste, profession, and leisure activities. Bourdieu's conception of class has been especially attractive to cultural criticism in general, since it emphasizes the importance of the arts in determining class and class interests.

**CLASSICAL BODY**  The classical body plays an important role in the writings of two major twentieth-century cultural theorists. Russian linguist Mikhail Bakhtin (1875–1975) develops concepts of the classical (or classic) and GROTESQUE BODY in *Rabelais and His World*, a study of the sixteenth-century French writer Rabelais. He distinguishes the classical BODY, which is clearly delineated and distinguished from its surroundings and possesses no open orifices, from the GROTESQUE BODY, which is typified by prominently displayed orifices and a lack of distinction from its environment. The SUBJECT possessing the classical body is delimited and contained. Bakhtin explains that the GROTESQUE BODY, which is always in the process of metamorphosis and always unfinished, transgresses its limits and overflows into its environment. It is not a discrete whole completely differentiated from its surroundings like the classical BODY.

French theorist Michel FOUCAULT also speaks of a classical BODY. As he explains in *Discipline and Punish*, "protocols of the classical body" were integral to the rationality that became the guiding principle of eighteenth-century European CULTURE and resulted in a proliferation of INSTITUTIONS such as prisons, hospitals, asylums, barracks, and schools designed to assure reason and order within a clearly established HIERARCHY (FOUCAULT, *Discipline and Punish*, p. 22). Like the classical BODY, which was defined by what it excluded through a process of rigid control, the Age of Reason was defined by what it excluded. Anything irrational, anything "low," anything impure, anything GROTESQUE was pushed to the margins.

In *The Politics and Poetics of Transgression*, Peter Stallybrass and Allon White explain Bakhtin's concept of the classical body as denoting "the inherent form of the high official culture" and as suggesting that "the shape and plasticity of the human BODY is indissociable from the shape and plasticity of discursive material and social norm in a collectivity" (p. 21). They point out that the classical body structured the DISCOURSES of "high" CULTURE such as philosophy, theology, law, and literature, in which were ENCODED discursive systems characterized by regulation, limits, and CLOSURE.

Bakhtin points out that the GROTESQUE BODY—the aged BODY, the pregnant BODY, the deformed BODY—is noncanonical in the artistic traditions of Western CULTURE. It was excluded from Renaissance high art and aesthetics and consequently from the subsequent tradition of high art in Western CULTURE, which developed out of the artistic ideal and CANONS of the Renaissance. The canonical, or classical BODY, which was central to the CANON, is described by Bakhtin in the following passage:

As conceived by these canons, the body was first of all a strictly complete, finished product. Furthermore, it was isolated, alone, fenced off from all other bodies. All signs of its unfinished character, of its growth and proliferation were eliminated; its protuberances and offshoots were removed, its convexities (signs of new sprouts and buds) smoothed out, its apertures closed. The ever unfinished nature of the body was hidden, kept secret; conception, pregnancy, childbirth, death throes, were almost never shown. The age represented was as far removed from the mother's womb as from the grave, the age most distant from either threshold of individual life. The accent was

placed on the completed, self-sufficient individuality of the given body (Bakhtin, *Rabelais and His World*, p. 29).

In contrast, GROTESQUE images are characterized by ambivalence and contradiction. By the standards of classical aesthetics (what Bakhtin calls "the aesthetics of the readymade and completed"), GROTESQUE images are ugly, even monstrous, carrying "all the scoriae of birth and development." (Bakhtin, *Rabelais and His World*, p. 25)

Within this canonical tradition, the female BODY is doomed to always fall short of the ideal. Characterized by orifices and uncontrollable BODY fluids, and prone to states, such as pregnancy, when boundaries between self and OTHER cannot be clearly delineated, it always retains an element of the GROTESQUE. In *The Female Nude: Art, Obscenity and Sexuality,* Lynda Nead argues that traditionally the female nude as a CONVENTION of visual REPRESENTATION has served to contain and regulate the female BODY. The practices and CONVENTIONS of visual art have worked to produce a female SUBJECT that is impenetrable and that serves to maintain distinctions between self and OTHER. She further asserts that, if the boundaries of the BODY are inseparable from the boundaries structuring the social and cultural, then TRANSGRESSION of the limits of the BODY in REPRESENTATION is also TRANSGRESSION of social limits.

Nead explains that the classical ideals of order and symmetry that permeate Western aesthetics extend from art criticism and art education into the juridical realm, where they STRUCTURE ethical standards and legal discourses on obscenity and on art that work to produce a coherent, rational individual. She explains further that the idea of unified FORM is integral to our conception of selfhood and individual SUBJECTIVITY. Such an idea of the self can be seen in PSYCHOANALYTIC DISCOURSE, in which SUBJECTIVITY is constructed in terms that emphasize boundaries and fix the limits of the BODY. She cites a passage from Freud's "The Ego and The Id" as evidence:

The ego is ultimately derived from bodily sensations, chiefly those springing from the surface of the body. It may thus be regarded as a mental projection of the surface of the body, besides. . . representing the superficies of the mental apparatus (Freud, "The Ego and the Id," p. 26).

Nead proposes that we view the classical female nude as a METAPHORIC expression of processes that separate and order, that produce clear differentiations between self and OTHER. She sees the female nude as a "discourse on the subject, echoing structures of thinking across many areas of the human sciences" (Nead, p. 7).

Nead discusses Robert Mapplethorpe's photographs of Lisa Lyon, winner of the first World Women's Bodybuilding Championship in 1979 , as images reflective of the control and containment typical of the classical body (Mapplethorpe, *Lady: Lisa Lyon*, fig. 33). Lyonn's BODY work and Mapplethorpe's manipulation of the photographic medium work together to create what Samuel Wagstaff, in his foreword to Mapplethorpe's book calls "straitjacket style," or "the world reinvented as logic, precision, sculpture in obvious light and shadow" (p. 8). Hard-edged FORM and stark lighting create a sculptural FORM that is accentuated by application of graphite to the model's BODY. Paradoxically, an image intended to cross GENDER lines, to blend mas-

culinity and femininity, ends up only reinforcing the bodily containment cultur-
ally PRESCRIBED for the female FORM. Thus, as Nead points out, "the act of
representation is itself an act of regulation" (Nead, p. 9).

**CLASSICAL CINEMA**   A term referring to the feature-length NARRATIVE
film type made and distributed by the Hollywood studio system, roughly from
1925 through 1960. Central to classical cinema are conventions of film practice
that are repeated from film to film and that the audience relies upon and expects.
The characteristics of classical cinema can be determined by the terms of produc-
tion (GENRE, stars, directors, producers); NARRATIVE (tightly organized PLOTS
with clearly defined conflicts and resolutions, and a focus on individual charac-
ters); and editing (alternation and repetition of shots, camera set-ups, angles,
editing patterns). Overall, there is in classical cinema a tendency toward balance,
symmetry, and resolution so that the film appears to move from beginning to
CLOSURE. The typical  film from this era is designed to produce a "REALITY
EFFECT"—to create the illusion of reality for the spectator. Laura Mulvey further
describes classical cinema as having a NARRATIVE STRUCTURE that produces a
polarity between an active/male and passive/female position. In such a film the
male SUBJECT acts and the female SUBJECT provides the passive object of the
viewer's visual PLEASURE (See Mulvey, "Visual Pleasure and Narrative Cin-
ema").

**CLOSURE**   A characteristic trait of classical NARRATIVE STRUCTURE where
we expect every element to be MOTIVATED, every event to have a cause (which
will be explained in the course of the NARRATIVE), every conflict, ENIGMA and
contradiction that the NARRATIVE sets up in the beginning to be resolved by the
end.

**CODE**   A term used in SEMIOTICS (or SEMIOLOGY) to indicate a SIGNIFIER or
SIGN, the use of which has become so common and so repeated that it fails to be
recognizable as ARBITRARY. The term also describes a set of rules or CONVEN-
TIONS that STRUCTURE a particular DISCOURSE. Film production, for example,
employs a complex system of codes of REPRESENTATION, such as editing, act-
ing, NARRATIVE, video and audio special effects, music, and dialogue. Some of
these codes—for example, editing—are unique to film, while some are shared
with other arts—for example, codes of lighting are shared with photography, and
NARRATIVE codes with novels.

**CODIFICATION**   The process through which a word, term, image, or any
other SIGNIFIER or SIGN becomes a CODE.

**COLONIAL(ISM)/COLONIALIZED**   In "The Economy of Manichean
Allegory," Abdul R. JanMohamed describes colonialist literature as exploration
of a realm lying at the edge of civilization. Since this uncivilized world has not
yet been "domesticated" by European CODES, it "is therefore perceived as uncon-
trollable, chaotic, unattainable, and ultimately evil." In his drive to dominate,
the colonizer regards this realm of the OTHER as a SITE of "confrontation based
on differences in RACE, language, social customs, cultural values, and modes of
production" (JanMohamed, p. 18). Colonialist literature ultimately affirms an

ethnocentric view, codifying the realm of the uncivilized in terms of the colonizer's mental constructs. JanMohamed asserts that "such literature is essentially SPECULAR: Instead of seeing the native as a bridge toward syncretic possibility, it uses him as a mirror that reflects the colonialist's self-image" (JanMohamed, p. 19).

Another major concern in studies of colonialism is with how the colonizer's destruction and "rewriting" of the history of the colonized functions as a mechanism of dominance and control. A concomitant concern centers on the question of whether, in such a situation of dominance, the colonized may achieve agency. This is one of the major concerns of Gayatri Chakravorty Spivak, who has discussed the question of whether it is possible for the colonized to find a "VOICE" that expresses anything other than an "essentialist fiction" (Spivak, "Can the Subaltern Speak?," p. 26).

In "Signs Taken for Wonders," Homi Bhabha discusses how the colonizer controls the colonized and how the colonized uses mimicry and imitation as coping strategies in a constantly oppositional atmosphere. Bhabha deals, as well, with the idea of hybridity, asserting that HYBRIDITY may constitute the colonized's most common and most effective means of subversion, because it exhibits the "necessary deformation and displacement of all sites of discrimination and domination" (p. 9).

Much as in literature, in visual art, concerns with colonialism focus on ways in which TEXTS produced by colonial POWERS function as sites of dominance and control, fixing the colonized in the position of OTHER. Historically, this has operated in part through ORIENTALISM, as explained by Edward Said. Artists who have made such destruction and rewriting their SUBJECT include Jimmie Durham and Elaine Reichek.

**COMMODIFICATION**   The process by which an object or activity is reified and converted into something that can be bought and sold, that is, a commodity. Many cultural theorists, such as Theodor Adorno and Clement Greenberg, see the commodification of art as a threat to its possibilities as a creative and revolutionary activity. As a result, the analysis and critique of the processes by which art becomes commodity has had a long history, especially in MODERNIST cultural criticism. See also FRANKFURT SCHOOL and FORMALISM.

**COMMUNICATION**   In general, the transferal of information and/or ideas from one SITE to another, usually through a medium of transmission and in the form of SIGNS, CODES, or SYMBOLS. In more recent years, the problems of communication have been taken up in SEMIOTICS, the study of SIGNS, and in other fields of cultural analysis and criticism.

**CONNOTATION**   The suggestive, associative, figurative sense of a word, image, or SIGN that extends beyond its strict literal definition or DENOTATION, beyond what appears to be its "natural" meaning. In practice, denotative and connotative meanings cannot be that easily distinguished, especially when we are dealing with images.

**CONTENT**  A term used to identify the intention, idea, interpretation, or concept of the WORK of art. In common usage content is often placed in opposition to the FORM or strictly material aspect of a WORK. Content is not always identical to SUBJECT matter, that is, what a WORK depicts. For example, the SUBJECT matter of a painting may be a woman holding a baby, but the content would be something else, for example, the Madonna and Child.

**CONTEXT**  Also called the "background," the idea of context is often used as a way to derive meaning from a WORK. WORKS are often "put into context" so as to give an interpretation more credence. Such credence is possible because of the usual understanding of context as the historical, personal, or cultural situation out of which the WORK of art comes. Recent POSTSTRUCTURALIST THEORY has challenged the traditional idea of context—which had long been accepted unquestioningly as natural background—with the notion that since context is available only through interpretation of other works and texts, it is itself a kind of artificial construction. Thus the strategy of using context to settle disagreements among differing interpretations meets with a complicating factor.

**CONTINUITY**  In NARRATIVES of all sorts, the achievement of continuity is an important aid to the creation of a "REALITY EFFECT." Continuity is the result of the suppression of the differences between separate NARRATIVE segments. In film production, for example, continuity is often the result of editing that bridges the gaps that results from different camera setups, so that the spectator ignores the edits. Major CONVENTIONS of continuity editing include the 180–degree rule, the shot/reverse shot and point of view constructions, eyeline match, match on action, the 30–degree rule, and an overall pattern of establishing shot/breakdown/reestablishing shot.

**CONVENTION**  See SEMIOTICS.

**COPY**  See SIMULATION.

**COUNTER-MEMORY**  A term used by FOUCAULT in his book *Language, Counter-Memory, Practice* to designate any DISCOURSE that runs counter to or in a different direction from the dominant or controlling DISCOURSES—or METANARRATIVES—at a given time. Counter-discourses uncover forgotten histories (thus, they are sometimes called counter-memories), as well as produce alternative explanations of the present.

**CRITICAL THEORY**  Once a term used to designate the FRANKFURT SCHOOL in particular, it now refers to a wider range of THEORIES on CULTURE and society, such as SEMIOTICS, FEMINIST THEORY, POSTSTRUCTURALIST THEORY, CULTURAL STUDIES, and many others.

**CULTURAL FEMINISM**  Over the past several decades different forms of FEMINISM have developed. Initially united by a dominant concern with the oppression of women, feminists have more recently perceived a need for recognition of their significant differences in viewpoint. Cultural feminism is a variety of feminist thought that has often been characterized as "ESSENTIALIST," since

it is primarily concerned with definition and celebration of an essential femininity with which cultural feminists believe all women are naturally endowed. Some, including feminist theorist Linda Alcoff, believe that the ESSENTIALIST aspect of cultural feminism grew out of the need for valorization of "positive attributes under oppression" (Alcoff, "Cultural Feminism Versus Post-structuralism," p. 418). (See POSTSTRUCTURALISM and POSITIONALITY.) Cultural feminism is often contrasted to POSTSTRUCTURALIST FEMINISM. Those holding a POSTSTRUCTURALIST view believe that femininity is culturally produced, and that GENDER is not fixed or stable but is, rather, amenable to infinite variation.

**CULTURAL MATERIALISM**  A kind of catch-all phrase, cultural materialism describes a number of approaches, including Marxist, POSTSTRUCTURALIST, and SEMIOTIC, to studying the arts, humanities, and mass CULTURE. After originating in Britain in the late 1970s as a more discrete approach, cultural materialism as practiced by Raymond Williams, Jonathan Dollimore, and Alan Sinfield was rooted in Marxism and stressed the relationships between cultural creations and economic, social, political, and historical contexts. Williams seems to have coined the phrase cultural materialism and used it to emphasize the material INFLUENCES on cultural activities. He revised the traditional Marxist idea that the economic BASE (industrial production) determines the character of the SUPERSTRUCTURE (the arts). Williams redescribed economics as a social, political, and cultural process rather than as a mechanical event or fixed state. Likewise, he envisioned cultural creations as more like economic and material production. In that way, both economic BASE and cultural SUPERSTRUCTURE gain the POWER of constituting one another.

**CULTURAL STUDIES**  The phrase "cultural studies" is often seen as vague and amorphous. This understanding is taken as an advantage to those involved in the practice of cultural studies, since it allows for a DIVERSITY of methods and topics used in the study of CULTURES. Cultural studies as we think of it now emerged in Britain with the founding of the Centre for Contemporary Cultural Studies at Birmingham University in 1964. Originally part of the English Department, the Centre eventually became its own department and included such scholars as Raymond Williams and Richard Hoggart. Cultural studies originally favored an approach to CULTURE termed CULTURAL MATERIALISM, but has since developed into an area of study, if not a DISCIPLINE, that incorporates the methodologies and topics of study from many different fields. Cultural studies has ushered in the current era of INTERDISCIPLINARY studies with its use of MARXIST, FEMINIST, SEMIOTIC, POSTSTRUCTURALIST, and other critical schools of thought.

**CULTURE**  Although the term "culture" has traditionally had the CONNOTATION of "high culture"—the fine arts such as Renaissance painting and sculpture, classical music, Shakespearean theatre, and so on—the term has been used in recent years to indicate a much wider sphere of social life. This sphere includes beliefs, practices, rituals, gestures, artificial production, spatial divisions, in short, the way of life of a people. The task of CULTURAL STUDIES is to come to terms with this sphere through a wide variety of methodologies.

# D

**D&G** Abbreviation for (Gilles) DELEUZE and (Félix) GUATTARI (see DELEUZE AND GUATTARI).

**DEATH OF THE AUTHOR** See AUTHOR.

**DECENTERED** According to Jacques DERRIDA'S notion of DECONSTRUCTION, a theory or argument becomes decentered upon the occurrence of a DECONSTRUCTION. The CENTER around which all SIGNIFICATION would be governed is lost and so the argument loses its grounding and its POWER to convince or persuade.

**DECONSTRUCTION** Deconstruction was introduced by Jacques DERRIDA in his writings and lectures in the late 1960s and has come to occupy an important position in the English-speaking intellectual world. One of the most misused and misunderstood terms in recent THEORY, deconstruction is most often taken at face value and confused with an analysis in which one "takes apart" an argument. In the broadest sense, deconstruction is a radical and devastating critique of structuralist SEMIOTICS, especially of such key concepts as CENTER and STRUCTURE. The resulting body of work, which is a SEMIOTICS without STRUCTURE, is called POSTSTRUCTURALIST SEMIOTICS, or POSTSTRUCTURALISM.

Deconstruction is best understood as more of an event than a method, movement, or philosophy. A deconstruction often revolves around a renewed interest in the RHETORIC of an argument, THEORY, or REPRESENTATION. While RHETORIC has long been seen as secondary to the logic of philosophical argument, the POSTSTRUCTURALIST sees RHETORIC as giving an argument the POWER to convince. Indeed, logic and rationality may be rhetorical devices. Through a "close reading," a crucial point in a TEXT is located where its logic and RHETORIC (or *what* it says and *how* it says it) contradict one another. This point is called an *APORIA*, or "impassable path," the point beyond which the argument cannot be followed. Through such a conflict, an argument becomes sus-

pect, de-structured, or "de-centered," and loses its POWER to convince. A new argument must then be reinscribed, since there is no assertion from POST-STRUCTURALISTS that RHETORIC can be done away with altogether. The extent to which philosophy, architecture, art, and other practices are fields of discursive struggle, while posed as disinterested scholarship or reflection, is made obvious. This predicament is often the concern of "deconstructive writing," along with DIFFÉRANCE, SUPPLEMENTARITY, FREE-PLAY, and DISSEMINATION, or the conditions of SIGNIFICATION after a deconstruction.

DERRIDA'S critique of STRUCTURALISM in his famous article "Structure, Sign, and Play in the Discourse of the Human Sciences" (originally published in 1967) is an example of a POSTSTRUCTURALIST reading for a deconstructive event. Derrida sees in STRUCTURALIST THEORY that the idea of "CENTER" is actually a rhetorical device. The CENTER, he argues, while ostensibly governing a STRUCTURE, at the same time must be positioned within STRUCTURALIST THEORY as if it were "outside" of STRUCTURE and REPRESENTATION. The CENTER cannot both limit and stabilize REPRESENTATION and be a mere product of REPRESENTATION. For DERRIDA, however, this notion of CENTER is "contradictorily coherent." If the CENTER truly existed outside of REPRE-SENTATION, we would not be able to speak or write of it. The CENTER would seem to be the organizing principle of SIGNIFICATION, yet it is, for DERRIDA, also a product of SIGN usage rather than something that exists "outside" of REPRESENTATION. It becomes possible, even necessary, to think that STRUCTURE was a FICTION, that there is no CENTER, and, more devastating, that CENTER has other names in European thought: "'essence,' 'being,' 'TELOS,' 'substance,' etc." (Derrida, p. 249).

A more straightforward example can be found in DERRIDA'S essay "Plato's Pharmacy." It concerns Plato's dialogue Phaedrus, in which there is a discussion regarding the nature of speech and writing and the implications for epistemology and the search for TRUTH. In the dialogue, Socrates states that speech is preferred to writing, which is speech's opposite and SUPPLEMENT. Speech, the "living word," has a "soul," while writing is "no more than an image," like a painting. A four-termed METAPHOR is developed: remedy is to poison as dialectic (speech) is to RHETORIC (writing). Elsewhere Plato states that speech is to writing as FORM (TRUTH) is to painting (illusion/image/REPRESENTATION). The HINGE that DERRIDA finds in Phaedrus is the repeated use of METAPHOR and analogy throughout the dialogue. For DERRIDA, it is precisely here that the fabric of Plato's argument unravels. Even though the logic of the dialogue would have us believe that speech is preferable to writing, since writing distances the READER from the TRUTH, the dialogue uses METAPHOR extensively to argue the point. Since METAPHOR substitutes one thing for another, it functions just as writing (and painting) does: it distances, spaces, or displaces one thing from or for another. The use of METAPHOR to argue the primacy and immediacy of speech, then, is more than a little ironic to DERRIDA. The logic of the dialogue contradicts itself with its own use of RHETORIC, and simultaneously reveals its dependence upon RHETORIC for its POWER to convince. This dialogue is not only one example among many for DERRIDA, but it is a prominent one, since it represents and perhaps begins the whole tradition in European philosophy (and those practices based upon or derived from it, like aesthetics) of a preference for

PRESENCE and immediacy over REPRESENTATION and ABSENCE (Derrida, *Dessemination*, pp. 108–112).

Recent art theorists and critics have used POSTSTRUCTURALIST THEORY in their examinations of the history of art, most notably in critiques of expressionism and FORMALISM. DERRIDA'S mode of reading has been applied to the general DISCOURSE of aesthetic AUTONOMY by Hal Foster, Stephen Melville, and other art critics and historians. Late modernist artists, operating under the influence of the FORMALIST THEORIES of Clement Greenberg, Michael Fried, and others, were developing art to an extreme and contradictory position. Color-Field and Minimalist works effaced literary and pictorial reference while emphasizing what was argued to be the "essence" of art: the processes of the medium and the qualities of materials. At the same time, however, it was clear from their modes of presenting their works that these objects were to be understood as art, and not as a "mere" or "ARBITRARY" objects. By the mid 1960s it eventually became increasingly difficult for American artists to produce WORK that further developed this neither/nor DISCOURSE (neither reference nor mere object) without at the same time finding that they had already exceeded the limits, or parameters, of that DISCOURSE.

From a DERRIDEAN and FOUCAULDIAN perspective, the logic of the stress on the "essence" of the WORK of art is contradicted by the specific RHETORIC (use of materials) of Minimalist art. This RHETORIC includes the complete lack of pictorial reference, of decorative embellishments, and of the "hand of the artist,"—in other words, all the traditional SIGNIFIERS of "art"—in favor of an object that refers only to itself, has a "simple gestalt," favors industrial techniques, and has a simple, unified whole. Ironically, the more art objects seemed to approach their essences through the use of this RHETORIC the more object-like they became. The logic of "aesthetic AUTONOMY" seemed to conflict with the RHETORIC used to present that AUTONOMY. This conflict marks an *APORIA* or deconstructive event, a RUPTURE or EPISTEMIC BREAK, that signals a shift from one dominant *EPISTEME* to another. This new *EPISTEME* has tentatively been called "POSTMODERNISM," but the term is not adequate, since FORMALISM is not categorically equivalent to MODERNISM.

**DECONSTRUCTIONISM/DECONSTRUCTIVISM**    Used very loosely and imprecisely, Deconstructionism and Deconstructivism refer to the body of literature surrounding DECONSTRUCTION, as well as to what some scholars see as a "movement" of like-minded POSTSTRUCTURALIST scholars.

In the field of architecture and a few other design professions, Deconstructionism and Deconstructivism have been opposed to POSTMODERNISM and refer to a particular style of architectural design produced in the late 1980s and in the 1990s. Some characteristics of DECONSTRUCTION in LITERARY THEORY, understood in a figurative sense, have been combined with some stylistic features of Russian Constructivism to develop into a design style that has been labeled "Deconstructivism."

**DECOUPAGE**   (From the French *decouper*, "to cut up.")  In film studies, the breakdown of a dramatic action into its constituent shots.

**DEFAMILIARIZATION** A strategy used especially by radical modernist artists in various fields to challenge our habitual ways of seeing and understanding, allowing or forcing us to "see afresh." The key technique for artists attempting to "make it strange" or to create an "alienation effect," as defamiliarization is also called, is to "foreground" the various devices of artistic language in such a way as to bring attention to the language itself and prevent habitual ways of seeing and reading. Pioneered by the Russian Formalists of the early twentieth century, defamiliarization was meant to disturb life's habitual IDEOLOGIES. FORMALIST art criticism pushed the attention to technique to such an extent, however, that its potential relationship to political strategies was lost. More recent artistic practice has recovered the strategy of defamiliarization, also called "INTERFERENCE," but with an emphasis on the more or less semiotic processes of the production of SIGNIFICATION, rather than on "baring the devices" of artistic production.

**DEFERRAL** According to the POSTSTRUCTURALIST writings of Jacques DERRIDA, meaning, or SIGNIFICATION, never finds a firm grounding or resting place after the occurrence of a DECONSTRUCTION. One result of a DECONSTRUCTION is a distancing or spacing of SIGNIFIERS from SIGNIFIEDS and SIGNS from REFERENTS. Even though we may DESIRE that our spoken, written, or graphic REPRESENTATIONS be linked directly and firmly to their REFERENTS, such connections are never quite achieved, but are constantly deferred.

**DÉJÀ-LU** Roland BARTHES coined the phrase *déjà-lu* to assert the idea that WORKS of literature—indeed, all art—are more textual rearrangements and adaptations of SIGNS already in circulation in society than pure inventions of creative genius. This is often hinted at when readers have the feeling that they have already read some part of a TEXT. Indeed, BARTHES'S very coinage of the phrase *déjà-lu* (from the French *lire*, to read), borrowed from the common phrase *déjà-vu* (already seen), both demonstrates and explains his idea. In the visual arts this idea was taken up in discussions of the strategies of APPROPRIATION and QUOTATION.

**DELEUZE/DELEUZIAN** Having to do with the philosophy and writing of Gilles Deleuze. See BODY WITHOUT ORGANS, BWO, D&G, DESIRING MACHINES, GUATTARIAN, NOMADOLOGY, PLATEAU, RHIZOMATIC AND ARBORESCENT, RHIZOME, AND SCHIZOANALYSIS.

**DENOTATION** The literal meaning of a word, image, or SIGN, as opposed to its CONNOTATION. In practice, denotative and connotative meanings cannot be easily distinguished, especially when we are dealing with images. What passes itself off as denotative, "natural" meaning may already carry a number of implicit CONNOTATIONS; this is how IDEOLOGY works, for instance, in photographic media. It is possible that one image is both denotative and connotative.

**DERRIDA/DERRIDEAN** Having to do with the work of French philosopher Jacques Derrida, most often associated with any of the issues surrounding DECONSTRUCTION.

**DESCRIPTIVE**  A way of writing, painting, or otherwise arranging signifying material so as to create a strictly denotative and TRANSPARENT reference to a SUBJECT. See also PRESCRIPTIVE.

**DESIRE**  In LACANIAN terms, the post-SPECULAR, or post-MIRROR STAGE child experiences a desire for the feelings of unity and harmony that characterize the idealized IMAGINARY (which is formed by the child's recollection of an earlier state of total identification with the mother, and a perceived lack of bodily separation from her). The child experiences a longing for this idealized prior stage when confronted with the necessity for adaptation to those cultural demands and constraints that are a necessary part of entry to, and existence in the SYMBOLIC. The child becomes driven by desire, constantly seeking out replacements for what has been lost in separation from the mother and entrance into the SYMBOLIC realm, which is characterized by the Law of the Father. (See IMAGINARY, SYMBOLIC, MIRROR STAGE, SPECULAR.)

**DESIRING MACHINES**  See BODY WITHOUT ORGANS.

**DIACHRONIC AND SYNCHRONIC**  Ferdinand de Saussure, in his SEMIOTIC THEORY, made the distinction between diachronic and synchronic to explain the DIFFERENCE between those aspects of a language that develop over time (diachronic) and those that are in operation at a given moment (synchronic). For Saussure, the study of linguistics would never be truly scientific unless it studied languages synchronically.

**DIALECTICAL**  The term dialectical has had a number of related but different meanings over the centuries. Traditionally, it describes a procedure of reasoning or logic through debate, discussion, or continuous argument, as in the Platonic dialogues. In the Hegelian and Marxist tradition, however, this term describes the interplay of contradictory or opposed principles or forces. In such a scheme, a unification of opposites, thesis and antithesis, is possible in a higher synthesis.

**DIALOGIC/DIALOGISM**  Current critical use of the terms dialogic and dialogism derives from the writings of Russian linguist Mikhail Bakhtin. Bakhtin asserts that all language carries with it a history and that the user of language interacts with that history in a dialogue, or a dialogic exchange. According to Bakhtin, PARODY, which involves "double-voicing," is a prime example of the dialogic. Parody takes on the history of the language employed and joins in a dialogue with it.

Peter Hitchcock asserts that the multiple voicing of the dialogic "fractures the monolithic and monologic DISCOURSE of POWER (whether, for instance, through a feminist intervention against the Law of the Father, or perhaps a critique of the naming of COLONIALISM)" (Hitchcock, p. xvi). The dialogic VOICE has recently been the SUBJECT of much discussion in POSTCOLONIAL/multicultural and women's studies. Henry Louis Gates has productively applied Bakhtin's conception of the dialogic to the study of African-American literature. Gates views PARODIC double-voicing in African-American literature as offering READERS and writers a means of distancing themselves from domi-

nant cultural traditions and, at the same time, a means of incorporating and critiquing elements of each other's writing.

Dale Bauer and Susan Jaret McKinstry apply Bakhtin's dialogic to FEMINISM. They regard feminist dialogics as a method of analysis of contemporary CULTURE that both stresses the cultural agency of oppressed groups and challenges a unified position. The heterogeneity of VOICES recognized within a dialogic approach to CULTURAL STUDIES offers the possibility of many SITES of discursive resistance to hegemonic INSTITUTIONS and STRUCTURES of POWER. In particular, they see feminist dialogics as bringing masculinized public language and the private (female) VOICE together in a productive act of resistance which bridges public and private spheres, subverting the splitting that often occurs between the alienated, rational public sphere and the nurturing, but often perceived as incomplete, private sphere. Feminist dialogics views monologism (speaking with one VOICE) as deriving from a position of dominance and, contrastingly, NARRATIVE as multivocal. NARRATIVE is recognized as "inherently multivocal, as a form of cultural resistance that celebrates the dialogic voice that speaks with many tongues, which incorporates multiple voices of the cultural web" (Bauer and McKinstry, p. 4). Feminist dialogics affords realization of the productive potential of recognizing conflicting VOICES.

Diane Price Herndl argues that Bakhtin's dialogism bears important similarities to what is commonly referred to as the "feminine language" found in the writing of women. Bakhtin did not include women in his literary studies. Herndl posits that this may be because women did not fit into his THEORY; she suggests, however, that an alternative explanation may be found in the possibility that women "fit too well" (Herndl, p. 8). Bakhtin described dialogism as the speech of an OTHER in the other's language, expressing authorial intent but in a refracted manner. Herndl feels this may be exactly what the female AUTHOR is doing, because the woman writer must use speech originating in and reproducing a masculine signifying system.

A particularly good example of the use of dialogism in contemporary art is found in Mary Kelly's *Interim*. In this WORK Kelly juxtaposes the VOICES of many women through incorporation of lines of TEXT that record women's conversations regarding their daily lives and their experience of FEMINISM.

**DIEGESIS** (Greek for "recital of facts.")   The DENOTATIVE material of film NARRATIVE, including the fictional space and time dimensions implied by the NARRATIVE; the fictive space and time into which the film works to absorb the spectator; the self-contained fictional world of the film.

**DIFFÉRANCE**   Neither a word nor a concept, *différance* is a sort of ever expanding pun. *Différance* was coined by Jacques DERRIDA to demonstrate the limits of logocentric understandings of linguistic (spoken) SIGNS, while introducing his idea of GRAMMATOLOGY. *Différance*, spelled with a lower case "a," is not the correct French spelling of *différence*. However, *différance* and *différence* are pronounced the same. In spoken form the difference remains unnoticed until it is put into written form, when the difference between the two is recognizable. Therefore, DERRIDA'S "term" combines the two senses of the French verb *différer* (to defer, and to differ). On the one hand, it demonstrates Saussure's remarks on the differential nature of SIGNS, since the "term" has no meaning outside of a

set of constant differentiations from other SIGNS and DEFERRALS outward to other discourses ongoing in CULTURE. On the other hand, différance demonstrates DERRIDA'S ideas of DEFERRAL by spacing itself away from other SIGNS and from a firm grounding, thus producing an unstable term.

**DIFFERENCE** In addition to the principle of BINARY DIFFERENCE used in SEMIOTICS, this term has developed a particular set of connotations in THEORIES of GENDER and ETHNICITY. The definition of DIFFERENCE has been a major preoccupation of second-generation FEMINIST theorists. Early feminist writers and first-generation feminist artists made SEXUAL differences a major preoccupation. They were interested in locating and venerating biologically based sources of differences of women from men and, at the same time, asserting the universality of an essential female nature. More recent feminist theorists have recognized the EUROCENTRIC and RACIAL bias of such assumptions and argue for the recognition of differences, rather than universal similarities, among women. Although THEORIES of difference owe something to SEMIOTICS and POSTSTRUCTURALIST thought, difference should not be confused with DIFFÉRANCE.

**DIRECT CINEMA** See CINEMA VÉRITÉ.

**DISCIPLINE** According to Michel FOUCAULT, discipline is an effect of POWER resulting from various DISCURSIVE PRACTICES of INSTITUTIONS. One straightforward result is the creation of "disciplines," in the sense of academic fields. Architectural structures can be used by INSTITUTIONS of POWER to produce discipline in the usual sense. Individual IDENTITY or SUBJECTIVITY can be formed through DISCOURSE. FOUCAULT'S most famous example of the disciplinary effect of material DISCOURSE on the individual is his discussion of Jeremy Bentham's 1791 design for a "Panopticon Prison." In *Discipline and Punish,* FOUCAULT tells us that the Panopticon was designed to be a multistoried, ring-like building with a tower erected in the CENTER (pp. 200–228). From the tower watchmen could observe the cells, which were located in the periphery of the circular STRUCTURE, without being seen themselves. Everything in each cell was open to clear and constant SURVEILLANCE, which, for FOUCAULT, assured an automatic functioning of POWER, even if the PRESENCE of a watchman was unknown. The Panopticon exercised POWER over bodies through an efficient organization of space. Eventually, the effect of this prison design was to relocate the constraining force of POWER from the watchtower to the prisoner himself. The prisoner was to become his own best keeper, keeping himself under SURVEILLANCE and disciplining himself at all times.

FOUCAULT used this prison design as a model for and example of the epistemological relations between the logic of SURVEILLANCE and MODERNIST disciplinary knowledge. For him, the Panopticon can be understood as a general model, defining POWER relations in everyday life. Here, POWER must be understood as both repressive and productive. The ultimate effect of power relations is to regulate the behavior of individuals through DISCOURSES that produce two types of "docile bodies." The INTELLIGIBLE BODY and the USEFUL BODY (also known as the practical BODY) are produced by the same discourses, and they are mutually supportive. The INTELLIGIBLE BODY produces meaning through sym-

bolic function. Its REPRESENTATIONS are based on normative concepts of the BODY found in discourses of wide cultural currency, such as medical and scientific discourses. The USEFUL BODY produces meaning and regulates behavior in a different way. It operates through *practical* use and function. The USEFUL BODY is one capable of performing certain functions deemed socially useful. FOUCAULT calls technologies of discipline and domination that operate upon the BODY "BIO-POWER." BIO-POWER centers on the BODY as an object to be manipulated.

**DISCOURSE**  Any social relation involving language or other SIGN systems as a form of exchange between real or IMAGINARY participants. Discourse can take any form, be it spoken or written words, architecture, medical practice, visual art, or law, to name a few of FOUCAULT'S favorite topics. (See DISCOURSE ANALYSIS.)

**DISCOURSE ANALYSIS**  The historian-philosopher Michel FOUCAULT, as part of his general interest in DISCOURSE, developed a method of analyzing DISCOURSE so as to reveal its relationship with POWER. Discursive exchange includes the conditions of expression, a source of articulation, as well as an addressee. These "positions" are not necessarily explicit, but are always implied by the DISCOURSE. FOUCAULT, through what he called "discourse analysis," attempted to account for the ways in which discourses are produced, regulated, and limited by its participants. At the same time, FOUCAULT was interested in how discourses produce, regulate, and limit their participants.

To FOUCAULT, ideas are extremely powerful things, but need some sort of *dispositif* or APPARATUS to have results. More often than not, this APPARATUS is an INSTITUTION of some sort. An INSTITUTION is not limited to a building and a number of people who work in it, but also includes a number of rules and conditions for the production of DISCOURSE. A university is an example of an INSTITUTION. Universities are made up of a number of people producing discourses on many topics in many DISCIPLINES, such as art history. Art history as we usually think of it is characterized both by the topics it attends to and the methods used to study those topics. The DISCOURSE of art history includes statements made by professionals and students in the field. Statements in the field of art history are regulated or "DISCIPLINED" by (usually) unspoken rules and regulations, or methods. One of the results is a particular DISCURSIVE REGIME, that is, a number of statements generally agreed upon as legitimate that deal with legitimate topics by legitimate professionals. In FOUCAULDIAN terms, the DISCURSIVE FORMATION of art history is disciplined by the DISCURSIVE PRACTICES commonly accepted by that profession. In the field of art history, one result has been the creation of a CANON, an unofficial but generally agreed upon set of works of art discussed in art history courses. Recent "REVISIONIST ART HISTORY" has challenged both the SUBJECTS and the methods of art historical practice.

**DISCURSIVE FORMATION**  See DISCOURSE ANALYSIS.

**DISCURSIVE PRACTICES**  See DISCOURSE ANALYSIS.

**DISCURSIVE REGIME** See DISCOURSE ANALYSIS.

**DISPOSITIF** See DISCOURSE ANALYSIS.

**DISSEMINATION** A term that describes the condition of SIGNIFICATION after a DECONSTRUCTION has occurred. SIGNS, no longer limited by processes at the structural level as described by STRUCTURALIST SEMIOTICS, have a potentially limitless growth of new meanings.

**DIVERSITY** A term—often used as roughly equivalent to PLURALISM in some CONTEXTS—that is part of the ongoing debate over multiculturalism. Diversity as a positive social value has been the SUBJECT of much recent discussion. Achievement of heterogeneity, rather than homogeneity, in INSTITUTIONS of POWER, in professions, in educational DISCOURSE, and in REPRESENTATIONAL practices has been the goal of those who favor diversity. Cultural diversity is one of the major goals of those who work to foster MULTICULTURALISM. (See COLONIALISM and POSTCOLONIAL DISCOURSE.)

**DOCILE BODY** See DISCIPLINE and BODY.

**DOMINANT CULTURE** A dominant culture is one that holds greatest POWER in a given social CONTEXT. Cultural INSTITUTIONS that are invested with greatest POWER, as well as behavior and practices deemed socially "correct" further the maintenance of the dominant culture. As Stuart Hall explains, "Any society/culture tends, with varying degrees of closure, to impose its classifications of the social and cultural and political world. These constitute a dominant cultural order, though it is neither univocal nor uncontested" ("Encoding, Decoding," p. 98). (See COLONIALISM and POSTCOLONIAL DISCOURSE.)

**DOXA** A term used by Roland BARTHES to refer to the rule of certain ideas at the expense of OTHER. Often posed as "TRUTH," doxa allows no terms that are significantly different from the sanctioned ones to enter intellectual debate. The concern with doxa in POSTSTRUCTURALIST THEORY has been to show how it is vulnerable to critique.

**DRAG PERFORMANCE** In drag, or cross-dressing, an individual dresses in the clothing considered appropriate to the opposite SEX. Such a "denaturalizing" of GENDER, unlinking PERFORMANCE of GENDER from sex-based gendered IDENTITY, may be seen as a TRANSGRESSIVE, and potentially subversive, PERFORMATIVE act (see PERFORMANCE/ PERFORMATIVE/ PERFORMATIVITY/ PERFORMATIVITY OF GENDER). A number of contemporary artists, including American photographer Cindy Sherman and Japanese photographer Yasunari Morimura, have engaged in selfportraiture which includes drag.

**DUALISTIC** In the European philosophical and scientific tradition, arguments and THEORIES are characteristically organized on a distinction between two opposing terms. As a consequence, some of the most influential ideas in the European tradition are centered around such oppositions as male and female, high and low, and good and evil. In the visual arts, a few of the more common du-

alisms have been FORM and CONTENT, inside and outside, and linear and painterly. It has been the explicit goal of many critics and theorists influenced by POSTSTRUCTURALIST thinking to expose the use of dualisms as a RHETORICAL device that unnecessarily limits the terms of debate in such a way as to allow for one of the terms to be in a more powerful position than the OTHER, thus predetermining the outcome of debate.

# E

**ECHOLALIA** A term used by many writers of LITERARY THEORY to indicate the echoing back and forth of possible SIGNIFICATIONS between different SIGNS. See also DIFFÉRANCE and SEMIOTICS.

**ÉCRITURE** The French word for writing, this term has also gathered a number of other CONNOTATIONS, including printed words, handwriting, the appearance of letters on surfaces, and graphic imagery or pictures. The term has more generally and more vaguely been used to refer to the material aspects of SIGNS—whether handwriting or paint or architectural materials—and their usage in combination.

**ÉCRITURE FÉMININE** *Écriture féminine* refers to women's writing as formulated by French feminist theorists. Those employing this formulation regard women's writing as reflecting a greater emphasis on certain aspects of experience than writing by men. These aspects include bodily experience, the emotions, and other forms of experience that are difficult to capture in words. The best-known proponents of this view include Hélène Cixous, Monique Wittig, and Luce Irigaray. In "Reinstating Corporeality: Feminism and Body Politics" Janet Wolff discusses how feminist strategies of resistance based on Irigaray and Cixous's premise that "writing from the BODY" can offer an appropriate expression of female experience are presumed viable because they exist outside of a male-defined signifying economy.

Jeanie Forte posits that a form of PERFORMANCE ART that utilizes the female BODY as its instrument can function similarly to *écriture féminine*. Noting that Cixous has recommended to feminists that "anything having to do with the body should be explored," Forte says that "Cixous's mandate for women is therefore to terrorize patriarchal DISCOURSE by writing from the locus of the inscription of difference, i.e., female sexuality" ("Women's Performance Art," p. 218). See also PEINTURE FÉMININE.

**EFFET DU RÉEL** French for "REALITY EFFECT."

**ELITE**  A term referring to a social distinction or ranking, elite has a number of negative CONNOTATIONS, most usually indicating an arrogant and self-serving CLASS. Once referring primarily to economic CLASS, the term now includes the sense that some groups are in possession of specialized and/or secret knowledge or information.

**ENCODE**  To make something into a CODE. See CODIFICATION.

**ENIGMA**  Greek for "riddle" or "mystery," the term is used in film studies to designate an element in the process by which classical NARRATIVES ensure the spectator/reader's absorption. The enigma is crucial information that is withheld early on in the NARRATIVE, thus creating suspense and AMBIGUITY, but will eventually be supplied, after a series of delays, so as to effect CLOSURE.

**EPISTEME**  Michel FOUCAULT uses the term *episteme* to indicate the total set of relations that unite a given period. These can be DISCURSIVE PRACTICES that result in sciences and other formalized systems of DISCOURSE, like philosophy. An episteme is not a form of knowledge, but is the totality of relations between the sciences or between other discourses. In an essay on Velázquez's *Las Meninas*, FOUCAULT adapts the idea of the *episteme* into an investigation of coexisting and interrelated discourses on techniques of painting, scientific CONVENTIONS, and aristocratic HIERARCHIES. His analysis of the painting concerns the problem of what can or cannot be put into a picture when an artist tries to paint within a particular *episteme*. FOUCAULT'S essay revolves around REPRESENTATION and the rise of what he calls the "Classical *Episteme*." To FOUCAULT, Velázquez depicts in classical taxonomic fashion three different categories of REPRESENTATION: the artist representing, the objects represented, and the spectator who views the REPRESENTATION. In short, Velázquez is highly successful in producing a REPRESENTATION of the episteme that existed in what FOUCAULT calls the "Classical Age."

**EPISTEMIC BREAK**  As an extention of his interest in *EPISTEME*, Michel FOUCAULT was fascinated by those accidents, unexpected reversals, entangled events, and "RUPTURES" in DISCOURSES that are the result of long-term practices in a field. These breaks occur in spite of the plans and desires of the people producing those discourses. In many ways this is roughly similar to Jacques DERRIDA'S description of deconstructions. The significance to FOUCAULT is that the RUPTURES or breaks in discursive structures make more readily apparent that things like social organizations, history, or the conception of the human being are artificial, have a history, and can be sustained only through great effort. Therefore, critical histories of such discursive organizations can be written, and they can be undone.

**ERASURE**  Jacques DERRIDA designates certain words he uses in his writings as being "under erasure." This means that while he is using a term he sees it as being PROBLEMATIC but indispensable. He indicates this by leaving the word in the TEXT, but imposing a large X over the term. The crossing out of the term

works like scare quotes, indicating the insufficiency or PROBLEMATIC nature of a term while using the term at the same time.

**ESSENTIALISM** See CULTURAL FEMINISM.

**ETHNICITY** A term used to describe a cultural or social continuum. Ethnicity is distinguished from RACE by a concentration upon the cultural consistencies between members of a group, rather than an explanation of such consistencies based upon biological or physiological terms. (See OTHER, POSTCOLONIAL, COLONIALISM/ COLONIALIZED, HYBRIDIZATION, DIVERSITY, RACE/RACISM.)

**EUROCENTRIC** The term eurocentric describes a preference for all cultural, scientific, religious, and philosophical WORKS in the European tradition. This preference is based on a presumption of the superiority of peoples of European descent.

**EXEGESIS** An explanation or interpretation of a TEXT or WORK of art.

**EXHIBITIONISM** A PSYCHOANALYTIC term referring to the gratification derived from showing one's BODY—or part of it—to another person, a gratification of erotic origin. It also refers to the PLEASURE of being seen or seeing oneself on SCREEN, which is related to narcissism. As a clinical perversion, exhibitionism is the passive counterpart of VOYEURISM.

**EXPRESSION** The notion, popular in MODERNISM, that one can somehow convey an idea or emotion through a medium such as an art object is the basis of expression. The very possibility of expressing emotions has in recent years come under criticism by a number of critics, such as Hal Foster, working from a roughly POSTSTRUCTURALIST position. See also DECONSTRUCTION and EXPRESSIONIST FALLACY.

**EXPRESSIONIST** One who is a practitioner of the idea of EXPRESSION, or, used as an adjective, something that expresses.

**EXPRESSIONIST FALLACY** The art critic and historian Hal Foster, in his article "The Expressive Fallacy" (pp. 59–77), criticizes Neo-Expressionist painters active at the time through the application of POSTSTRUCTURALIST THEORY, most notably DECONSTRUCTION. Foster discusses expressionism in general as a specific language, but a language that is so "obvious" that its conventionality is forgotten. Expressionist art asserts the PRESENCE of the artist. But this is a paradox for Foster, since in the assertion of the artist's PRESENCE through the mark or the gesture, the PRESENCE of the artist is displaced in favor of the SIGN. In other words, since the mark is a REPRESENTATION of the artist, it is also a SIGN of the ABSENCE of the artist, for if the artist were truly present "in" the WORK there would be no need to signify that PRESENCE. Ostensibly, a type of transparency is operative in EXPRESSION, that is, material elements are secondary to and revelatory of what the painting expresses, that is, "subjective reality." But to Foster, EXPRESSIONIST painting makes use of CODES that are

based upon a substitution of paint for feeling. Foster's point in criticizing expressionism is to show how it is constructed rhetorically, that is, through ARBITRARY and culturally based SIGNIFYING systems. For him, the EXPRESSIONIST self and SIGN both belong to a preexistent image repertoire. Jasper Johns, Roy Lichtenstein, and Gerhard Richter create works that demonstrate this paradox. For Foster, expressionism is more than just a style or technique. It is an example of a specific language, that which makes painting an "ideological SITE," where the social DISCOURSE on the "authentic" human being is to be found, a SITE he found especially important in the NEO-CONSERVATIVE 1980s.

# F

**FANTASMATIC** In *The Language of Psycho-analysis*, Jean Laplanche and Jean-Bertrand Pontalis define the fantasmatic as a cluster of UNCONSCIOUS fantasies that produces an individual's general psychic life, including dreams, and structures the formation of individual IDENTITY and the character and quality of one's life as a whole (p. 317). The fantasmatic produces the individual's inner FANTASY life, in which he or she plays the lead role. In Kaja Silverman's words, it provides the individual's "scenario for passion, or, to be more precise, the 'scene' of authorial desire" (Silverman, *The Acoustic Mirror*, p. 216). For Freud the most common FANTASY scenarios, which involve the primal scene, seduction, and castration, derive from the Oedipus complex (See Freud, *The Standard Edition*, vol. 14, p. 269).

**FANTASY** Discussions of fantasy have played a major role in recent FILM THEORY, in which fantasy theory has been explored as offering the potential for development of modes of spectatorship that do not participate in a BINARY STRUCTURE aligning the male viewer with the active and dominating role and the female viewer with the passive and objectified position. The goal of such exploration is to locate and articulate alternate positions for the male and female viewers that do not rely upon fixed, SEX-based GENDER positions.

Such THEORY finds its basis in Freud's outline of three primal fantasies, each of which plays a vital role in the formation of the individual SUBJECT. The first of such fantasies is that of the primal scene, which deals with the child's physical conception; the second is that of seduction, which plays a role in the origin of DESIRE in the child; and the third is the castration fantasy, which plays a part in the recognition of SEXUAL DIFFERENCE and thus acts as a constitutive force in the development of GENDERED IDENTITY.

In "Fantasia," an influential essay on fantasy published in the British feminist journal *m/f* in 1984, Elizabeth Cowie explains how fantasy functions as a structuring force. She asserts that it operates "as the mise-en-scène of DESIRE, the putting into a scene, a staging, of DESIRE" (p. 149). Cowie summarizes how the discussion of fantasy has developed as a feminist issue over the last decades.

First appearing as an issue in early FEMINISM, which was driven by the asser-
tion that "the personal is political," it was discussed not only in terms of male
SEXUAL fantasy and how it functions to objectify women, but also in terms of
how women's greater awareness of their own SEXUAL fantasies could facilitate
consciousness-raising and thus play a role in resistance to domination. Early
feminist debate, Cowie tells us, tended to polarize on the issue of fantasy. Some
viewed SEXUAL fantasy as inherently dehumanizing, as unavoidably involving
the treatment of another human being as an object, while others saw fantasy as
an incontrovertible fact of human existence, the exploration of which might
prove valuable in an understanding of its function in the exercise of SEXUALITY
and in the formation of GENDERED IDENTITY.

More recently, feminist theorists such as Judith Butler have explored ways in
which fantasy can function as a means of escape from, and resistance to, SEX-
based GENDER constraints. Viewing GENDER as PERFORMATIVE, Butler posits
that the fantasy realm can act as the rehearsal space for the PERFORMANCE of
SUBJECT positions that free one from enactment of GENDER roles deemed the
normal and proper expressions of one's SEXUAL INDENTITY. Fantasy can, in this
view, play a productive role in the unfixing of GENDER from SEX. In an inter-
view published in *Artforum* in 1992, Butler asserts that, though fantasy is not
free of social relations of POWER, it can "in its various rehearsals of the scene of
social power, . . . expose the tenuousness, moments of inversion, and the emo-
tional valence—anxiety, fear, desire—that get occluded in the description of
'structures'." Butler feels it is important to explore the process whereby fantasy
"orchestrates and shatters relations of power" (Butler, "The Body You Want," p.
87). She disagrees with those, such as Andrea Dworkin, who believe that visual
representations dictate DESIRE and produce a determined response. Butler sees
this as reductive and evidence of a behaviorist view. When such views are ap-
plied to the debate on PORNOGRAPHY, the danger exists that they will be enlisted
to support regulation of people's desires and fantasies and may "obliterate the
ethical distinctions between fantasy, representation, and action" (p. 87). Butler
goes on to discuss PORNOGRAPHY as offering resistance because it "*replays*
relations of power" in a PHANTASMATIC rather than a mimetic way. She discusses
the limits of FEMINIST FILM THEORY, which has failed to take into account cross
GENDER identifications. She feels that visual forms of REPRESENTATION (visual
art, film, and so on) can destabilize normative modes of identification and thus
offer a challenge to, and a reconfiguration of, the existent limited range of
SUBJECT positions that our CULTURE offers.

Images and ideas—or fantasies—of the artist's own invention have always
been the constitutive elements of visual art. Recent artists have used this tradi-
tional function in a more SELF-REFLEXIVE way than earlier artists. Exploration
of how fantasy functions in the formation and maintenance of GENDERED
IDENTITY has been a major concern of many such artists who deal with SEX and
GENDER issues, including Silvia Kolbowski, Cindy Sherman, and Victor Bur-
gin.

**FEMALE GAZE**   Since the publication of Laura Mulvey's essay "Visual
Pleasure and Narrative Cinema" in the British film journal *Screen* in 1975, the
idea of a MALE GAZE, constructed through the filmic practices of mainstream
NARRATIVE cinema, has been the SUBJECT of much speculation by feminist

cultural theorists. Mulvey theorizes that Hollywood conventions of cinematic practice construct the GAZE as male. Speculation on the possibility of a female gaze, of a female SUBJECT position that is not passive but is active and actively desiring, has played a significant role in feminist discourse subsequent to Mulvey's article. (See ACTIVE DESIRE, MALE GAZE, and FEMINIST FILM THEORY.)

**FEMININE DESIRE** FEMINIST FILM THEORY has exerted a profound influence on recent art criticism and practice (see FEMINIST FILM THEORY). Laura Mulvey's writings spawned much debate among feminist theorists, visual artists, and art writers regarding whether it was possible to produce representations of the female BODY that could embody and convey women's DESIRE. Other theorists who have written much on this topic include Victor Brugin, Mary Ann Doane, Kaja Silverman, Teresa de Lauretis, and Annette Kuhn.

**FEMININE MASQUERADE**    Much has been written recently about "femininity" as masquerade. This concept has taken a prominent role in the development of FEMINIST FILM THEORY, and has been seen as a significant feature of the WORK of a number of contemporary artists, including Cindy Sherman.

Recent discussions of femininity as masquerade—such as those of Mary Ann Doane in "Film and Masquerade: Theorizing the Female Spectator," Judith Butler in *Gender Trouble*, and Steven Heath in "Joan Riviere and the Masquerade"—find their source in the classic TEXT on this SUBJECT, Joan Riviere's "Womanliness as a Masquerade," originally published in 1929. In Riviere's Freudian explanation of masquerade, woman assumes a feminine masquerade (taking on exaggerated feminine qualities) as an attempt to mask her wish to have the PHALLUS. She does so to avoid the wrath of those from whom the PHALLUS has been acquired through (SYMBOLIC) castration. Riviere says the fear of retribution comes from the woman's wish to take the place of the father. The woman's rivalry with the father is not over the mother, but over the father's position as active participant in public DISCOURSE and in SIGNIFYING PRACTICES such as writing, speaking, and visual REPRESENTATION. According to this view, the masquerade that women assume and that we see in the WORK of such artists as Cindy Sherman, conceals the woman's DESIRE to occupy a SUBJECT rather than an object position. As Judith Butler explains,

the rivalry with the father is not over the desire of the mother, as one might expect, but over the place of the father in public discourse as speaker, lecturer, writer—that is, as a user of signs rather than a sign-object, an item of exchange. This castrating desire might be understood as the desire to relinquish the status of woman-as-sign in order to appear as a subject within language. (*Gender Trouble*, p. 51)

Riviere goes on in her essay to assert that masquerade is central to being a woman:

The reader may now ask how I define womanliness or where I draw the line between genuine womanliness and the "masquerade." My suggestion is not, however, that there is any such difference; whether radical or superficial, they are the same thing. (Riviere, p. 38)

In this view, womanliness *is* masquerade. That is, no essential femininity exists. Rather, female-ness is produced through PERFORMANCE of femininity, through taking on those qualities and actions deemed feminine.

Cindy Sherman's project has been to work within the DISCURSIVE PRACTICES of REPRESENTATION that serve to produce and reproduce "the feminine" in our CULTURE. Sherman's APPROPRIATION of works by male artists and her APPROPRIATION of the role of male artist may be seen, according to Laura Mulvey, as evidence of her wish, at one and the same time, to be the PHALLUS (to be the female OBJECT OF DESIRE, the artist's model) and to have the PHALLUS (to be the maker of SIGNS, the male artist).

As Judith Butler explains in *Gender Trouble*, according to LACAN, woman appears to be the PHALLUS through masquerade (Butler, p. 46). LACAN writes:

Let us say that these relations will revolve around a being and a having which, because they refer to a signifier, the phallus, have the contradictory effect of on the one hand lending reality to the subject in that signifier, and on the other making unreal the relations to be signified (Lacan, "The Meaning of the Phallus," pp. 83–85)

Because woman does not possess a penis, it is necessary to mask her lack, so as to avoid evoking a fear of castration. (See PHALLUS, and FEMINIST FILM THEORY.)

**FEMININITY AS MASQUERADE**   See FEMININE MASQUERADE.

**FEMINISM**   In the most general sense, feminism consists of an acknowledgment of a historical devaluation of women—indeed the whole category of the feminine—and a corresponding demand for equal rights and status for women. Early in the twentieth century the feminist struggle focused on women's voting and reproductive rights. In the resurgence of feminism experienced in Europe and the United States in the 1960s and 1970s, reproductive rights were again at issue, as were new concerns and demands involving equal access to education, employment, and other opportunities that were often denied women on the basis of their SEX.

The expression of feminist demands for change can be broken down into four positions, each of which is informed by a different theoretical framework. These four positions, as outlined by cultural theorist H. Leslie Steeves, are RADICAL, LIBERAL, MARXIST/SOCIALIST, and PSYCHOANALYTIC- and CRITICAL-THEORY-influenced feminism. RADICAL FEMINISM is based on the assumption that men and women possess innately different natures. Radical feminists see male control over women's reproductive processes as the major means by which PATRIARCHY is maintained, and some believe that a total separation of the sexes is necessary for change. Many, such as Mary Daly, also feel that it is necessary for women to develop a language separate from that of the PATRIARCHY. In the realm of art practice, those adhering to this separatist viewpoint have worked to develop forms of visual expression, such as *PEINTURE FÉMININE*, that are uniquely expressive of women's essential nature.

The second position, LIBERAL FEMINISM, finds its basis in the tenets of liberal political philosophy and holds that the best means to alleviate the oppres-

sion of women is to ensure women equal opportunity. Such equal opportunity is to be ensured by laws that find their basis in rational argument. Liberal feminists are sometimes referred to as equity feminists, since their basic belief is that women's oppression can be eliminated through the equal treatment of all individuals, regardless of their SEX. They do not hold that existent INSTITUTIONS or social structures need to be changed. Rather, they feel that the freedom and opportunities those INSTITUTIONS and structures provide must be offered to all. In the field of art, liberal or equity feminism finds expression in attempts to assure equal REPRESENTATION of women artists in museums, galleries, universities, and so on, and in the demand that the art historical CANON be augmented so that women artists are equally represented.

The third type includes both MARXIST and SOCIALIST FEMINISM. Both Marxist and socialist feminists regard CLASS oppression under capitalism as the primary problem. Socialist feminists find PATRIARCHY an equally oppressive force. Both differ from radical feminists in that they reject the idea of an innate or essential femininity. They also disagree with liberal feminists, in that they believe that the social structures of a capitalist society prevent AUTONOMY of action; this view of capitalism causes them to believe in the necessity of revolutionary social change. One of the social structures that both Marxist and socialist feminists find most oppressive to women is the family. They feel that, if women are ever to achieve equal status with men, the family STRUCTURE must undergo radical change. But, when it comes to GENDER, Marxist and socialist feminists differ significantly. Socialist feminists see Marxists as GENDER-blind. They feel that, in their concern with oppression due to CLASS, Marxists overlook oppression due to GENDER. Notable Marxist art historians include Griselda Pollock, T. J. Clark, and John Berger.

The fourth type of feminism, which is influenced by PSYCHOANALYTIC and CRITICAL THEORY, has had perhaps the greatest influence on contemporary art THEORY and practice. Feminists holding this view believe that changes necessary to eliminate the oppression of women must be achieved through changes in behavior that will significantly alter existent social and psychological structures which have worked to produce existent beliefs and patterns of behavior. Study of the social processes that work to produce individual beliefs is the necessary first step toward an understanding of necessary changes. FEMINIST FILM THEORY, which has had a profound effect on contemporary art THEORY and practice, finds its basis in this position. (See FEMINIST FILM THEORY.)

In the fields of contemporary art THEORY and practice, one can see the development of these four basic types of feminism. The tenets of RADICAL FEMINISM can be seen most clearly in the earliest of such WORK. Much feminist art of the 1960s and 1970s took as its goal expression of an innate and incontrovertible femininity with which women were presumed uniquely endowed. During this period, feminists and feminist artists granted privileged status to those things they perceived as common to all women. Common SUBJECTS were female (hetero)SEXUALITY, childbirth, and motherhood. Women's common experience was seen as the source of a unifying strength that was believed necessary to fight PATRIARCHAL oppression. The work of Judy Chicago illustrates best  the typical concerns of feminist artists of this period. Like a number of other women artists of the 1970s, Chicago was concerned with exploring the possible existence of a uniquely feminine aesthetic and a uniquely feminine way

of working. Finding a VOICE for their concerns in art critic Lucy Lippard, Chicago and a number of other feminist artists of the 1970s posited that women's art was characterized by certain physical properties, including a central void (what later became known as "VAGINAL ICONOGRAPHY"), a preference for soft veils of color, and tactility. Such qualities were believed to be expressive of the bodily experience of women. They also felt that women could employ to best advantage their presumed natural predilection for cooperative effort through collaborative projects. Throughout her critical practice, Lippard has maintained the position that, if feminist art and art criticism is to succeed, its practitioners must not be content merely with incorporation of their WORK into those INSTITUTIONS and systems of reward that culturally validate art and artists. It must be a separatist practice. Most important, the goal of feminist artists and critics must be to change art.

A large installation piece of 1974–79, *The Dinner Party*, produced through the collaboration of Chicago and scores of other women whom she supervised, serves as a particularly good example of feminist art of this period. Chicago's installation consists of a triangular table bearing thirty-nine different place settings. Each setting is dedicated to a woman from history and includes a round ceramic plate bearing a REPRESENTATION of female genitalia sculpted in high relief, which sits on a fabric runner embroidered with the woman's name and with SYMBOLS associated with her and/or her historical period. Intended as a feminist variation of Leonard da Vinci's *The Last Supper*, Chicago's WORK drew much critical attention to the concerns of what has become known as "first-generation" feminist art.

The division of feminist art and artists into first and second generations was first made by art historians Thalia Gouma-Peterson and Patricia Matthews in "The Feminist Critique of Art History," an article published in *Art Bulletin* in 1987. In this influential article, the authors provide a summary and analysis of writings that are the product of feminist art history and criticism. They begin with the 1970s, when the first writings resulting from this new area of scholarly inquiry were produced, and proceed to shortly before the date of their study's publication. The authors' division of those works into first and second generations does not simply serve to locate artists, writers, and their ideas chronologically; more significantly, it designates two dominant bodies of THEORY that bear significant conceptual differences. In their comprehensive study, Gouma-Peterson and Matthews analyze the nature and implications of these differences and offer speculations on the practical effects of art historical and critical practices that find their basis in the assumptions of each.

As Gouma-Peterson and Matthews explain, documentation of women artists previously ignored and neglected was the major accomplishment of first-generation feminist art historians. Such writers' attempts to position their SUBJECTS as qualitative equals of their male contemporaries, however, did little to analyze and critique those INSTITUTIONS and configurations of POWER that have worked to exclude women. This position does not question these very conception of "genius," which finds its basis in a necessarily masculine model and thus function to exclude women from art practice. Further, it propagates the view that there actually were many women of high artistic accomplishment in the past, and that the art historian's task is simply to uncover and document their PRESENCE, thus rescuing female artists from obscurity so that their "genius"

may shine forth unobstructed. Far from illuminating those structures of POWER that have worked to marginalize women artists, such an approach in fact seems to generate the view that such exclusionary constructions were not of major import, since there were presumably many women artists who developed and flourished despite the limitations they imposed. Gouma-Peterson and Matthews explain that such an approach, which fails to realize the practical effects and implications of its methodology, may lead to a simple duplication of the exclusionary practices of traditional art history. That is, it may simply produce another CANON, one of "white female artists (primarily painters), a CANON that is almost as restrictive and exclusionary as its male counterpart" (p. 327). Authors who engaged in this scholarship include Germaine Greer, Eleanor Tufts, Hugo Munsterberg, Karen Peterson and J. J. Wilson, Elsa Honig Fine, Josephine Withers, and Wendy Slatkin.

As an alternative to such approaches, Gouma-Peterson and Matthews offer Rozsika Parker and Griselda Pollock's *Old Mistresses: Women, Art and Ideology*, published in 1981. This WORK is not a compendium of women artists, nor is it an attempt to rescue women artists of previously unrecognized high quality from obscurity; instead, as its authors state, it is "an analysis of the relations between women, art and ideology" (pp. 132–133). Such an approach, which employs strategies of DECONSTRUCTION, has provided a model for a politically feminist art historical practice that aims to bring change through analysis of those culturally dominant practices and forms of REPRESENTATION that serve to marginalize and oppress women. U. S. publications that were central to the dissemination of the ideas informing first-generation art practice and criticism include *Womanspace Journal, Feminist Art Journal, Women and Art, Women Artists Newsletter, Chrysalis: A Magazine of Women's Culture, Heresies*, and *Women's Art Journal*. British periodicals such as *Spare Rib, Block*, and *Art History* were also significant to the development of such DISCOURSE.

More recently, feminist art practice and THEORY has explored how images of women work to subjugate them. This includes iconographic analysis that seeks to reveal how images of women in Western CULTURE commonly function to position them as the passive objects of an active MALE GAZE. Carol Duncan and Griselda Pollock offer methodological models for this form of visual analysis. Another mode of inquiry that Gouma-Peterson and Matthews regard as offering great potential for feminist historians employs historical images of women as sources for the study of women's history. Margaret Miles is an art historian who has productively employed such an approach.

Instead of concentrating on discrimination in the art world and advocating greater inclusion of women into the CANON, second-generation feminists have adopted a different strategy, one that is informed by literary POSTSTRUC-TURALISM, SEMIOTICS, PSYCHOANALYTIC THEORY, and MARXIST THEORY. Gouma-Peterson and Matthews divide second-generation art criticism and methodology into two dominant strands, noting that Lippard uses "CULTURAL FEMINISM" as a label for the first group, and "SOCIALIST FEMINISM" as a name for the second. Those in the first group, which has existed since the beginning of feminism, are concerned with what it is to be female and tend to diminish DIFFERENCE from men, because DIFFERENCE is equated with inequality and thus, they believe, with oppression. Their primary strategy lies in documentation of women's experiences. Often labeled as "ESSENTIALIST," those in the first

group regard the category of woman as fixed, as determined by social and cultural forces, and, according to some, as characterized by an inherent female nature. They take a separatist position, celebrate what is uniquely female, and attempt to uncover and document the oppression of women.

Second-generation feminists, on the other hand, view the category of woman as unfixed, always in process, and most properly investigated through her ideological construction and REPRESENTATION within a male-dominated system. Rather than defining GENDER itself, they are interested in CULTURE as the field that produces definitions of femininity and within which such definitions are contested. They are concerned with, "an interrogation of an unfixed femininity produced in specific systems of signification" (Tickner, "Sexuality and/in Representation," p. 28). In short, first-generation feminists attempt to investigate those varied historical REPRESENTATIONS of women that find their basis in the fixed category of "woman" and are expressed through the fixed SIGNS of femininity. They discern and celebrate CONTINUITY. In contrast, second-generation feminists explore those signifying systems that construct the feminine in order to discern strategies for unfixing the feminine, thus undermining patriarchal constructions of dominance. They seek to expose discontinuity and disjunction.

Gouma-Peterson and Matthews contend that art historical methodologies have shown equally dramatic differences from first-generation to second-generation practice. Whereas first-generation art historians were engaged in a project of recovery and attempts to integrate women into the CANON, second-generation writers have been interested in deconstructing and critiquing the DISCIPLINE. Noting a marked contrast between British and American feminist art historical methodologies, Gouma-Peterson and Matthews cite Elaine Showalter's description of dominant British contributions to feminism: "an analysis of the connection between gender and class, an emphasis on popular culture, and a feminist critique of Marxist literary theory" (Showalter, p. 8). Gouma-Peterson and Matthews also quote Lisa Tickner's explanation of the major difference between American and European feminism: "The crucial European component in the debate has been the theorization of the gendered subject in ideology [based on Althusser and Lacan in particular]" (Lisa Tickner, "Sexuality and/in Representation," p. 19). While European CRITICAL THEORY has had a profound impact on the field of art criticism in America, it has had decidedly less influence on the field of art history in the United States. Reasons given for this DIFFERENCE are, first, that the education of American students of art history, unlike that of their British counterparts, does not generally include CRITICAL THEORY. Second, within the highly conservative field of art history, the use of social history as a method of investigation seems radical. First-generation feminist art historians employed such a methodology from the beginning: given the limitations of the field, they have found an approach that is sufficiently radical and therefore have seen no reason to change methodology. The last reason Gouma-Peterson and Matthews give is that there exists in the United States a distrust of methodological approaches of European origin; when such approaches are utilized by American scholars, they are often "unsynthesized models" that "tend to turn away potential advocates as well" (Gouma-Peterson and Matthews, p. 351).

Gouma-Peterson and Matthews go on to assert that one of the main contributions feminist theorizing has made to the field of art history is that it has caused questions to be raised about the field that would otherwise not have been asked.

Questions raised by feminist art historians have caused a reevaluation of the exclusionary practices of the DISCIPLINE as a whole. After making this initial observation, Gouma-Peterson and Matthews present and briefly critique a number of recent revisionist art historical studies, including the WORK of Ann Sutherland Harris, Diane Russell, Mary Garrard, Norma Broude, Whitney Chadwick, Carol Duncan, Linda Nochlin, Eunice Lipton, Anthea Callen, and Griselda Pollock. Anthea Callen's *Women Artists of the Arts and Crafts Movement, 1870–1914* and Griselda Pollock's "Women, Art and Ideology: Questions for Feminist Art Historians" are cited as superior examples of such scholarship. Gouma-Peterson and Matthews refer to Pollock as "the figure who now most comprehensively and consistently illustrates the most radical positioning feminist art history," and admire her WORK because it demonstrates a synthesis of PSYCHOANALYTIC, MARXIST, and DECONSTRUCTIVE THEORY and is "informed by contemporary philosophical and critical notions of society, class, gender, and ideology, understood as historical processes rather than static and 'manageable block[s] of information' to be applied to artworks, or that artworks might be used to illustrate" (Gouma-Peterson and Matthews, p. 355). Pollock is lauded for demonstrating through her WORK that "art is constitutive of IDEOLOGY, it does not merely illustrate it" (p. 355). Her WORK is further praised for fully situating her SUBJECTS within their historical contexts. For example, in "Modernity and the Spaces of Femininity," in which she examines how SEXUAL DIFFERENCE structured the products of artists Mary Cassatt and Berthe Morisot, she "offers a model of feminist art history, which examines not the positions in which women have been placed through male stereotypes (still a valid undertaking, especially as carried out by Duncan and others), but rather a map of the territory that was available to them and that they occupied as women, outside of the male world" (Gouma-Peterson and Matthews, p. 356). In thus situating her SUBJECTS, Pollock shows a marked divergence from first-generation feminists. As Gouma-Peterson and Matthews explain, "Pollock's ideological stance towards the nature of feminist research thus stands in opposition to the methodologies of feminist writers of the 1970s who sought to discover, uncover, and assert the importance of women artists either within a male structure or separate from it" (p. 356).

Since the publication of Gouma-Peterson and Matthews's article, the field of feminist art criticism has seen a number of significant changes. Such changes have resulted from a number of INFLUENCES, including the rising prominence and combinatory effects, refinements, and extensions of psychoanalytically based CRITICAL THEORIES; FOUCAULDIAN-derived THEORIES regarding the BODY and its role in the construction of SUBJECTIVITY; POSTCOLONIAL THEORY and its popular manifestation in MULTICULTURALISM; and QUEER THEORY. It has appeared to some that feminist art theorists and practitioners have recently retreated to first-generation feminist concerns, observable in a renewed concern with SEX- as opposed to GENDER-based IDENTITY, a profusion of static and PERFORMANCE ART that showcases all variety of SEXED BODY parts, and a preoccupation with ways in which the BODY functions to produce SEX-based gendered IDENTITY (see Kolbowski and Nixon, eds., "Feminist Issues"). When such presumed "symptoms" of regression are closely examined, however, they reveal a more complex trajectory.

Gouma-Peterson and Matthews's article provides a convenient point of departure for an analysis of the changes in art critical practice of the last ten years. The main line of their argument finds its foundation in a system of rigid binaries: first generation and second generation; ESSENTIALIST and constructionist; British and American; even East Coast and West Coast. Considering that the authors are well-trained art historians, the oppositional STRUCTURE of a DIALECTICAL approach is not surprising. In their eagerness to simplify their argument, however, Gouma-Peterson and Matthews have unwittingly duplicated the sort of BINARY thinking that has produced the sorts of exclusionary practices they laud second-generation feminist practices in art history and criticism for working to subvert.

An awareness of the negative effects of systems of belief that categorize individuals on the basis of BINARY models (positioning them as male or female, black or white, self or other, straight or gay, young or old, and so on) is one of the major shifts in critical thinking that have occurred since the publication of Gouma-Peterson and Matthews's article. POSTSTRUCTURALIST THEORY had developed to a large degree by the time of their article's publication. In the field of art history and criticism—whether feminist or not—however, it had made few inroads. This has since changed. Of course, this shift in thinking is not restricted to cultural THEORY; it is CRITICAL THEORY, however, which has most directly influenced art critical writing. The changes in cultural THEORY that have probably had the most profound effect on visual art writing and practice are those that have occurred in psychoanalytically based CRITICAL THEORY. Other areas of cultural study that have dramatically impacted art and art writing include SUBALTERN studies and THEORIES of the cultural "OTHER," QUEER THEORY, and attempts to explore Kristeva's conception of ABJECTION.

As Gouma-Peterson and Matthews contend, one of the most valuable contributions that feminism has made to art history is an awareness of the exclusionary bases of the DISCIPLINE. Once the feminist critique revealed those elements of the field that worked to exclude women, the ways they worked to exclude other groups became apparent, as well. Art criticism and art practice of the last ten years have tried to reveal similarly exclusionary biases in the contemporary art world, most evident in attempts to include individuals and SUBJECTS formerly excluded from critical art DISCOURSE. This is one of the primary reasons why we have recently seen such a profusion in galleries and museums of SUBJECTS previously considered "beneath" art—excrement, urine, and a whole array of other human detritus.

**FEMINIST ACTIVIST ART** Groups of feminist artists have banded together to fight discrimination against women in the world at large, and in the art world in particular. The most recent of such groups include The Guerrilla Girls and the Women's Action Coalition (WAC).

The Guerrilla Girls make discriminatory practices in the art world the SUBJECT of their PERFORMANCE. A group of women who dress up in gorilla suits to hide their IDENTITY, they engage in actions carefully orchestrated so as to draw media attention to their cause. They are perhaps best known for the posters they post in and around New York City's gallery and museum districts. Their posters employ subtle IRONY and humor to convey facts regarding discriminatory practices against women in the art world. For instance, a 1989 poster

critical of the acquisition practices of New York's Metropolitan Museum poses the question, "Do women have to be naked to get into the Met. Museum?" The reply, which appears next to an image of a nude female wearing a gorilla head, tells us "Less than 5% of the artists in the Modern Art Sections are women, but 85% of the nudes are female." At the bottom of the poster they identify themselves, listing their name along with the identifying tag they always provide. It reads: "Guerrilla Girls, Conscience of the Art World."

The Women's Action Coalition has engaged in similar dissemination of facts regarding sexism in the art world. WAC, however, does not limit its criticism to the realm of art. Organized in January 1992 by a group of New York women, by 1993 WAC had over two thousand members in New York, and chapters had formed in twenty cities throughout the United States, in London, Paris, and Toronto. Their tactics include public demonstrations, staging of media events, and the publication of a fact book, *WAC Stats: The Facts About Women*, which includes sections providing statistics on AIDS, abortion, cosmetic surgery, eating disorders, rape, menopause, SEXUAL harassment, and other issues concerning the welfare of women. The section of the book on art listed such facts as: "5% of works in museums are by women," "17% of works in galleries are by women," "26% of artists reviewed in art periodicals are women," and "Women artists' income is 30% that of male artists" (*WAC Stats*, p. 14).

**FEMINIST FILM THEORY** PSYCHOANALYSIS has recently undergone a period of intense scrutiny. As a "master DISCOURSE" of Western CULTURE, it has been the object of much critical analysis by POSTSTRUCTURALISTS and other contemporary theorists who are interested in deconstructing and otherwise analyzing culturally dominant discourses. The recent critique of PSYCHO-ANALYSIS as a cultural DISCOURSE has had an impact on feminist art THEORY in a number of ways. Psychoanalytically based feminist film theory has yielded especially fruitful applications to art. Foremost among feminist film theorists who have had an influence on art critical writing is British theorist Laura Mulvey.

Beginning in the 1970s, a number of cultural theorists interested in PSYCHOANALYTIC explanations of behavior engaged in a lively debate produced by application of psychoanalysis to film. Mulvey, whose now-famous essay, "Visual Pleasure and Narrative Cinema," was first published in England in 1975, was at the CENTER of this debate. Mulvey theorized that Hollywood conventions of cinematic practice construct the GAZE as male. The female BODY acts as the FETISHIZED object of the MALE GAZE, and those in the audience necessarily take on the role of masculine VOYEUR. Further, the combination of NARRATIVE and SPECTACLE (the functions of telling and showing) reflects a system of SEXUAL imbalance in which the male is the active SUBJECT and the female is the passive object.

Mulvey's essay has had a dramatic impact on art critical writing in North America. Its most widely disseminated idea, that female SUBJECTS in Western film function as the passive objects of an active MALE GAZE, has been fruitfully applied to art critical and art historical writing.

By the early to mid-1980s, a number of studies and exhibitions that used Mulvey's THEORIES as their basis had appeared. Probably the most influential in terms of their impact on visual art were Kate Linker's "Representation and Sexu-

ality," published in 1983, and an exhibit at New York City's New Museum of Contemporary Art in 1984, *Difference: On Representation and Sexuality*, which was cocurated by Linker and Jane Weinstock. This exhibit and the catalog published to accompany it, which includes essays by Linker, Weinstock, and Victor Burgin, made a significant impact on subsequent art writing and practice. The WORK of several feminist artists of the 1980s served as the focus of much art criticism that found its basis in feminist film theory. Among these artists are Cindy Sherman, Silver Kolbowski, Barbara Kruger, and Victor Burgin.

Since within her framework women could only function as the objects of SPECTACLE, not as spectators, Mulvey's THEORIES left little room for nonobjectifying representations of women in visual art forms or for expression of feminine as opposed to MASCULINE DESIRE. Feminist DISCOURSE subsequent to Mulvey's seminal article has called for exploration of the development of forms of REPRESENTATION that can could embody and convey women's DESIRE. Mulvey herself responds to such criticism and somewhat revises her THEORIES in the light of the debate that follwed the publication of *Visual and Other Pleasuress*. A collection of responses to Mulvey's article is contained in *The Female Gaze: Women as Viewers of Popular Culture*, edited by Lorraine Gamman and Margaret Marshment. Other recent publications in which the authors attempt to reconceptualize the GAZE in terms less polarized along a male/female axis include: "Ex-Changing the Gaze: Re-Visioning Feminist Film Theory," by Gertrud Koch, "Rethinking Women's Cinema: Aesthetics And Feminist Theory," by Teresa de Lauretis, *Hard Core: Power Pleasure and the 'Frenzy of the Visible'*, by Linda Williams, Now You See It: Studies on Lesbian and Gay Film, by Richard Dyer, and "*The Color Purple*: Black Women as Cultural Readers," by Jacqueline Bobo.

**FETISH/FETISHISM**   In Freudian terms, the fetish is a SIGNIFIER that stands in for the PHALLUS, and which thereby allays the male fear of castration that is attendant upon sight of the female genitals. Operating through the processes of METAPHOR and METONYMY, it does not necessarily involve vision, since it can operate through smell and hearing as well as sight. In contemporary art, however, the visual aspects of fetishism figure most prominently. A concern with fetishism is most commonly seen in artistic efforts which involve interrogation and examination of discourses of SEXUALITY, such as much recent feminist art.

In *The History of Sexuality, Volume 1: An Introduction*, Michel FOUCAULT asserts that the nineteenth and twentieth centuries have seen a "multiple implantation of 'perversions'" (p. 37). He explains how, in an attempt to repress those undesirable SEXUAL behaviors they observed as spreading through their environment, medical experts of this period have engaged in identifying and naming such perversions. The effect of such naming, however, has been to stimulate their proliferation rather than to eliminate or repress their expression. FOUCAULT identifies fetishism as the "master" or "model perversion" of this period. He believes that fetishism "from at least 1877, served as the guiding thread for analyzing all the other deviations" (p. 154). In large part due to FOUCAULT'S discussion of fetishism, and perhaps in equal measure due to feminist film theorists' and cultural theorists' explorations of PSYCHOANALYTIC DISCOURSE,

fetishism has been the SUBJECT of much recent cultural DISCOURSE. It has also served as the SUBJECT of WORK by a number of contemporary artists.

In her 1975 essay, "Visual Pleasure and Narrative Cinema," Laura Mulvey outlines a THEORY of mainstream cinema that has formed the basis for much subsequent theoretical writing on the SUBJECT. Mulvey uses Freud's concept of the fetish as one of her main precepts, basing her ideas on the premise that fetishism involves a disavowal that women lack a penis (see Freud, "Fetishism," in *The Standard Edition of the Complete Psychological Works*, vol. 21). According to Freud, a fetish disavows the physical reality of SEXUAL DIFFERENCE. Knowledge of women's lack is acquired by the sight of female genitals and is retained by the infant. But, Freud tells us, conscious awareness of such knowledge is denied through substitution of that which is seen immediately prior to the female genitals. The DESIRE that she have a penis is assuaged by transfer to a particular BODY part or an object such as shoes, fur, and so on. Knowledge of women's lack is retained while, at the same time, the fetish object maintains the belief that she has a penis.

What is really at issue in such disavowal of lack is the operation of the penis as PHALLUS. The penis is only the physical stand-in for the PHALLUS, which actually serves as the SIGNIFIER of SEXUAL DIFFERENCE, which sets into motion the PLAY of DIFFERENCE and SIGNIFICATION. The DESIRE for woman to have a PHALLUS is what gives the FETISH such force. Fetishism's disavowal of SEXUAL DIFFERENCE is disavowal of the PHALLUS through substitution of something that woman does possess. Because such disavowal does maintain the PHALLUS, it also maintains the necessary precondition for DIFFERENCE and thus for language.

Mulvey regards cinema as characterized by three relationships of looking. First is the spectator's GAZE at the SCREEN; second is the camera's look, which captures the event filmed; and third is the GAZE that the actor directs toward other actors. Mulvey contends that, in classic cinema, such GAZES do not meet. For instance, the camera does not look at the audience, and the actors do not look into the camera. This guarantees the controlling distance necessary to the PLEASURE Mulvey sees as inherent to the GAZE. It allows satisfaction of the SCOPOPHILIC drive, which derives PLEASURE from satisfaction of a voyeuristic DESIRE. In addition, such VOYEURISM demands a NARRATIVE and, thus, temporal element. In Mulvey's words, it "demands a story, depends on making something happen, forcing a change in another person, a battle of will and strength, victory/defeat, all occurring in a linear time with a beginning and an end" (Mulvey, "Visual Pleasure and Narrative Cinema," p. 29). However, fetishism involves fixation, which stops the flow of NARRATIVE, and demands abolishment of the distance between REPRESENTATION and viewer that is necessary to voyeuristic PLEASURE. Fetishism reinstalls an immediate relationship that carries promise of satisfaction of DESIRE.

Because, in Freudian terms, fetishism must involve SEXUALITY, fetish objects and fetishized BODY parts are those that are already prone to sexualization within a CULTURE. In "'You Don't Know What Is Happening, Do You, Mr. Jones?'" Laura Mulvey develops further her ideas regarding the operation of the fetish in contemporary visual CULTURE. Finding in the WORK of British artist Allen Jones the operation of the fetish as disavowal of women's lack and thus as defense against male fear of castration, Mulvey describes his WORK as exhibiting

the three aspects of fetishistic images of women that are found in POPULAR visual CULTURE. She describes these as: "woman plus phallic substitute," "woman minus phallus punished and humiliated, often by woman plus phallus," and "woman as phallus" (p. 128).

Mulvey finds a model for the workings of the fetish in the WORK of contemporary photographer Cindy Sherman. Over the past two decades Sherman has produced a series of photographs for which she serves as both model and artist. When posing for her WORK, she is always in disguise and sometimes in DRAG. In "A Phantasmagoria of the Female Body: The Work of Cindy Sherman," Mulvey describes Sherman's work from 1977 to 1987 as providing a "narrative of the feminine," which develops chronologically but also spatially, from the exterior of the BODY to the interior. She theorizes that Sherman's WORK operates like a fetish. Sherman-the-model conceals, while Sherman-the-artist reveals, the MASQUERADE that constructs femininity. Sherman reveals, Mulvey contends, femininity as all surface; and, since the existence of surface presupposes existence of an interior, an interior space is produced. Sherman's WORK, paradoxically, opens up what femininity as MASQUERADE works to conceal. (See FEMININE MASQUERADE.) Sherman makes visible the MASQUERADE of femininity. We know Sherman is under the disguise. The illusion draws attention to itself. By making artifice obvious, by FOREGROUNDING the illusion, Sherman undercuts it. Mulvey explores the sources of Sherman's NARRATIVE of disintegration and decay. She explains how femininity acts as a veil, concealing (through MASQUERADE) a threatening interior "enchantress-turned-hag." Mulvey believes that the interior space that lies beneath woman's surface allure often functions as METAPHORIC expression of essence beneath appearance, TRUTH beneath falsehood, reality beneath FICTION, plain speech beneath cosmetic RHETORIC. FEMININE MASQUERADE echoes the fetish in that it both confirms and denies the threat of castration. Sherman's images operate like the fetish, which operates semiotically through "the deceit of artifice" (Mulvey, "Phantasmagoria," p. 147). For Freud fetishism involves a simultaneous confirmation and denial. The possibility of castration is recognized through the fetish, but it is also simultaneously denied through the fetish. The oscillation involved in this operation of the ego is seen by Mulvey as similar to the viewer's experience in POSTMODERN art of an oscillation between credibility and incredibility. The fetish provides protection against a traumatic memory (castration anxiety). It also functions as a memento, a reminder of something that occurred in the past and of what may potentially happen in the future. Sherman's MASQUERADE both asserts and conceals the female BODY as the SITE of anxiety.

Another contemporary artist who uses fetishistic imagery is Mary Kelly. In *Post-Partum Document*, an installation of 1983, she explores how the male child serves as a PHALLIC substitute and, thus, as a form of female fetish. She interrogates ways in which mothers' collections of memorabilia of their children's infancy, which, she asserts, are prompted by fear of the "empty nest," serve as PHALLIC substitutes through their function as fetish objects that disavow loss. In the "Corpus" section of *Interim*, a four-part installation completed in 1990, Kelly employs fetishistic images of clothing in an attempt to expose the workings of COMMODITY fetishism and female DESIRE.

**FICTION** In traditional terms, a work of fiction is a fabricated work, a work of imagination and invention, and as such, associated with deceit, falsity, and lies. In more recent usage, the term fiction has come to indicate all "messages," "worldviews," or "points" embodied in and created by texts and it has lost CONNOTATIONS of falsity. Many arguments in favor of this view point to the Latin root *fictio*, meaning something made or constructed, but without any negative CONNOTATION. This can be a disconcerting definition of fiction for those who have invested greatly in the truth of especially important historical documents like the Constitution or the Bible. The point of this redefinition of fiction, however, is not to designate all types of writing "false," but to underline the productive and constructive nature of all SIGNIFYING activities.

**FIGURES/ FIGURATIVE LANGUAGE/ FIGURATION** See RHETORIC.

**FILM THEORY** Film theory comprises a number of technical and theoretical concerns. Some technical areas of interest to film theorists are art direction, composition, special effects, camera angles, cropping, editing, eye-line match, match on action, reaction shots, relational editing, lighting, flashbacks, flash-forwards, and NARRATION—in short, all those techniques that are used to create CONNOTATIONS through the filmic medium. Theoretical concerns are more varied and are indicated by such terms as ACOUSTIC MIRROR, ACTIVE DESIRE, ACTIVE/PASSIVE, APPARATUS, AUTEUR THEORY, CINEMA VÉRITÉ, CLASSICAL CINEMA, DESIRE, FEMALE GAZE, FEMININE DESIRE, FETISH/ FETISHISM, GAZE, GENDERED SPECTATORSHIP, MALE GAZE, MASCULINE DESIRE, OBJECT OF DESIRE, PORNOGRAPHY, SCOPOPHILIA, SCREEN THEORY, SPECTACLE, SPECTATORSHIP, SPECULAR/SPECULARIZATION, SUTURE, TABLEAU SPACE, and VOYEURISM.

**FIRST-GENERATION FEMINISM** First-generation feminist art practice and writing developed in the early 1970s in the United States and Europe and was most influential throughout that decade. Although it has been largely displaced by SECOND-GENERATION FEMINISM, in the case of some artists and writers, such as Judy Chicago and Lucy Lippard, it has extended into the present. First-generation FEMINISM is characterized by an interest in REPRESENTATION of the female anatomy in general and female genitalia in particular, attempts to identify and employ a uniquely "feminine" aesthetic, the identification of a central void construction as a prominent compositional feature of women's artwork, the production of pieces that required the collaboration of large groups of women, the revival of traditional women's art and craft forms such as needlework and china painting, a belief in the existence of prehistoric matriarchal CULTURES, a belief in a universal "female-ness," the production of WORK intended to celebrate the "feminine," and a belief that women artists of the past and present should be located and added to the existing art historical CANON. GODDESS ART and work that is regarded as expressive of feminine spirituality are two characteristic forms of first-generation feminist art. (See GODDESS ART and SPIRITUAL FEMINISM.) First generation feminist artists include Judy Chicago, Rachel Rosenthal, Carolee Schneeman, and Mary Beth Edelson. (See FEMINISM.)

**FOREGROUNDING**  See DEFAMILIARIZATION.

**FORM**  The term "form" has usually been used with two different but interrelated ideas in mind. First and foremost, form refers to the "formal elements," or "visual elements"—line, color, shape, mass, and so on—that are used by the artist in the creation of the WORK of art. The arrangement of these elements gives the WORK an overall form, a less precise idea that is often used interchangeably with anything from composition to overall visual appearance. Form in this second sense refers to both the elements used in the WORK and the overall result of their use. Ideas of form are especially important to FORMALISM, a critical position taken by formalist historians, critics, and theorists.

**FORMALISM**  Any position on art that concentrates exclusively on the formal properties of an art object is called formalism. Formalism as a critical position was first identified with the writings of Clive Bell and Roger Fry. In their attempts to understand how art exerts power over viewers, they theorized that the power of art was the result of a certain combination and organization of formal elements within the WORK. In its more extreme versions—found in the writings of Clement Greenberg and Michael Fried—great attention was given to the visual FORM of a WORK, while little or no consideration was given to any possible expressive intentions or political functions. Formalist critics, especially in postwar America, were primarily concerned with the AUTONOMY and SELF-SUFFICIENCY of the WORK of art (the ability of art to depend upon nothing but itself for its definition as art) and with the SELF-REFERENCE or SELF-RE-FLEXIVE ability of art (the ability of art to become so abstract that it makes no pictorial reference to other objects in the world). Formalism was so dominant after World War II that it has often been identified with MODERNISM.

**FOUCAULT/FOUCAULDIAN/FOUCAULTIAN**  Having to do either directly or indirectly with the WORK of Michel Foucault, especially his writings on DISCOURSE, DISCOURSE ANALYSIS, and POWER.

**FRAME**  The idea of the frame has become more central to considerations of visual art in recent years, especially after the decline of formalist influence, the full impact of Michael Fried's ideas of THEATRICALITY, and a reconsideration of the idea of the frame by POSTSTRUCTURALIST thinkers like Jacques DERRIDA.
   Ostensibly, a frame functions to separate a picture from the rest of the world. This function, however, can be, and often is, accomplished not by a literal frame but by architectural spaces, art historical texts, and philosophical argument. What allows a museum, as an example, to function as a frame is its ability to remain "invisible" while at the same time delimiting a literal and figurative space that constitutes art or CULTURE. Ironically, the "pure interiority" of a museum or any frame, following DERRIDA, is always pressed upon by the excess of its "OTHER," that which has been excluded. Art historian John Tagg, borrowing from FOUCAULDIAN DISCOURSE ANALYSIS and from DERRIDEAN DE-CONSTRUCTION, describes the frame in this general sense as a space in which a legitimized DISCOURSE—for example, the DISCOURSE of art history—is allowed. From this point of view, the frame becomes a margin of certainty, surrounding its contents with value, ordering and delimiting the field of visuality,

regulating and positioning the viewing SUBJECT, whose PLEASURE of looking is exercised only within the authority of the frame (see John Tagg, "A Discourse (With the Shape of Reason Missing)," *Art History* 15, no. 3 (September, 1992): 360–364).

In FILM THEORY, "frame" has at least four meanings: (1) Any single image on the film strip; (2) the size and shape of the image as projected onto the SCREEN; (3) the dividing line between SCREEN space and darkened theater space; (4) the compositional unit of film design, involving the graphic dynamics of the image as well as the utilization of off-SCREEN space.

**FRANKFURT SCHOOL**   The Frankfurt Institute for Social Research was founded in 1923 in Frankfurt, Germany, and was loosely associated with the University of Frankfurt. The Institute was originally conceived as a center for the study of social sciences and the humanities that would be autonomous of public financing and so allow its members some freedom in the topics of study and in the conclusions drawn from their studies. The Institute moved to Zurich in 1934 to escape the Nazis, and eventually found its way to New York by the late 1930s. After World War II the Institute returned to Frankfurt. The Frankfurt School, as the Institute eventually came to be known, has included such members as Felix Weil, Max Horkheimer, Theodor Adorno, Herbert Marcuse, and Leo Lowenthal. Walter Benjamin was not officially a member, but did receive financial support and was a close associate with many members of the Frankfurt School. In the 1950s and 1960s a new generation of students trained at the Institute, including Jürgen Habermas and Peter Bürger.

In the 1930s, heavily influenced by MARXIST THEORY, Horkheimer and others at the Frankfurt School developed the concept of "CRITICAL THEORY," which in this case should not be confused with "New Criticism" or with a label for all critical thinking or THEORIES. *Ideologiekritik*, or the critique of social interests that underlie systems of ideas or IDEOLOGIES, is the term applied to CRITICAL THEORY and it assumptions are borrowed from Marx's writings. The basic idea is that all forms of cultural production, including the arts, are rooted in ideological interests, be they CLASS, ETHNIC, or GENDER interests. Many members of the Frankfurt School saw cultural production as an instrument for protecting those interests, and so aesthetics and the arts became central to the Frankfurt idea of CRITICAL THEORY.

Theodor Adorno, in *Aesthetic Theory* (1970) and in essays later collected in *The Culture Industry: Selected Essays on Mass Culture* (1991), developed a CRITICAL THEORY of art consistent with Frankfurt School principles. Adorno argues that behind the world of appearances lies the TRUTH of the "phantasmagoria" of capitalism: despite what they think, people are not free, but live in a world that is a kind of prison. They have restricted forms of thought and action imposed upon them by the existing social forces of capitalist production. Consequently Adorno rejects the mimetic tradition of artistic REPRESENTATION of "the real," which he sees as the reification of the superficial world of appearances and a reinforcement of existing IDEOLOGICAL interests. This mimetic tradition includes both the straightforward practice of copying nature, and the idea that a WORK of art can accurately represent society. Adorno argues for the validity of an art that has the ability to reject MIMESIS and defy the effects of commercialism. AVANT-GARDE art should attempt to escape the CULTURE industry

and continually resist the marketplace by asserting the essentially radical
AUTONOMY of art and by developing new art forms that are at odds with existing
social conditions (e.g., "difficult" music and theatre, abstract painting and sculp-
ture, and so on). In many ways Adorno and the formalist American art critic
Clement Greenberg echo one another.

**FREE-FLOATING**   See FREEPLAY.

**FREEPLAY**   According to POSTSTRUCTURALIST THEORY, a SIGN is no
longer tied or anchored to its REFERENT in any necessary way, a fact especially
noticeable after a DECONSTRUCTION. In such a condition, the SIGN is said to be
in freeplay or "free-floating." However, POSTSTRUCTURALISTS realize—and
this is especially true with Michel FOUCAULT—that SIGNS are never truly in
freeplay or free-floating. SIGNS are still tied firmly to their REFERENTS, but
these ties are established and maintained through INSTITUTIONAL practices with
political effects.

# G

**GATEKEEPING** In CULTURAL STUDIES, a phrase referring to the activity on the part of ELITE groups that results in restricted or limited access to high CULTURE. Gatekeepers are exemplified by journal editors, college professors, and gallery and museum directors.

**GAZE** See MALE GAZE and FEMALE GAZE.

**GENDER** Gender is defined as a complex of culturally acquired characteristics that are attributed to individuals of a certain SEX. See GENDER THEORY.

**GENDER THEORY** Gender theory involves the study of how the processes of gendering, of acquisition and maintenance of a "masculine" or "feminine" IDENTITY, operate in a CULTURE. Gender studies arose out of women's studies along with the growing conviction that SEX, but not gender, is linked to biology. Intense scrutiny has been given to the processes of formation—and marginalization—of gendered IDENTITY of individuals occupying gender positions, including those who identify themselves as HOMOSEXUAL, bisexual, trans-sexual, prepubescent, postmenopausal, and so on. Recent prominent gender theorists include Judith Butler, Laura Mulvey, Kaja Silverman, Kobena Mercer, Craig Houser and Victor Burgin. Individual artists who have made exploration of gender central to their WORK include Barbara Hammer, Harmony Hammond, and Robert Mapplethorpe.

Since the 1990 publication of her first major study, *Gender Trouble: Feminism and the Subversion of Identity*, philosopher Judith Butler's THEORY regarding the PERFORMATIVITY OF GENDER has been the SUBJECT of much discussion and debate. Butler has brought into the gender debate, and served as a major elucidator of the ideas of, a number of cultural theorists, including Michel FOUCAULT, Jacques LACAN, Monique Wittig, Luce Irigaray, and Hélène Cixous. (See PERFORMANCE/ PERFORMATIVE/ PERFORMATIVITY/ PERFORMATIVITY OF GENDER.)

**GENDERED SPECTATORSHIP** Gendered spectatorship refers to the idea developed in FEMINIST FILM THEORY that filmic practices found in classic NARRATIVE cinema construct the viewer as male, crating an objectifying MALE GAZE and producing and reproducing cultural constraints that position men as active and women as passive. A gendered spectator, then, is a viewer who is constructed as the occupant of a particular gendered position ("masculine," "feminine," and so on) by the filmic practices of the cinematic form. (See FEMINIST FILM THEORY, MALE GAZE, and FEMALE GAZE.)

**GENDERED SUBJECTIVITY** Gendered subjectivity refers to the GENDER IDENTITY one takes on, to the SUBJECT position, or role, one assumes in relationship to expression of one's GENDER.

**GENEALOGY** Included in Michel FOUCAULT'S DISCOURSE ANALYSIS is a concern with the material techniques by which persons are made into SUBJECTS. FOUCAULT calls his task "genealogy," and describes it as trying to arrive at an analysis that can account for the constitution of the SUBJECT within a historical framework. FOUCAULT'S discursive approach to the problem concentrates on the methods and effects of institutionalized discourses and the knowledge they circulate throughout society (see Michel Foucault. *The Archaeology of Knowledge and the Discourse on Language*). Like Louis ALTHUSSER, FOUCAULT pays particular attention to how these discourses eventually aid in producing both controlled and productive individual citizens. The individual is the SITE of struggles of and for POWER, as well as a surface upon which institutionalized discursive battles for the meaning of IDENTITY and SUBJECTIVITY take place. As Paul Bové describes FOUCAULT on this point, the SUBJECT comes to be whatever or whoever he or she is within these sets of institutionalized fields (see Paul Bové, *Mastering Discourse: The Politics of Intellectual Culture*).

**GENRE** In the visual arts, the term "genre" has two very different meanings. First, it means something roughly equivalent to "category." There can be many genres of painting, including landscape, still life, portraits, and so on. Second, the term can be used to refer to a specific category, that of scenes of everyday life, a type of painting especially POPULAR from the eighteenth century well into the nineteenth century.

**GODDESS ART** A significant number of feminist artists of the 1970s made one of their major concerns an exploration of the role that goddess worship played in ancient CULTURES. They hoped to find a source of MYTH and imagery that was woman-centered and that celebrated a presumed universal femininity. They "unearthed" and utilized images of women from CULTURES that they felt identified a feminine animating force in nature and that engaged in ritual goddess worship. Many used the female BODY as SYMBOLIC of the generative, animating force of nature. Others constructed altars and/or staged elaborate rituals intended to invoke or celebrate the POWER of the goddess that, they believed, resided in every woman. Mary Beth Edelson was among the most vocal of such "goddess artists." Photographing her nude BODY in natural settings, and thus expressing an identification of woman with nature, she inscribed the resulting prints with spirals, horns, moons, and other forms she felt expressed the spiri-

tual power residing in the woman. Edelson explains her conception of the goddess as "an internalized, sacred metaphor for an expanded and generous understanding of wisdom, power, and the eternal universe." Contending that she is "alive and evolving in contemporary psyches as well as being an ancient, primal, creative force," Edelson says that the goddess "embodies the unity of mind-body-spirit, and a wholeness that includes our dark sides" (Mary Beth Edelson, "Objections of a 'Goddess Artist'," p. 34). Speaking of Goddess Head, a ritualistic PERFORMANCE piece of hers from the 1970s, Edelson explains that "like earlier private rituals in which I used my own body as a stand-in for a primary sacred being (Goddess), [this performance piece] broke the STEREOTYPE in our CULTURE that women do not have direct GENDER IDENTITY with the sacred" (p. 36). She maintains that such "creative ritual" affords her "direct access to metaphysical experience" and undermines "the stereotype that the male gender is the only gender than can identify in a firsthand way with the body and, by extension, the mind and spirit of a primary sacred being." Work containing such ritual and imagery was, Edelson contends, specifically feminist because they "connected directly to Goddess as an expanded image of woman as a *universal being* and not limited to the stereotype of woman as *'other'*" (p. 36).

Another prominent artists of this GENRE was Ana Mendieta. Mendieta constructed small-scale earthworks in the FORM of a female BODY'S outline and filled them with the earth-altered photographs of her nude BODY, which she inscribed with spirals, horned moons, wings, and other marks of female spiritual POWER, and Ana Mendieta's archetypal female forms, made from earth, covered in tiny white flowers, or seared with gunpowder, are powerful examples of contemporary spiritual art. The pioneering WORK of many women artists has also had a decisive influence on the politics and practice of the American Green and ecofeminist movements, both of which have incorporated the issues of women's bodily and SEXUAL AUTONOMY into their agendas.

**GRAM**  An alternative term for *DIFFÉRANCE*.

**GRAMMATOLOGY**  Grammatology is the term used by Jacques DERRIDA to designate his general study of and theorizing on writing, alphabets, reading, and graphic marks. This interest is opposed to the SEMIOLOGY of Saussure and others, the science of SIGNS, and the traditional subordination in SEMIOLOGY of writing to speech. See ÉCRITURE.

**GRAND NARRATIVE**  See METANARRATIVE.

**GRAPHEME**  Jacques DERRIDA, as part of his THEORY of GRAMMATOLOGY, posed the grapheme as the smallest unit of written language. DERRIDA was especially concerned to pose the grapheme in relationship to the SEME, or the smallest unit of (usually) spoken SIGN as understood by SEMIOLOGY.

**GROTESQUE**  Mikhail Bakhtin (1895–1975), Russian philosopher of language and literature, made the grotesque and the CARNIVAL, the collective ritual characterized by grotesque display of the BODY, the subjects of much of his writing. Bakhtin developed concepts of the CLASSICAL and grotesque BODIES in *Rabelais and His World*, a study of the sixteenth-century French writer Rabelais.

Bakhtin regards Rabelais's images as deriving from an aesthetic of folk CULTURE, which is characterized by a "MATERIAL BODILY PRINCIPLE" that finds expression in "GROTESQUE REALISM." In the tradition of GROTESQUE REALISM all things bodily become grossly exaggerated, exceeding all normal and proper limits. In CARNIVAL," as conceived by Bakhtin, the "high" and the "ideal" are lowered through laughter linked to the "bodily lower stratum" and lower bodily functions. GROTESQUE REALISM celebrates all those aspects of material existence that are commonly regarded in Western CULTURE as base or degraded.

Bakhtin describes traditional grotesque images as depicting their SUBJECT in the process of metamorphosis. Such images typically involve dismemberment, disintegration, pregnancy, birth, and old age. They are characterized by ambivalence, since they usually contain, in one image, both the beginning and the end of the life course, both birth and old age verging on death. Bakhtin explains that in images of the grotesque body the SUBJECT is close to either birth or death, but the two are united into one. He says that the grotesque body, which is always in the process of metamorphosis and always unfinished, transgresses its limits and overflows into the environment. It is not a discrete whole completely differentiated from its surroundings like the CLASSICAL BODY. Images of GROTESQUE REALISM stress those parts of the BODY that are open, allowing penetration. Bakhtin explains how the unfinished BODY, the open BODY, lacks definite boundaries that separate it from its surroundings. It is merged with its surroundings.

Using Bakhtin's ideas as her basis, Mary Russo has noted the importance of the grotesque to FEMINIST THEORY. Because women are associated with the "quintessentially grotesque events" of SEXUAL intercourse, birth, and menstruation, they are most closely associated with the grotesque. Those characteristics that define the female BODY as grotesque can be employed in exaggerated form in caricature as a critique of social norms.

Examples of the grotesque in contemporary art can be found in the photography of Joel-Peter Witkin, whose SUBJECTS include aborted fetuses, sideshow freaks, and dwarves. Another photographer who employs the TRANSGRESSIVE potential of the grotesque is John Coplans. Photographing his aging nude FORM and often concentrating on the most "base" element of his physique, his toes and feet, Coplans's WORK shows the influence of early twentieth-century photographer Jacques-André Boiffard, who, in turn, found a basis for his grotesque imagery in "The Big Toe," an essay by surrealist writer Georges Bataille.

The WORK of photographer Cindy Sherman also displays elements of the grotesque. Serving as both model and master artist in her *Master Model* series, Sherman problematizes traditional portraiture, which, in Western CULTURE, bases its POWER on the assumption of a unitary individual "essence" that the "master" artist or photographer can capture and preserve. Sherman interrogates the processes whereby culturally dominant practices of visual REPRESENTATION construct individual SUBJECTIVITY. Such practices work to produce in the viewer the sense of a coherent, delimited self, which is always clearly distinguished from others. These practices work to produce the CLASSICAL BODY, as opposed to the grotesque body. In the FOREGROUNDING of artifice, in the addition of obviously fake BODY parts, such as breasts, noses, and bulging bellies, Sherman seems to suggest that the classical Cartesian SUBJECT has come apart.

The practices of REPRESENTATION that work to produce a coherent self distinct from its surroundings have become obvious and have thus failed their function.

**GROTESQUE BODY**  See GROTESQUE.

**GROTESQUE REALISM**  Russian linguist Mikhail Bakhtin develops the concept of GROTESQUE realism in *Rabelais and His World*, his study of the six-teenth century French writer Rabelais. Bakhtin cites degradation, the debasement or lowering of those things and ideas normally positioned as high and ideal, as the primary principle of GROTESQUE realism. In its PARODIC character and its basis in humor, the GENRE of GROTESQUE realism employs laughter that mate-rializes and degrades. This laughter brings its SUBJECT down to the earthly level, gives its SUBJECT corporeal existence. The degrading laughter characteristic of GROTESQUE realism is, according to Bakhtin, linked to the "bodily lower stra-tum." In its association with things earthly, GROTESQUE realism participates in all those aspects of material existence that are commonly regarded in Western CULTURE as base or degraded.

**GUATTARI/GUATTARIAN**  Having to do with the philosophy or writing of Félix Guattari. See also BODY WITHOUT ORGANS, D&G, DELEUZIAN, DESIRING MACHINES, NOMADOLOGY, PLATEAU, RHIZOMATIC AND AR-BORESCENT, RHIZOME, and SCHIZOANALYSIS.

**GYN-ECOLOGY**  Mary Daly coined the term "gyn-ecology," making it the title of her 1978 book on the subject. Arguing for complete rejection and separa-tion from PATRIARCHY, even to the extent of refusing to use the same language as men, Daly theorized that the cooperative efforts of women-only groups could result in whole new bodies of knowledge and ways of understanding the world, or whole new "ecologies" of meaning.

**GYNOCENTRIC**  First-generation feminists such as Elaine Showalter, Mary Daly, and Adrienne Rich called for the development of gynocentrism. Gynocen-tric characteristics and activities are those that are believed to exhibit uniquely feminine strengths and that could, through their fostering and encouragement, fa-cilitate women's resistance to PATRIARCHY.

**GYNOCRITICS**  LITERARY THEORIST Elaine Showalter first used the word "gynocritics" in 1979 to describe feminist criticism that focuses on the woman writer. She contends that gynocritics generates interest in the study of the experi-ence of women as a means to develop new models that are not simply modifica-tions of male THEORY. Showalter explains: "Gynocritics begins at the point when we free ourselves from the linear absolutes of male literary history, stop trying to fit women between the lines of male tradition, and focus instead on the newly visible world of female culture." (Showalter, "Toward a Feminist Poet-ics," p. 28). As a form of RADICAL FEMINISM that advocates a separate artistic practice and development of an artistic FORM that is the exclusive product of women's experience, gynocritics may be seen as the literary equivalent to first-generation feminist art practices which focused on cognate issues.

# H

**HEGEMONY** The WORK of Antonio Gramsci has been instrumental in establishing the meaning of hegemony currently in use. Gramsci extended the meaning of the term beyond its CONNOTATIONS of dominance and control to include ways in which humans perceive their relationship to the world. It is different from IDEOLOGY in that it is not limited to a concern with the interests of the ruling classes, but also focuses on an acceptance of "normal reality" and "common sense" by those subordinated to the ruling classes. Thus hegemony is broader than IDEOLOGY, because it includes the control of CULTURE as a centrally important element in the continuing domination of the ruling classes, as important as the Marxist conception of the BASE.

**HERMENEUTICS** Another word for interpretation.

**HETEROSEXIST** Something or someone exhibiting a bias in favor of the heterosexual over the homosexual, bisexual, trans-sexual, or any form of sexuality other than heterosexual.

**HETEROSEXUAL DESIRE** Heterosexual desire occurs in an individual who experiences a SEXUAL attraction to an individual who is identified as of the opposite SEX.

**HETEROSEXUAL MATRIX** In *Gender Trouble: Feminism and the Subversion of Identity*, philosopher and GENDER theorist Judith Butler explains the "heterosexual matrix" as a "grid of cultural intelligibility" that naturalizes DESIRES, BODIES, and GENDERS. Butler derives her idea from two other theorists of GENDER, Monique Wittig and Adrienne Rich. Wittig developed the idea of a "heterosexual contract" in her WORK; and, in a 1980 essay, "Compulsory Heterosexuality and Lesbian Existence," Rich used the term "compulsive heterosexuality" to describe the hegemonic processes that produce GENDER and that require that individuals conform to the patriarchally defined notion of GENDER as an expression of a fixed and stable SEX. In Rich's view, GENDER is oppositionally

produced through the hierarchical and compulsory practices of heterosexuality, which maintain male dominance, through what Butler terms the "heterosexual matrix" (Butler, *Gender Trouble*, p. 151).

**HETEROTOPIA**   According to the writings of Michel FOUCAULT, hetero-topias are understood best in opposition to utopias. While utopias are rhetorical and idealist, heterotopias are those real spaces that exist outside of and in opposi-tion to the ideals of a community. Examples of heterotopias are hospitals, nurs-ing homes, cemeteries, prisons, and sometimes Indian reservations. FOUCAULT sees heterotopic spaces as elements of larger discursive organizations used in the production of disciplined SUBJECTS in society.

**HIERARCHICAL THEORY**   Any THEORY that uses a HIERARCHY as its basis.

**HIERARCHY**   Much attention has been given in POSTSTRUCTURALIST THEORY to the arrangement of "self-evident" BINARY OPPOSITIONs or concep-tual pairs that are used as the basis of an argument or THEORY. Jacques DERRIDA, in a key TEXT on DECONSTRUCTION, wrote extensively on Plato's positioning of the terms "speech" and "writing" in the dialogue "Phaedrus" (see DECONSTRUCTION). DERRIDA understood such an arrangement as written into an argument so as to give one term a privileged or ruling position over the other from the very start. The first term is presented as primary and ontologically prior (usually coming first, both in the presentation of the pair, as well as being seen as having existed first), while the other term is secondary and serves as a SUPPLEMENT to the first—e.g., male/female, high/low, young/old, na-ture/CULTURE, and civilized/savage. A hierarchy is thus established. This hierar-chy controls the meaning of the argument and restricts its possible direction and outcome. A DECONSTRUCTION can produce a reversal, whereby the ruling term becomes governed by the other term. Due to the potential critical contribution of this POSTSTRUCTURALIST conception of hierarchies, hierarchical constructions have formed a major concern for feminist theorists. Feminists have attempted to demonstrate the historical bias within European CULTURE that is based upon and continued through hierarchical strategies. At the same time, partly due to DERRIDA'S critique of hierarchies, feminists have demonstrated the possibilities of an overturning or outright rejection of hierarchies.

**HINGE**   See PLAY.

**HOMMELETTE**   The term HOMMELETTE derives from a PLAY on words by Jacques LACAN. LACAN uses the word to describe the pre-Oedipal stage of early childhood development, when the child is unable to differentiate itself from its surroundings. The very young child has not yet developed an ego, which relies on the sense of a circumscribed self that, in the PSYCHOANALYTIC scheme, ac-companies the development of an awareness of bodily containment and limits; so his/her sense of self is like the runny, undifferentiated mass of an omelette. The PLAY on words relies on the French word for "man," which is "homme," and the suffix "-ette," which serves as a diminutive. Thus, an "homme[l]ette" would

mean "little man," which is how a young child (either male or female) may be regarded.

**HOMOSEXUAL DESIRE**  Homosexual desire occurs in an individual who experiences a SEXUAL attraction to an individual who is identified as of the same SEX.

**HYBRIDIZATION/HYBRIDITY**  In POSTCOLONIAL studies hybridization refers to the mixing of CULTURES and peoples that occurs as the result of colonization. In *The Location of Culture*, Homi K. Bhabha asserts that "the margin of hybridity, where cultural differences 'contingently' and conflictually touch. . . resists the binary opposition of racial and cultural groups. . . as homogeneous polarized political consciousnesses" (p. 207). Bhabha explains that hybridity challenges assumptions regarding cultural purity and authenticity. In challenging such cultural distinctions, it may operate as an effective form of opposition and subversion, because it makes visible the "necessary deformation and displacement of all sites of discrimination and domination" (Bhabha, "Signs Taken for Wonders," p. 9). In the field of MULTICULTURAL studies, hybridity has been discussed by Henry Louis Gates as offering the possibility for a complex and dynamic common American CULTURE.

**HYBRID POETICS**  According to Andre Lefevere, hybrid poetics occurs when two cultural traditions meet and elements from a historically dominated CULTURE mix with those from the historically DOMINANT CULTURE. This interaction constrains the production of literature produced by individuals in the dominated CULTURE, but leaves the literature of the dominant tradition unaltered.

**HYPERREAL**  According to the SEMIOTIC THEORY of Jean BAUDRILLARD, the term "hyperreal" describes a condition of reality when that reality has been displaced by a SIMULATION. In other words, when the use of simulations becomes so convincing that one cannot tell the DIFFERENCE between the SIGN and the real, a condition of hyperreality exists.

**HYPERTEXTUAL**  See INTERTEXTUALITY.

# I

**ICON** In Charles Sanders Pierce's semiotic THEORY, a SIGN that represents its object mainly by way of similarity or ICONICITY, e.g., a map or a portrait.

**ICONICITY** An analogous relationship between image and object or REFERENT.

**ICONOGRAPHY** A long-standing tool of interpretation used by art historians, iconography has taken on a different specific meaning in FILM THEORY in recent years. Patterns of imagery in relation to NARRATIVE, MISE-EN-SCÈNE and other cinematic structures; visual CONVENTIONS attached to a body of TEXTS, whether defined by GENRE, star, or director (AUTEUR).

**IDENTITY** The term identity has two interrelated meanings in contemporary critical thinking. First, it refers to the relationship of SIGNS for their referents. When a SIGN is taken to be the REFERENT, that is, when the DIFFERENCE between a SIGN and its REFERENT is not recognized, it is said that there is an identity between the two. The second meaning of the term identity is subsumed under the phrase IDENTITY POLITICS.

**IDENTITY POLITICS** Identity politics refers to the idea that individuals tend to form their opinions on political issues on the basis of their GENDER, RACE, ETHNICITY, and SEXUAL orientation. A variety of identity politics can be seen in the art WORK of individuals who favor artistic expression based on issues regarding the artist's RACE, GENDER, ETHNICITY, and so on, over forms that strive toward presumably universal or strictly aesthetic concerns.

**IDEOLOGICAL STATE APPARATUS (ISA)** See APPARATUS.

**IDEOLOGIEKRITIK** See FRANKFURT SCHOOL.

**IDEOLOGY** In Marxist THEORY, ideology plays in important role in the continued domination of the working classes by the ELITE ruling classes. Ideology is most commonly referred to as a kind of "false consciousness" that prevents workers from defining their problems and solutions. These ways of "false thinking" are produced especially by INSTITUTIONS that have a vested interest in maintaining the relationships of workers and the ruling CLASS, such as religions and educational INSTITUTIONS. This conception of ideology, generally equivalent to illusion, has been supplemented by recent theorists so as to include almost any form of SIGN usage, even that by Marxists, since no textual formation is actually disinterested or free of illusion in some sense.

**IMAGINARY** French psychoanalysis Jacques LACAN (1901–1981) revised Freud through SEMIOTIC THEORY by centering his THEORIES of the SUBJECT and PSYCHOANALYSIS on language. Since an analyst works with a patient's statements and repeated (ENCODED) behaviors, SIGNS are really all that is available to him/her. As a child develops the ability to use language (SIGNS), the child becomes socialized. In his "rewriting" of Freud, LACAN introduced several important concepts into PSYCHOANALYTIC DISCOURSE, which are useful to those interested in the processes of socialization, especially GENDER formation. One such concept is the Imaginary. The Imaginary in LACANIAN terms is the prelinguistic stage of development. It is prior to self-awareness and is characterized by a child's *direct experience* of the mother without any sense of separate IDENTITY. At this stage, the child's IDENTITY is interchangeable with that of the mother.

Mary Kelly is a contemporary artist who has used LACANIAN THEORY in her WORK. Most notable is her use of LACAN'S concepts of the Imaginary, the REAL, the SYMBOLIC, and the MIRROR STAGE in *Post-Partum Document*, an installation which deals with the birth and early childhood of her son and her relationship to him.

**IMAGINARY BODY/IMAGINARY ANATOMY** When Sigmund Freud formulated his ideas regarding hysteria, he theorized that an understanding of the hysteric's symptoms was crucial to an understanding of the relationship between the libido and the BODY. Such theorizing was extended by French psychoanalyst Jacques LACAN, especially in WORK dealing with the development of the ego. LACAN speaks of an "imaginary anatomy" that the hysteric mimics and that displays an "astonishing somatic compliance." He says that hysterical symptoms

follow the pattern of a certain imaginary anatomy which has typical forms of its own. In other words, the astonishing somatic compliance which is the outward sign of the imaginary anatomy is only shown within certain definite limits. I would emphasize that the imaginary anatomy referred to here varies with the ideas (clear or confused) about bodily functions which are prevalent in a given culture. (Lacan, "Some Reflections on the Ego," p. 13)

In "A Critique of the Sex/Gender Distinction," Australian feminist theorist Moira Gatens discusses LACAN'S THEORIES regarding the imaginary body.

Gatens's basic assertion is that, if feminists are to employ an effective strategy
of resistance to PATRIARCHY and capitalism, they must first develop "a coherent
account of the construction of male and female subjectivity" (Gatens, p. 154).
Gatens builds her argument on LACAN'S ideas regarding the imaginary body, as-
serting that "'masculinity' and 'femininity' correspond, at the level of the imagi-
nary body to 'male' and 'female' at the level of biology." Her argument, how-
ever, "does not imply a fixed essence to 'masculine' and 'feminine' but rather an
historical specificity" (Gatens, p. 155). Gatens speaks of hysteria as described by
LACAN and "phantom limbs" as proof of a libidinal or narcissistic relationship
of the individual SUBJECT to the BODY that defies rationalist and behaviorist ex-
planation. She invokes Schilder's assertion that all healthy individuals have both
a material BODY and a "BODY-phantom" or imaginary body. The latter of these,
the interiorized image of the BODY, Schilder theorizes, is a necessary condition
for intentionality (Paul Schilder, *The Image and Appearance of the Human Body*,
passim).

Gatens notes further that the consistency with which certain hysterical symp-
toms, such as *anorexia nervosa*, are enacted from one patient to another within a
given CULTURE attests to the "social character of the imaginary body" (Gatens,
p. 152). She explains that the imaginary body is specific to the social and histor-
ical CONTEXT of the individual SUBJECT and is constructed through the BODY
by the combined effects of a number of factors, including a shared cultural lan-
guage, a privileging of particular areas of the BODY (the genitals, mouth, and so
on), and INSTITUTIONS and DISCOURSES on the BODY such as medicine, educa-
tion, and legal DISCOURSE. Gatens further asserts that an understanding of the
imaginary body is crucial to finding a CODE to decipher the personal meaning of
biological maleness and femaleness, of the cultural experience of masculinity and
femininity. An understanding of the ways in which the imaginary body functions
is key to the realization that the behaviors regarded as SEX-specific—that is,
"masculine" or "feminine"—are reactions to and/or manifestations of our shared
UNCONSCIOUS and conscious conceptions of biology. Such awareness, Gatens
contends, leads to an understanding that there is not an arbitrary connection be-
tween SEX and GENDER, that "masculinity and femininity as forms of SEX-ap-
propriate behaviours are manifestations of an historically based, culturally shared
phantasy about male and female biologies" (Gatens, p. 152).

**IMPERIALISM** Imperialism, which forms the SUBJECT of much COLONIAL
and POSTCOLONIAL DISCOURSE, consists of the political dominance of one em-
pire or nation over a foreign country or the act of acquiring and ruling over
colonies or dependencies (see COLONIALISM, POSTCOLONIAL DISCOURSE).

**INDEX/INDEXICAL SIGN**   In Charles Sanders Pierce's SEMIOTIC
THEORY, a type of SIGN that has an existential bond with its object—a ther-
mometer, for example. Film participates in that category of SIGNS to the degree
that it depends on photochemical processes.

**INFLUENCE**  See REVISIONIST ART HISTORY.

**INFORME**  The French novelist, philosopher, and art critic Georges Bataille
regarded the *informe* ("unformed"), which he likened to spit, as capable of sub-

verting rational, categorical thinking. He further developed this concept through the idea of *BASSESSE* (baseness), the mechanism by which the *informe* could be achieved. (See BASSESSE.)

From 1929 to 1930 Bataille published a magazine, *Documents*, in which he developed the concept of the *informe*. Rather than assigning a definite quality to the informe, Bataille ascribed a function to it: to subvert formal categories and to thereby undermine categorical thinking. In the "dictionary" published in *Documents* in serialized form, he wrote under the entry for *informe*: "to affirm that the universe resembles nothing and is formless comes down to saying that the universe is something like a spider or a blob of spit" (Bataille, *Documents* 1, no. 7, p. 382). Further explaining the concept, he said "to make the academics happy, the universe must take on form. The whole of philosophy has no other aim but to put what is into a frock coat" (p. 382).

**INSTITUTION** A term used by Michel FOUCAULT and others to designate an APPARATUS that regulates DISCOURSE, with powerful effects. (See DISCOURSE ANALYSIS.)

**INSTITUTIONAL CRITIQUE** A critical tendency in recent art and art criticism, inspired to an extent by the WORK of Michel FOUCAULT, to articulate the relationships of cultural INSTITUTIONS to political and economic POWER. Championed by critics of the so-called *OCTOBER* GROUP, such as Rosalind Krauss, Douglas Crimp, and Benjamin Buchloh, the artists involved in this project include, among others, Louise Lawler, Hans Haacke, Michael Asher, Daniel Buren, and Andrea Fraser.

**INSTRUMENTALISM** A critical position on the arts that expects or requires art to be a means for some end other than itself is called "instrumentalism." Prominent examples of art as an instrument include art therapy and art used for religious purposes. In MODERNISM the instrumentalist position often took on a more PRESCRIPTIVE tone, and specifically required art to document the living and working conditions of a society and/or to incite a change in those conditions. In other words, instrumentalism became in MODERNISM the view that art should have a social function, inspire revolution or radical social change. This position on the arts, in many ways exemplified by Meyer Schapiro's "The Social Bases of Art" (1936), stands in contrast both to the FORMALIST position and to the more common EXPRESSIONIST position, since exclusive attention to FORM and overly self-centered SUBJECT matter distract attention from social problems.

**INTELLIGIBLE BODY** See DISCIPLINE.

**INTERDISCIPLINARY** There are two ways in which a study can be said to be interdisciplinary: first, when it includes methodologies from other disciplines, and second, when it includes topics of study from various disciplines. Interdisciplinary approaches to the history of art came to be common in the late 1970s, with the application of LITERARY THEORIES of various stripes to the study of art. Another result of interdisciplinary studies was the gradual realization that POPULAR CULTURE was worthy of serious consideration by scholars. This

was partly because of the ways in which SEMIOTIC THEORY, as one example, could be applied to any SUBJECT without altering its principles in any significant way.

**INTERFERENCE**  See DEFAMILIARIZATION.

**INTERPELLATION**  The French social theorist Louis ALTHUSSER combines SEMIOTICS, LACANIAN PSYCHOANALYSIS, and Marxist THEORY in his examination of IDEOLOGY. To ALTHUSSER, IDEOLOGY is not merely the "false shadow" of material-economic processes, but a necessary social function in everyday life. IDEOLOGY, ALTHUSSER claims, represents the "imaginary relationship" of individuals to their "*real* conditions of existence." IDEOLOGICAL STATE APPARATUSES (ISAs)—the family, the professions, schools, museums, the courts, film and television, newspapers and magazines, and advertising—constitute individuals as SUBJECTS through "interpellation" or "hailing," through which IDEOLOGY addresses itself directly to a SUBJECT. In this "hailing" we recognize ourselves as SUBJECTS by acknowledging our interpellation. IDEOLOGY operates through what ALTHUSSER calls a "mirror-STRUCTURE"; that is, IDEOLOGY is aimed at and centered on the SUBJECT. IDEOLOGY is more than mere "falsities" masking the "real." It is also a material system of social practices that have effects on individuals, providing them with their social identities and positions. In this way IDEOLOGY "naturalizes" otherwise ARBITRARY social arrangements.

**INTERSUBJECTIVITY**  A term used to describe something similar to interpersonal, that is, social. The specific CONNOTATIONS of this term for contemporary theorists include the notion that the SUBJECTIVITY of many individuals is produced by common forces.

**INTERTEXTUALITY**  A relation between two or more TEXTS in which one TEXT is echoed or included in another TEXT. This is accomplished by a repetition of part of one TEXT in another. In literature intertextuality is exemplified by Shakespeare's use of common songs and limericks in his plays. Intertextuality is more commonly called QUOTATION and/or APPROPRIATION in the visual arts. In Picasso's famous painting *Guernica*, for example, there is a repetition of FIGURES from Goya's *Third of May, 1804*.

**IRONY**  Usually, irony is the perception of an inconsistency between the ostensible meaning of an otherwise straightforward statement and the rhetorical FORM or contextual conditions of the statement. The result is often humorous. Sarcasm, for example, uses verbal language in such a way as to produce a conflict between what is said and what is really intended. Other methods of producing irony include the use of certain FIGURES of speech, a conflict between the narrator and the events narrated, or a feigning of ignorance for the eventual purpose of persuasion. The inconsistencies of ironic language are related to DECONSTRUCTION. As such, DECONSTRUCTION, or POSTSTRUCTURALIST THEORY in general, is often described as META-IRONY.

# J

**JOUISSANCE** Brought into widespread use in literary and CULTURAL STUDIES by Roland BARTHES, *jouissance* has been understood as signifying PLEASURE, joy, and enjoyment, with SEXUAL overtones. In addition, the term signifies a reader's pleasurable involvement with a TEXT that becomes so intense that the READER loses all self-awareness, as well as all objective distance from a TEXT.

# L

**LACAN/LACANIAN** Lacanian THEORY has been informed by the ideas of French psychoanalyst Jacques Lacan (1901–1981). Lacan's ideas have proved particularly influential in women's studies, especially in French feminist THEORY as practiced by Hélène Cixous and Luce Irigaray and in FEMINIST FILM THEORY. Adding the SEMIOTIC THEORY of Ferdinand de Saussure to the ideas of Freud, Lacan posits that STRUCTURES of the UNCONSCIOUS manifest themselves symbolically in language. But Lacan differs from Saussure, the father of SEMIOTIC THEORY, in his belief that the SIGNIFIER and the SIGNIFIED do not bear a fixed relationship, but instead shift. He differs from Freud in that he does not view DESIRE as a sexually driven biological force, but instead as expression of a drive toward a unity of being that is ultimately unattainable. Lacan's THEORY of the MIRROR STAGE has proved particularly influential in the area of FEMINIST FILM THEORY and in much visual art that has drawn on FILM THEORY (see MIRROR STAGE, and FEMINIST FILM THEORY). Visual artists who have produced WORK with a basis in FILM THEORY include photographers Cindy Sherman, Sylvia Kolbowski, and Victor Burgin.

**LACUNAE** Any missing element or gap in a TEXT or argument. This term is often used literally, to indicate a missing part of a written or printed manuscript, but is also used figuratively to refer to missing elements in an argument or a gap produced by a DECONSTRUCTION.

**LANGUE AND PAROLE** Ferdinand de Saussure made a distinction between *langue* and *parole* that was to become important in the formulation of STRUCTURALIST SEMIOTICS in France. *Langue*, which is roughly translatable into English as "language," was considered by Saussure to be the total abstract system and shared rules of a language. *Parole*, roughly translatable as "speech," is any actual use of the rules of language in particular utterances. Instances of *parole* can be various, but they are made possible by *langue* and are confined to the limits it sets up. To Saussure, *langue* is the social bond between members of a given community, existing both within the brains of individuals and within the

collectivity. It represents the various CONVENTIONS of the use of language at work in a society, and so has been considered by many theorists as an IN-STITUTION. *Langue* is to Saussure the proper object of the study of linguistics.

In the visual arts, *langue* finds a rough equivalent in some FORMALIST notions of art. According to this view, the total systematic use of a few conventionalized formal elements—line, color, shape, mass, and so on—can result in a great variation of specific art objects. Another example of an equivalent of *langue* in the visual arts is that of various artistic CONVENTIONS, like perspective. A particular system of perspective—for example, one-point perspective—can be used in many different paintings to depict a great number of different scenes. Some art critics and art historians study various art objects with an eye to explaining the workings or origins of what has been called "visual language."

**LEGITIMACY**  Michel FOUCAULT and other recent theorists have investigated the ways in which some actions and discourses gain the status of valid, true, and permissible, while others do not. Those INSTITUTIONAL qualifications that confer legitimacy are important to critiques of the arrangements of POWER in society because they can be used as tools in rearrangements of POWER relations.

**LIBERAL FEMINISM**  See FEMINISM.

**LINGUISTIC PARADIGM**  In general, this term refers to a number of theoretical developments in the SEMIOTICS of linguistics that have also been applied to other areas in the arts and humanities as if they were another system of linguistic SIGNS. Examples include BARTHES'S analysis of fashion and LACAN'S claim that the UNCONSCIOUS is structured like a language.

**LITERARY THEORY AND CRITICISM**  The phrase "literary theory" refers to a much larger set of ideas than those dealing with literary works in a strict sense. Literary theory refers to a large area of THEORY that may have had its beginnings in literary studies in a strict sense, but that eventually came to be applied to cultural production in general and to problems like GENDER, politics, art objects, and even music. Literary theory in this broad sense can be understood as SEMIOTICS, DECONSTRUCTION, DISCOURSE ANALYSIS, PSYCHOANALYTIC THEORY, MARXIST THEORY, CULTURAL STUDIES, FILM THEORY, RECEPTION THEORY, and theories of GENDER and ETHNICITY.

**LOGOCENTRISM**  A term used by Jacques DERRIDA to indicate a traditional preference in European thought, exemplified by STRUCTURALIST SEMIOTICS, for the *Logos*, PRESENCE or CENTER—that which fixes meaning but is at the same time outside of REPRESENTATION. *Logos* can simply mean "word," but it also often denotes an ultimate principle of TRUTH or meaning, such as The Word of God, TRUTH, Man, and so on. Logocentrism, also called "the metaphysics of presence" by DERRIDA, has resulted in the subservient position of writing to speech and a repression of DIFFERENCE in favor of sameness. See also DE-CONSTRUCTION, PHONOCENTRISM, PHALLOCENTRISM, and PHALLOGO-CENTRISM.

**LOGOS**  See LOGOCENTRISM.

# M

**MALE GAZE** The idea of a male gaze that is constructed through the filmic practices of mainstream NARRATIVE cinema has been the SUBJECT of much speculation by feminist cultural theorists. The phrase is used extensively by Laura Mulvey in her essay "Visual Pleasure and Narrative Cinema," published in 1975 in *Screen*, an influential British journal on contemporary CULTURE. The term designates the tendency of Hollywood film toward a REPRESENTATION of women in such a way as to heighten the SEXUAL or erotic aspects of the women's bodies. Further, the combination of NARRATIVE and SPECTACLE (the functions of telling and showing) reflect a system of SEXUAL imbalance in which the male is the active SUBJECT and the female is the passive object. The female BODY acts as the FETISHIZED object of the male gaze, and those in the audience necessarily take on the role of masculine VOYEUR. Mulvey theorizes that Hollywood conventions of cinematic practice construct the GAZE as male. As Mulvey phrases it, the appearance of the woman's BODY is CODED for visual and erotic impact so as to connote a "to-be-looked-at-ness." Typically, the implied view of the male spectator is provided to all viewers via the lens of the camera, with examples often cited in Alfred Hitchcock's *Rear Window, Birds,* and *Vertigo,* among others. (See FEMALE GAZE and FEMINIST FILM THEORY.)

**MARGINALITY** Its use originating in LITERARY THEORY, marginality refers to the position of those individuals who are excluded from majority CULTURE. In its early usage in MODERNIST LITERARY CRITICISM, it referred to individuals whose nationality or social status made them outsiders and, thus, offered them a position from which a critique of DOMINANT CULTURE was most feasible. More recently it has been used by feminists to describe the position of women, who have traditionally been forced to operate from the margins of those CULTURES of which they are members. It has also found currency in the writings of scholars working in POSTCOLONIAL THEORY and MULTICULTURAL studies as a term DESCRIPTIVE of the social and cultural status of COLONIALIZED peoples, minorities, and those of the lower classes.

**MARXIST LITERARY THEORY AND CRITICISM** Different but interrelated positions can be roughly grouped under the heading of Marxist literary theory and criticism. In general Marxism is a form of MATERIALISM, and is therefore concerned with the historical problem of the struggle for the control of the material conditions on which life depends. To Marxists, the ways in which problems of individuals are defined, as well as the ways in which solutions are formed, are all limited by IDEOLOGIES that develop through such struggles and IDEOLOGIES mask the true nature of the struggles. To Marxist theorists, IDEOLOGIES (superstructure)—which includes mental images, imagination, ideas, beliefs, philosophies, art and literature—are secondary to material conditions (BASE). As a result, many Marxist critics have sought to understand the formative POWER of the material conditions of a society on literary and artistic products.

One way of grappling with the relation between material conditions and the arts is to show how the economic and industrial BASE of a society is "reflected" in the arts of that society. In addition, critics have approached the arts in order to gain a greater understanding of, as well as to criticize, how the arts have been used as APPARATUSES that mask the true nature of the conditions of existence. In that vein, much Marxist THEORY and criticism takes a DIALECTICAL or oppositional stance to existing social arrangements, leading many Marxist writers and critics to use literature and its history as a means to change the ARBITRARY arrangements of social CLASS and the control of the material conditions of existence. Marxism and Marxist THEORY and criticism have generally neglected various topics that are not strictly economic in nature, such as GENDER, age, ethnic differences, indigenous peoples, and environmental degradation. MARXIST FEMINISM has been one of the responses to that neglect.

In the practice of art history, there have been several writers working from this generally Marxist vein. Meyer Schapiro had a long history as an investigator into the relationships of CLASS and the arts, as have other historians like T. J. Clark and Griselda Pollock. Although not usually considered art historians, Pierre Bourdieu and Terry Eagleton have also dealt with the problem of aesthetics and CLASS in their WORK.

**MARXIST/SOCIALIST FEMINISM** See FEMINISM.

**MASCULINE DESIRE** Masculine desire has played a role in recent cultural THEORY, primarily through debate engendered by FEMINIST FILM THEORY. Feminist film theorists regard mainstream cinematic practices as expressive of masculine desire because they produce an active masculine viewer whose voyeuristic GAZE positions women as passive objects. (See FEMINIST FILM THEORY, MALE GAZE, FEMALE GAZE, and DESIRE.)

**MASQUERADE** See FEMININE MASQUERADE.

**MASTER NARRATIVE** A master narrative is any MYTH or set of MYTHS that is constitutive of the story—or history—a CULTURE creates regarding its origins, beliefs, social structures, and so on. Master narratives tend to naturalize such social conditions and beliefs, that is, they make dominant social structures seem natural and necessary. In addition, master narratives always reflect the be-

liefs and concerns of majority CULTURE, of those groups that hold greatest POWER. With the rise of MULTICULTURALISM, the art world has served as a SITE of resistance to master narratives, a SITE for the intervention of "little NARRATIVES" that tell the stories of groups marginalized by majority CUL-TURE. Artists of color and ethnic minorities have produced counter-NAR-RATIVES, which work to expose the contingent, rather than necessary and natural, nature of master narratives.

**MASTERY**  Recent feminist critiques of psychoanalysis have taken up the issue of mastery. Freud attempted to cure neurosis by leading the patient to formulation of a unified, coherent life's story. He believed in the healing capacity of storytelling—the "talking cure." Through talking, through bringing the contents of the unconscious to the conscious level, normalcy is achieved. Defining the sign of neurosis in individuals as the "inability to give an ordered history of their life," Freud's goal in the treatment of hysteria waas to achieve "an intelligible, consistent, and unbroken case history" (Freud, *Dora*, p. 32). Freud felt that he had failed in the case of one of his patients, Dora (the object of analysis in his publication of 1905, *Dora: An Analysis of a Case of Hysteria*), because she left treatment befor he had achieved resolution. Freud felt that this failure was due to his inability to master the process of transference (the transfer of the pataient's feelings about a parent to the analyst). As pointed out by recent criticis of Freud's methods, however, his feelings of failure may have resulted from his inability to "master" Dora's story, to find one coherent interpretation of her experience.

Susan Rubin Suleiman gives a summary and analysis of related ideas concerning women and psychoanalysis in "Love Stories: Women, Madness and Narrative." She covers a number of the most interesting recent analyses of Freud's treatment of Dora, including Donald Spence's *Narrative Truth, Historical Truth: Meaning and Interpretation in Psychoanalysis*, Steven Marcus's "Freud and Dora: Story, History, Case History," and the articles collected by editors Charles Bernheimer and Claire Kahane in *In Dora's Case: Freud-Hysteria-Feminism*.

In her installation of 1984–89, *Interim*, Mary Kelly incorporates psychoanalytic discourse through reference to early formulations of hysteria in a critique of the foundations of psychoanalysis and its definition of individual identity and subjectivity. Commenting on Freud's attempts to cure neurosis through assisting the patient in forumlating a coherent life's story, Kelly presents women's lives as fragmented and lacking in overall coherence. She presents the formation of self-identity as a process akin to intertextuality. There is no single, coherent "text" to an individual life—there are, rather, many stories in each individual case. Kelly's work constitutes a feminist critique of a culture that is constantly telling women who they should be, what they should be, and that the stories of their lives should cohere and conform to preconceived ideas.

**MATERIAL BODILY PRINCIPLE**  Russian linguist Mikhail Bakhtin developed his concepts of the CLASSICAL and GROTESQUE BODIES in *Rabelais and His World*, a study of the sixteenth-century French writer Rabelais. Bakhtin regards Rabelais's images as deriving from an aesthetic of folk culture, which is characterized by a "material bodily principle" that finds expression in grotesque

realism.   In the tradition of grotesque realism all things bodily become grossly exaggerated, exceeding all normal and proper limits. (See GROTESQUE.)

**MATERIALISM**   Usually associated with Marxist theory and criticism, materialism is a predisposition to the study of the arts that stresses economic and productive activities rather than subjective or idealistic concerns.

**MATERNAL BODY**   In the psychoanalytic theory of Julia Kristeva the maternal body is given up when the child takes up the position of speaking SUBJECT and enters the SYMBOLIC. In *Powers of Horror: An Essay on Abjection,* Kristeva posits that the maternal body in the state of pregnancy threatens fundamental distinctions between subject and object, self and OTHER. Consequently, it is identified as ABJECT.

**MEANING AND SIGNIFICANCE**   The terms meaning and significance have become important ones in recent criticism. Meaning was once thought to be a property of an object or literary work, as in the phrase "that painting has meaning." It was widely assumed and even theorized that meaning somehow "resided in" a work or "belonged to" a work in some important way. In more recent theory, especialy SEMIOTIC theory and discourse analysis, "meaning" has been replaced by "significance," and is considered as the result of a social process rather than as a property of an object, albeit bestowed upon it by an artist.

**MEDIA STUDIES**   An imporant activity for recent theorists, especially those operating at the BIRMINGHAM SCHOOL OF CULTURAL STUDIES, the study of mass media and popular culture in general is seen as a way to guage the ways in which power is distributed throughout society. Taking a generally Marxist view, mass media, an apparatus of illusion, is the means by which idelogy is distributed.

**MEDIATION**   According to traditional thought, the experience of an object is said to be mediated if one experiences a REPRESENTATION of that object. It is as if the REPRESENTATION comes between the object and the viewer. Immediate experience has always been preferred to mediated experience, with the implicit value placed on the "real" or "original" object. Recent THEORIES of REPRESENTATION such as POSTSTRUCTURALIST SEMIOTICS have put into question the preference of immediate experience, primarily by demonstrating that what we take to be immediate experince is not representable to others without mediating it somehow, and therefore contradicting the value of immediate experience. Some theorists, like Jean Baudrillard, have gone so far as to suggest that immediate experience is not possible.

**METACRITICISM**   Very simply, a criticism of criticism. In recent years, the criticism of past criticism has been an important contribution to literary studies. Many criticis and theorists have written lengthy responses to previous scholarship on various topics in order to demonstrate tye shortcomings of some scholars and the advantages of thier own approach. In this way a whole genre of critical studies has developed, consisting of the study of the history of criticism.

**METAFICTION**  See MISE-EN-ABYME.

**META-IRONY**  See IRONY.

**METALANGUAGE**  Technically, metalanguage refers to the ability to use language to speak about language. Similar to metacriticism, it is the function of language that allows for the study of language, as exemplifieed by SEMIOTICS.

**METANARRATIVE**  A narrative that refers to another narrative or other narratives. This has a similar relationship to language usage as do METACRITICISM and METALANGUAGE and is criticial for the study of language.

**METAPHOR**  A figure of speech or TROPE consisting of two parts (traditionally called tenor and vehicle) expressing and creating a relation of comparison between two similar but ordinarily unrelated elements—for example, "life is an adventure." As such, metaphor operates through paradigmatic substitution, unlike metonymy. In the visual arts, critics often speak of art objects in metaphorical terms when they say make statements like "that painting is strong," or "it stands on its own." These phrases are ususally not meant literally (although we usually do not give them a second thought), but refer to qualities such as the formal organization of the work or the emotional impact on the viewer.

**METONYMY**  A figure of speech or trope that substitutes the name of one thing with the name of another thing closely asociated with it—for example "hand" instead of applause and "suit" instead of banker or businessperson. As such, metonymy operates through syntagmatic substitution, unlike metaphor.

**MIMESIS**  A term referring to the practice of representation that seeks to create a likeness of an original as accurately as possible. The mimetic approach to painting and sculpture was attacked fiercely by MODERNISTS in favor of a more abstract mode of REPRESENTATION, which they viewed, in a quasi Platonic vein, as more appropriate to the REPRESENTATION of TRUTH.

**MIRROR STAGE**  French psychoanalyst Jacques LACAN (1901–1981) revised Freud through SEMIOTIC THEORY by centering his THEORIES of the SUBJECT and PSYCHOANALYSIS on language. Since an analyst works with a patient's statements and repeated (ENCODED) behaviors, signs are really all that is available to him/her. As a child develops the ability to use language (SIGNS), the child becomes socialized. In his "rewriting" of Freud, LACAN introduced several important concepts into PSYCHOANALYTIC DISCOURSE, which are useful to those interested in the processes of socialization, especially GENDER formation. On such concept is the Mirror Stage.

The Mirror Stage of early life, as theorized by LACAN, can be briefly explained as follows. Typically, between the ages of six and eighteen months, the human infant becomes fascinated with its own mirror image. Self-recognition as well as recognition of the OTHER through the mirror occur in three stages. First, the child, held by an adult in front of the mirror, confuses its image with that of the OTHER person. Second, the child comes to understand the nature of images;

it comes to recognize the difference between the mirror's reflection and the objects or persons reflected. Third, it recognizes not only the reflection as its *own* image, but also the DIFFERENCE between its image and the image of the OTHER. The child comes to view its BODY as a totalized whole; it also experiences, however, a sense of alienation (or what some characterize as fragmentation) because the image is external to it. This process, whereby the child comes to perceive itself as distinct from others, need not literally involve a mirror. Various social conditions and processes function as "mirrors" and serve to facilitate the Mirror Stage. These include other people's voices, their reactions to the child's voice or actions, and so on In the Mirror Stage as described by Lacan the dhild makes transition from the realm of the IMAGINARY to the SYMBOLIC. Passage through the Mirror Stage acompanies entry into the realm of language.

Mary Kelly is a contemporary artist who has used LACANIAN THEORY in her work. Most notable is her use of LACAN'S concepts of the IMAGINARY, THE REAL, THE SYMBOLIC, and the Mirror Stage in *Post-Partum Document*, an installation that deals with the birth and early childhood of her son and her relationship to him.

**MISE-EN-ABYME**   From the French, meaning "throwing into the abyss." Also called METAFICITON, this term refers to the infinite regress created by the internal reduplication of a TEXT, that is, the repetition of part of the TEXT inside itself.

**MISE-EN-SCÈNE**   In French, literally: "having-been-put-on-stage."   In FILM THEORY and criticism, this usually refers to that part of the cinematic process that takes place on the set (as opposed to editing or MONTAGE which takes place afterwards). It also refers to the director's control over what appears within the film FRAME. Cinematic mise-en-scène includes aspects that overlap with the art of theatre: setting, props, costumes, make-up, lighting, the movement of the FIGURES, and spatial coordinates.

**MISPRISION**   See MISREADING.

**MISREADING**   Also called misprision, misreading describes an intentional distortion of a TEXT for the purposes of criticism. The purpose is not to make a certain type of criticism more tenable, but to show that it is possible for all TEXTS to be misread and "misunderstood," thereby proving the inability of language to operate in ways that can secure meaning once and for all. Misreading, intentional or otherwise, can be a productive way to create new understandings.

**MODERNISM**   Traditionally, "modern" meant current, up-to-date, and new. Recent changes in art THEORY and criticism, however, have been so extensive and so fundamental—and the resulting significant differences so outstanding—that it now seems to many critics and theorists that "modern" is best replaced by "modernism," and best understood as a particular era or epoch of history, the vital development of which has ceased or culminated. Dates used for the beginning of modernism vary—from the 1400s in Italy, 1789, 1848, or the 1860s in France, and 1918 throughout Europe—but there is more general agreement on the dates of the end, culmination, or zenith of modernism—the 1960s and 1970s.

It is generally agreed that modernist CRITICAL THEORY in the visual arts was based on the assumption that art is a creative and expressive activity, resulting in unique and original objects. Critical positions, however, are more specific and are often understood as requirements or expectations of art. There are three major critical positions on art that are now seen as especially modernist: the EX-PRESSIONIST, INSTRUMENTALIST, and FORMALIST positions. EXPRES-SIONISM expects art to communicate in some fashion the feelings and emotions of the artist and to evoke feelings in the viewer. INSTRUMENTALISM requires art to be a tool or instrument for some other end, most commonly social change. Finally, FORMALISTS attend exclusively to visual and technical aspects of the art object, sometimes requiring art to be produced in such a way that it refers to nothing other than itself. Most statements on art can fit into one or another of these three categories, although most people understand art from a combination of them. Within each of these positions many other themes or topics enter discussions on art. Primitivism, for example, is often involved in discussions of EXPRESSIONST painting and sculpture. Progress is implicitly or explicitly linked to a TELEOGOCIAL model of the history of art from the FORMALIST point of view. Taken as a whole, modernist CRITICAL THEORY, joined with not too dissimilar art historical methodologies and many unspoken restrictions and prejudices, was in large part responsible for the shape of the modernist CANON.

**MONTAGE**   French for "assembling" or "putting together." In film editing, this usually refers to traditions outside the CONTINUITY system (for example, the Soviet cinema of the 1920s). In Hollywood films, montage sequences (sequences compressing historical events, newspaper headlines, and so on) usually stand out by contrast to the dominant CONTINUITY style of editing.

**MOTIVATED/UNMOTIVATED** See SEMIOTICS.

**MULTICULTURAL(ISM)**   Multiculturalism concerns indigenous, ETH-NIC, and minority CULTURES that have been marginalized by other, DOMINANT CULTURES. Its foremost task is encouragement of cultural DIVERSITY. In the United States, multiculturalism developed as a reaction and a form of resistance to cultural HEGEMONY, which naturalized the dominance of Euro-Americans over all other cultural groups. Heterogeneity and the transformation of constraining INSTITUTIONAL structures and practices are among the goals of multiculturalism.
THEORIES regarding the cultural OTHER have formed a major concern of multicultural studies in the United States, most commonly concentrating on African Americans, but also on Native Americans, Hispanics, and Asian Americans. One sees a concern with visual REPRESENTATION of African American women as early as 1987, in the writing of Michele Cliff. But is is not until the early 1990s that such writing begins to flourish, as seen in the criticism of Lorna Simpson's work by bell hooks and the art criticism and cultural THEORY of Michele Wallace. Although hooks had been a frequent contributor to *Artforum* throughout the early 1990s, her first book devoted to critical writing on visual art, *Art on My Mind: Visual Politics*, was not published until 1995. Trinh T. Minh-ha's *Woman, Native, Other*, one of th few art critical writings on Asian American women, appeared in 1989 and was followed by the same author's *When the*

*Moon Waxes Red* in 1991. Critical writing on Hispanic artists and/or by Hispanic writers has been minimal, but it shows signs of growing vitality in the writings of Amalia Mesa-Bains and Coco Fusco, particularly significant are Fusco's recently published *English is Broken Here: Notes on Cultural Fusion in the Americas* (1990) and her essay "Passionate Irreverence: The Cultural Politics of Identity" for the catalog to accompany the highly controversial 1993 Whitney Biennial Exhibition. Native American artists who work in a contemporary rather than a traditional vein have received relatively little representation in the multicultural surge of the 1990s. Mention of Native American women artists and writers is even more difficult to find. Kay Walkingstick, an artist and writer of Cherokee descent, has written on contemporary Native American art for *Artfourm*, while Jaune Quick-to-See Smith co-authored an exhibition catalog, *Women of Sweetgrass, Cedar, and Sage*, to accompany what remains the best known and most highly regarded show of work by Native American women. A number of native artists are represented in Lucy Lippard's *Mixed Blessings: New Art in a Multicultural America*, a 1990 publication that has proved the most comprehensive source to date on contemporary American artists of color. (See OTHER, POST-COLONIAL, COLONIALISM/COLONIALIZED, HYBRIDIZATION, DIVERSITY, and RACE/RACISM)

**MULTIVALENT** When a WORK of art has a number of possible interpretations it is said to be multivalent.

**MYTH** According to the SEMIOTIC THEORY of Roland BARTHES, a myth is a particular type of speech. Myth arranges SIGNS so that they become signifiers in a larger system of SIGN usage. Thus myth is a kind of dense and compounded SIGN that is so far removed from its existence as a SIGN that it takes on the POWER of TRANSPARENT and naturalized DISCOURSE. The extent of the use of SIGNS as SIGNIFIERS constitutes a layering of myth, what BARTHES calls ORDERS OF REPRESENTATION.

# N

**NARRATION** The act of telling a STORY, or the description of action, by a character or a narrator.

**NARRATIVE** The representation of a chain of events in cause-effect relationship, occurring in time. A narrative has two basic aspects: STORY and PLOT.

**NATRURALIZING/NATURALIZATION** A DISCOURSE is said to be natural or naturalized when the producer of that DISCOURSE appeals to nature (or the "real") in some way so as to lend persuasiveness to that DISCOURSE. To use nature as a foundation for an argument is a powerful strategy, since the existence and solidity of the natural world is difficult to deny. Recent LITERARY THEORISTS such as Roland BARTHES, Jacques DERRIDA, and Michel FOUCAULT, and many feminist critics, however, have noted that the rhetorical strategy of appealing to nature often has the unexpected and contradictory effect of exposing the ways in which nature becomes a figure of speech in a TEXT rather than the firm reality assumed to exist outside the TEXT. As such, a TEXT can produce its own semse of estrangement from nature, defeating its original purposes. Attempting to point out the incongruities between DISCOURSES and "the real world" can be a very effective tool for the criticism of powerful INSTITUTIONALIZED DISCOURSES.

**NATURE/CULTURE DEBATE** In her influential essay of 1974, "Is Female to Male as Nature is to Culture?" Sherry Ortner posits that women are universally identified with nature and men with CULTURE. This identification is seen as the source of women's oppression and inferior status, since nature is associated with beings at lower levels of existence, who have not altered their environment through the agency of CULTURE. Women's reproductive function, in Ortner's view, causes them to be involved in species-level functions, and thus causes their identification with nature rather than CULTURE. Recent responses to Ortner's THEORY have criticized her tendency to engage in BINARY distinctions, excluding from consideration those CULTURES (such as some Native American

CULTURES) that show less concern with differentiating and classifying individuals along the clearcut lines of a male/female BINARY division. Those who have been most critical of her argument include Catherine Lutz, Nicole-Claude Mathieu, Jane Fishburne Collier, and Sylvia Yanagisako.

**NEGOTIATION**   The idea of negotiation as used in recent CULTURAL STUDIES denotes action that takes place within the structural constraints of POWER but, at the same time resists such constraints. Negotiation involves both acting within the parameters set by social constraints and simultaneously developing and using strategies to subvert domination and control.

In the field of MEDIA STUDIES, Stuart Hall has developed the idea of the negotiated CODE. He asserts that the majority audience views and understands television via a set of CODES that derive from the GRAND NARRATIVES of majority CULTURE. The viewers' interpretation of what they see and hear is consonant with the HEGEMONIC viewpoint, which "defines within its terms the mental horizon, the universe, of possible meanings, of a whole sector of relations in a society or culture" and "carries with it the stamp of legitimacy—it appears coterminous with what is 'natural', 'inevitable', 'taken for granted' about the social order" (Hall, p. 102). The viewers' decoding of what they view via a negotiated CODE combines oppositional and adaptive elements. It "acknowledges the legitimacy of the hegemonic definitions to make the grand significations (abstract), while, at a more restricted, situational (situated) level, it makes its own ground rules—it operates with exceptions to the rule" (Hall, p. 102).

The WORK of a number of contemporary visual artists who have incorporated mass media imagery and TEXT into their artwork, such as Barbara Kruger and Jenny Holzer, may be seen as exploration of the functioning of such negotiated CODES. Both Kruger and Holzer incorporate reference to the GRAND NARRATIVES of Western CULTURE, while, at the same time, they resist by mixing up and slightly altering the CODES, both visual and verbal, that operate in media CULTURE.

**NEO-CONSERVATIVE**   In the visual arts the term neo-conservatism has a meaning not dissimilar to its use outside the art world. In general, neo-conservatism in the arts refers to an artistic and/or critical position that is consistent with MODERNIST cultural values, for example, EXPRESSION, ORIGINALITY, and FORMALIST critical criteria. The rise of American Neo-Expressionist painting in the late 1970s and early 1980s, coming along as it did with the rise of a generalized political neo-conservatism, prompted many critics writing from a more or less Marxist viewpoint to wonder about the ideological consistencies between the two. Hal Foster, in his critique of what he termed "the expressionist fallacy," asserted that the resurgence of EXPRESSIONIST figurative painting was a result of the neo-conservative trend in the nation as a whole.

**NEW ART HISTORY**   See REVISIONIST ART HISTORY.

**NEW HISTORICISM**   See REVISIONIST ART HISTORY.

**NEW MUSEOLOGY**   See REVISIONIST ART HISTORY.

**NEW WESTERN HISTORY**  See REVISIONIST ART HISTORY.

**NOMADOLOGY**  See NOMADS.

**NOMADS**  In the writings of Gilles DELEUZE and Félix GUATTARI, the figure of the nomad is used to describe how the BODY WITHOUT ORGANS (BWO), the SUBJECTITIVITY that remains after the POSTSTRUCTURALIST disorganization of the body, keeps moving and circulating in a constant process of reforming and transforming itself. The nomad is free of all roots—preferring RHIZOMATIC to ARBORESCENT models of thought—all identities, and can therefore resist and perhaps even subvert the state and all normalizing powers and fixed forms of fascist subjectivity found in modernity (see Deleuze and Guatarri, *A Thousand Plateaus*, 1987).

**NORMALIZING DISCOURSE/NORMALIZATION**  Normalizing discourses work to induce individuals to conform to a social standard. In the THEORIES of Michel FOUCAULT, normalizing discourse operates through disciplinary power. FOUCAULT conceives of disciplinary POWER not as a form of repression that is imposed from the top down, on one group by another, but as a force operative through a network of discourses—INSTITUTIONS, practices, technologies, and so on—that serves to produce positions of dominance and subordination within specific contexts.

An example of normalizing discourse is fashion photography, which operates through images of women that produce a normative femininity to which SUBJECTS feel constrained to conform. One artist who deals with such normalizing discourse is Jana Sterbak. In publicity photographs and art magazine reproductions of *Vanitas: Meat Dress for an Albino Anorectic* (1987), a sculpture consisting of sixty pounds of uncooked flank steak sewn together to form a dress, Sterbak invokes the DISCOURSE of fashion photography. In such photographs the dress is worn by an attractive young model in a post characteristic of high fashion imagery so as to evoke the DISCOURSE of fashion photography, in which the female BODY is offered as the SPECULAR object of the MALE GAZE.

# O

**OBJECTHOOD**  According to the American art critic Michael Fried, object-hood is the condition of non-art, since a WORK of art is in some essential respect not a *mere* object. To Fried, minimal art is a prime example of objecthood, since if not for the THEATRICAL circumstances in which minimalism finds itself, much of it could be mistaken for an object. Minimal art has a PRESENCE, like all objects do, but lacks the PRESENTNESS of MODERNIST art.

**OBJECTIFICATION**  In terms of FEMINIST FILM THEORY, the cinematic GAZE objectifies the female BODY. In classical Hollywood cinema, WOMAN, is denied the status of SUBJECT, functioning as the passive object of the active MALE GAZE. (See FEMINIST FILM THEORY.)

**OBJECT OF DESIRE**  According to feminist film theorists, Hollywood conventions of cinematic practice construct the GAZE as male. The female BODY acts as the FETISHIZED object of THE MALE GAZE, and those in the audience nec-essarily take on the role of masculine VOYEUR. Further, the combination of NARRATIVE and SPECTACLE (the functions of telling and showing) reflects a system of SEXUAL imbalance in which the male is the active SUBJECT and the female is the passive object of desire. (See FEMINIST FILM THEORY, MALE GAZE, FEMALE GAZE, and DESIRE.)

**OBJECT RELATIONS THEORY**  Child psychologist Melanie Klein's Object Relations Theory positions the child's relationship to the mother's breast as central to childhood development. This puts Kleinian THEORY at odds with traditional PSYCHOANALYTIC THEORY, which regards the relationship to the fa-ther, enacted in the Oedipal drama, as central to development. In a 1992 photo-graph titled *Version.* Canadian artist Kati Campbell shows a child breastfeeding. An adult male hand intrudes from the upper register of the image, marking the mother's breast, the child's source of gratification, as a point of contestation. Campbell's interest in Klein's THEORIES is also apparent in a video installation of the same year, titled *Battle of the Titans.* This WORK is composed of two

parts. The first consists of a wall-size projection of a 9–1/2 minute continuous loop video of Campbell dressing her two-and-a-half-year-old daughter. Two large cutout photo reproductions of Surrealist Hans Belmer's poupees, or dolls, revolve around the SCREEN on a metal track. In the second part of the installation, three video monitors mounted in a low, curved enclosure show tapes of Campbell's daughter watching the first recording being played back on a studio monitor. In the first tape the daughter's determined resistance to her mother's attempts to dress her serves as a METAPHOR for the child's difficult entry, via the mother, into the social realm. In the second, the child's obvious enjoyment at watching her resistance to her mother, alternating with her attempts to blot out her mother's image on the SCREEN, convey the feelings of ambivalence toward the mother that Klein has described as central to healthy development.

*OCTOBER* **GROUP**  A term used to refer to a number of historians, theorists, and critics published in the American journal *October*, including the founding editors Rosalind Krauss and Annette Michelson, as well as others like Hal Foster, Douglas Crimp, Laura Mulvey, Joan Copjec, Yve-Alain Bois, and Homi Bhabha. *October* is widely regarded as one of the primary vehicles for the introduction of contemporary THEORY and criticism to the American art world.

**OPAQUE**  See TRANSPARENT/OPAQUE.

**OPEN AND CLOSED TEXTS**  "Open texts" and "closed texts" are those TEXTS that are open (unlimited) or closed (limited) to interpretations. In an interesting turn of events, the Italian theorist Umberto Eco reverses these understandings. To him, open TEXTS are, ironically, those that aim at eliciting a precise interpretation. They are the TEXTS that will invariably provoke "aberrant" interpretations. The TEXTS that are usually considered "open," on the other hand, are not truly open. Their interpretations seem unlimited, but are actually closed, in the sense that there is a limit  to their interpretation (even if that limit is unknown as yet).

**OPPOSITIONAL READING**  A critical mode of reading. In this mode, the READER reads a TEXT with skepticism, reading "against the grain," or resisting the ostensible flow of the TEXT. (See NEGOTIATION.)

**ORDERS OF REPRESENTATION**  See MYTH.

**ORIENTALISM**  Orientalism is a technique of defining and asserting on the part of Europeans, through art, their cultural DIFFERENCE and superiority. Although many Europeans and Americans today think of China, Japan, Korea, or other countries in east Asia when they hear "the Orient," the term was applied in the nineteenth century to any peoples east of Europe, especially the what we now call the "Middle East." Orientalism is one of a large number of techniques involved in colonizing other lands and peoples. Orientalist WORK employs highly realistic REPRESENTATION, the presumed result of objectively accurate observation, in order to achieve an effect of truthful depiction of its SUBJECTS. Literary critic and POSTCOLONIAL theorist Edward Said originated the idea of Orientalism as used in contemporary THEORY in his 1978 book, *Orientalism*.

Art historians, such as Linda Nochlin, have recently made use of Said's ideas. In her "The Imaginary Orient," Nochlin examines the WORK of nineteenth-century French painter Jean-Léon Gérôme and explains how conventions of realistic painting contributed to various justifications of European IMPERIALISM.

**ORIGINALITY**   One of the highest-held values of MODERNIST CULTURE was originality. The term is generally used to designate two interrelated ideas. First, originality describes uniqueness, newness, and the "first." In that sense, to be original means to be different and on the cutting edge. The term "AVANT-GARDE" is often used in this sense. The second sense of originality concerns the origin or source of the WORK of art and refers to the creator-artist-genius. In this sense, the value of originality is the value of the individual creative human SUBJECT.

Recent POSTSTRUCTURALIST or POSTMODERNIST art  historians, theorists, and critics have questioned the status of notions of originality. Rosalind Krauss, in her essay "The Originality of the Avant-Garde: A Postmodernist Repetition," published in *October* in 1981, questioned the originality of MODERNIST AVANT-GARDE artists. Krauss noted the repeated use of the grid format among many MODERNIST artists throughout the twentieth century. Although many of these artists—such as Piet Mondrian, Joseph Albers, Ad Reinhardt, Sol Lewitt, and Agnes Martin—have been praised as "original," the repeated use of the grid is paradoxical, if not contradictory.

**OTHER**   In recent cultural THEORY, the concept of the Other differs significantly depending on whether the CONTEXT is Western CULTURE in general or PSYCHOANALYTIC  THEORY in particular. In THEORY informed by PSYCHOANALYSIS, the idea of the Other is drawn from LACAN and is used to designate those who are other than oneself and as such are necessary to the construction of the individual SUBJECT. In "On a Question Preliminary to any Possible Treatment of Psychosis," LACAN describes the Other as "the locus from which the question of [the individual subject's] existence may be presented to him" (Lacan, *Ecrits*, p. 172). The idea of the psychoanalytic Other is also commonly found in recent LACANIAN-based feminist THEORY, including that of French theorists Hélène Cixous and Luce Irigaray, who offer affirmation and celebration of woman's Otherness as a feminist strategy.

In *The Second Sex*, Simone de Beauvoir explains that Otherness is "a fundamental category of human thought" and that "no group ever sets itself up as the One without at once setting up the Other over against itself" (p. xxiii). Within this CONTEXT, woman is the Other, who, by her SEXUAL DIFFERENCE, serves to define the male as the universal SUBJECT. Speaking of those systems of belief that STRUCTURE Western philosophy and religion, de Beauvoir explains that "humanity is male and man defines woman not in herself but as relative to him; she is not regarded as an autonomous being." She explains further that woman is "defined and differentiated with reference to man and not he with reference to her; she is the incidental, the inessential as opposed to the essential. He is the subject, he is the Absolute—she is the Other" (p. xxii).

In the study of Western history and CULTURE in general the idea of the Other is applied to both the SEXUAL "Other," woman, and the cultural Other, the non-European or the person of color. The cultural Other has been taken up specifi-

cally by those working in the fields of POSTCOLONIAL THEORY and MUL-
TICULTURAL studies. Much as woman is identified in traditional Western sys-
tems of thought as Nature in contrast to man as CULTURE, non-Westerners are
identified as uncivilized, as existing closer to nature and thus at a lower evolu-
tionary level than Westerners (see NATURE/CULTURE DEBATE). Such position-
ing has served in many cases as a convenient justification for colonization. It has
served to support the reasoning of the colonizers, who believe that those peoples
they have conquered are the fortunate recipients of their benevolent care. As bear-
ers of the "White Man's Burden," they feel obligated to impose upon the inferior
cultural Other systems of thought, technologies, and ways of living that will, in
Western eyes, ultimately benefit them.

**OVERDETERMINATION**   This term was introduced in its current meaning
by French philosopher and social theorist Louis ALTHUSSER in the late 1960s.
ALTHUSSER added a social and political CONNOTATION to the Freudian concept
of a SYMBOL that is the result of several separate or related causes. For
ALTHUSSER, a social event, such as a revolution, can be understood as overde-
termined if it is the result of a range of social forces. This use of overdetermina-
tion is an alternative to simpler cause and effect explanations of social change.

# P

**PANOPTIC/PANOPTICON** See DISCIPLINE.

**PARALITERARY** In visual art, a term used by Rosalind Krauss in the journal *October* to describe those artists and critics whose works reflect in some way the concerns presented by LITERARY THEORY AND CRITICISM. She did not claim that artists and art critics were the same as their literary counterparts, but that some members in the art world were trying to deal with some parallel issues to those in the world of letters.

**PARODY/PARODIC** A mock imitation of style or technique, especially as part of a larger critique, parody often takes the form of an exaggerated mimicry. Parody has historically been seen as a parasitic form of creation, dependent as it is on previous and well-known literary, THEATRICAL, or artistic works and personalities. As such, parody in MODERNISM was often ignored by serious critics and artists. In more recent years, however, parody has come to be recognized as a new NARRATIVE type with a critical edge.

In recent GENDER THEORY, parody has taken on a particular significance, especially in the writing of philosopher Judith Butler. In *Gender Trouble: Feminism and the Subversion of Identity*, Butler develops a THEORY of GENDER as a PERFORMATIVE act. She explains how parodic PERFORMANCE can function as a form of resistance to culturally dominant SEX-based GENDER distinctions. Parody can be particularly valuable, she contends, in emphasizing and drawing attention to the DIFFERENCE between culturally dominant configurations of GENDER that are regarded as natural and ones that are flawed copies. Repetition of GENDER in parodic form reveals the illusory belief that IDENTITY based on GENDER originates from an inner depth or core of being.

**PAROLE** See LANGUE AND PAROLE.

**PASSING  PERFORMANCE**  In terms of GENDER study, a passing per-
formance occurs when an individual successfully creates the illusion that he/she
is of a GENDER which is contrary to his/her biological SEX.

**PASTICHE**  A term used primarily in criticism of POSTMODERN architecture
to describe the ways in which a number of different styles and/or ornamental el-
ements are combined in the design of a single building. Referring especially to a
lack of unification of disparate parts, the term is meant to call attention to the
"pasted together" look of the overall design.

**PATRIARCHY**  Patriarchy designates a system governed by men in which
POWER and authority are invested in the father. In feminist and CRITICAL
THEORY usage, it denotes the set of IDEOLOGICAL constructs that work to main-
tain the authority of men and to propagate the oppression of women. It is impor-
tant to note, however, that patriarchy is not identical to "male." Not all men
participate equally in patriarchy and, historically, women have played important
supporting roles in patriarchal systems.

**PEINTURE  FÉMININE**   Peinture Féminine, a variant of ÉCRITURE
FEMININE, has developed in visual art (see ÉCRITURE FÉMININE). This label has
been used to describe the WORK of feminist artists, such as Nancy Spero, who
believe that a uniquely feminine FORM of painting, based generally on women's
unique experience of the world and specifically on women's bodily experience,
can be developed.

**PERFORMANCE/PERFORMATIVE/PERFORMATIVITY/PER-
FORMATIVITY  OF  GENDER**  The idea of the performative has gained
wide currency in contemporary GENDER THEORY.  It should not be confused
with PERFORMANCE  ART, which emerged in the 1960s as a form of EX-
PRESSION that incorporates music, theater, and dance and takes place before a
live audience.  In *Gender Trouble: Feminism and the Subversion of Identity* Ju-
dith Butler develops a THEORY of GENDER as a PERFORMATIVE act (see
GENDER and GENDER THEORY). She regards GENDER as something that is pro-
duced by the individual's PERFORMANCE, which conforms to cultural expecta-
tions of GENDER. In this view, GENDER is not SEX-based; rather, it is dependent
upon the GENDER one performs.
    Butler posits PARODIC PERFORMANCE as a form of resistance to culturally
dominant SEX-based GENDER distinctions. Parody can bring emphasis and atten-
tion to the DIFFERENCE between culturally dominant configurations of GENDER
that are "naturalized" and the ones that are flawed copies. Repetition of GENDER
in PARODIC form reveals the illusory belief in IDENTITY based on GENDER as
springing from an inner depth or core of being. As Butler explains: "As the ef-
fects of a subtle and politically enforced performativity, gender is an 'act,' as it
were, that is open to splittings, self-parody, self-criticism, and those hyperbolic
exhibitions of 'the natural' that, in their very exaggeration, reveal its fundamen-
tally phantasmatic status" (Butler, *Gender Trouble*, p. 147).
    Butler proposes that a subversive strategy, if it is to be effective, must operate
within the processes of SIGNIFICATION by participating in the repetitive prac-
tices that construct IDENTITY. She says:

To enter into the repetitive practices of this terrain of signification is not a choice, for the 'I' that might enter is always already inside; there is no possibility of agency or reality outside of the discursive practices that give those terms the intelligibility that they have. The task is not whether to repeat, but how to repeat or, indeed to repeat and, through a radical proliferation of gender, to *displace* the very gender norms that enable the repetition itself (Butler, *Gender Trouble,* p. 148).

**PERFORMANCE ART**  Performance art as a major GENRE developed in the 1960s in both the United States and Europe. The 1970s, however, is the era most associated with performance art because it is the decade when it flourished. In fact, as H. H. Arnason asserts, it is regarded by many as the art FORM that most characterizes the 1970s (Arnason, *History of Modern Art*, p. 566). Now a very broad category that has come to include any art PERFORMANCE before a live audience, performance art developed out of the early twentieth-century influence of Dada.

Still a viable GENRE today, performance art is an effective FORM for artists interested in social protest. Most recently, it has proved an especially effective vehicle for artists' commentaries on PORNOGRAPHY and censorship. Among contemporary performance artists who have dealt with issues of PORNOGRAPHY are Karen Finley and Annie Sprinkle.

Linda Williams suggests that Annie Sprinkle's performance work, which blurs distinctions between PORNOGRAPHY and art, may offer a resistant position from which women can act. Williams explores the possibility that Sprinkle's strategy may offer the same sort of agency that has been proposed by a number of recent GENDER theorists. The agency such theorists, most prominently Judith Butler, have proposed stems from resistance to assumption of a fixed and stable gendered IDENTITY. The agency Sprinkle offers stems from resistance to assumption of fixed gendered positions as established by the CONVENTIONS of PORNOGRAPHY (See Linda Williams. "Provoking Art: The Pornography and Performance of Annie Sprinkle.")

**PHALLIC/PHALLUS**  The phallus is the SYMBOLIC expression of male POWER. As a SYMBOLIC stand-in for the penis, it represents the biological base of PATRIARCHAL POWER.

**PHALLOCENTRISM**  Phallocentrism is used in feminist THEORY to describe those cultural structures, norms, and systems of belief that work to support and naturalize PATRIARCHAL POWER. This POWER is invested in the PHALLUS as the SYMBOLIC expression of male POWER. French psychoanalyst Jacques LACAN'S essay "The Signification of the Phallus," delivered as a lecture and published in 1966, explores the signifying capacity of the PHALLUS.

**PHALLOGOCENTRISM**  In the writings of Jacques DERRIDA, a neologism that combines the implications of PHALLOCENTRISM and LOGOCENTRISM. For DERRIDA, the traditional Western privileging of PRESENCE over ABSENCE in philosophical DISCOURSE actually repeats systems of POWER relations and is analogous to the preference or even the DESIRE for the PHALLUS. In Western philosophy, the PHALLUS is implied through structuring principles like unity, wholeness, and order. Examples of phallogocentrism are to be found in

the classic "MASTER NARRATIVES" of Western civilization, thereby implicating them in a systematic but not necessarily conspiratorial support of PATRIARCHY.

**PHANTASMATIC**  See FANTASMATIC.

**PHARMAKON**  Greek for "pharmacy," "poison," or "drug," the term is often used to refer to Plato's discussion, through Socrates, of the importance of speech and the evils of writing and REPRESENTATION in general. In the dialogue *Phaedrus*, Plato refers to writing as a poison, while designating speech as a cure. This general arrangement of FIGURES of speech in the dialogue was called "Plato's Pharmacy" by Jacques DERRIDA in his reading of it. See DECONSTRUCTION.

**PHONOCENTRISM**  See VOICE, PRESENCE, and LOGOCENTRISM.

**PLATEAU**  Gilles DELEUZE and Félix GUATTARI use the term "plateau" (borrowed from Gregory Bateson's essay on Balinese CULTURE and libidinal economy) to describe the situation when circumstances combine to bring activities to a pitch of intensity that is not automatically dissipated in a climax leading to a state of rest. The term also refers to the technique employed by DELEUZE and GUATTARI of randomly juxtaposing different NARRATIVE segments and arguments within the "same TEXT." These random juxtapositions of conceptual "flows" are "plateaus" along an otherwise horizontal or RHIZOMATIC organization of an exposition. In fact, plateaus are connected to other plateaus, and create wider rhizomes.

**PLAY**  The term "play" has been used widely by a number of theorists. In general, the term designates the essentially unstable quality of TEXTS and carries with it three interrelated meanings. First, TEXTS "have play," in the sense that they have the potential to give or break apart at a particular spot, like a weakened piece of metal or a gate on a bad HINGE. Second, once readers find weaknesses in TEXTS, they can "play" with elements, creating new, enjoyable, and unexpected meanings. Third, readers can "play" a TEXT in the sense that one "plays" a fish: through grappling with a TEXT, they can come to some position of authority over it.

**PLEASURE**  See *JOUISSANCE*.

**PLOT**  The discursive organization of a NARRATIVE, that is, the filmic actualization of NARRATIVE events. In contrast to the mental reconstruction of events that comprises a film's story, plot refers to the order and manner in which events are presented in the film itself. Story and plot *can* coincide, but they usually differ; the plot may alter the sequence (e.g., flashback), duration (e.g., a lifetime), and frequency (e.g., a repeated action) of events as they have presumably occurred in the story.

**PLURALITY/PLURALISM**  A cultural condition in which no critical school of thought or model of operation is dominant. It is often linked to POSTMODERNISM, especially in some of its earlier definitions. See also DIVERSITY.

**POLYSEMY**  See MULTIVALENT.

**POPULAR**  See MEDIA STUDIES and INTERDISCIPLINARY.

**POPULAR CULTURE**  See MEDIA STUDIES and INTERDISCIPLINARY.

**PORNOGLOSSIA**  Pornoglossia is a word coined by Deborah Cameron in *Feminism and Linguistic Theory* to designate language that works in much the same way that visual imagery works in PORNOGRAPHY. So conceived, pornoglossia refers to language used to describe women in exclusively SEXUAL terms.

**PORNOGRAPHY**  Exploration and discussion of pornography in art practice and art critical writing of the past decade or so has centered on issues of censorship. Opinions on censorship in the art world are deeply divided. Most arguments tend to align with one of two positions, which find their basis in ideas regarding how the pornographic image is read, whether such reading leads the viewer to act, and whether such actions as it stimulates are harmful or oppressive to those being acted upon.
   Those on the anticensorship side see pornographic imagery as a meaningful and socially valuable REPRESENTATION of the SEX act. Many see such REPRESENTATION as offering the potential for a greater understanding of SEXUALITY and for a more complex—and, thus, more valuable—understanding of how visual images function within a male-dominated, capitalistic economy that is driven by DESIRE. In addition, those who value art for its expressive potential see pornographic REPRESENTATIONS as significant expressions of an important aspect of human behavior. Among those who hold anti-censorship views are Judith Butler and Linda Williams. In an interview published in *Artforum* in 1992, Judith Butler expresses her disagreement with those, such as Andrea Dworkin, who believe that visual REPRESENTATIONS dictate DESIRE and produce a determined response, saying that censorship disallows exploration of the processes whereby FANTASY "orchestrates and shatters relations of POWER" ("The Body You Want," 87). Butler feels that, when views such as Dworkin's are applied to the debate on pornography, the danger exists that they will be enlisted in support of regulation of people's DESIRE and FANTASIES. This may lead to obliteration of "the ethical distinctions between fantasy, representation, and action." (p. 87) Butler further asserts that PORNOGRAPHY may offer resistance because it *"replays* relations of power" in a FANTASMATIC instead of a MIMETIC way. Butler feels that visual forms of REPRESENTATION such as art and film, which operate on the level of FANTASY, can destabilize normative modes of identification, and thus challenge and reconfigure the existing limited range of SUBJECT positions available to individuals in our CULTURE. (See FANTASY.)
   Those who favor censorship tend to adhere to the assertion that pornography is the THEORY and rape is the practice. That is, they see pornography as enabling the act of domination it represents. Most prominent among them are Catharine MacKinnon, Andrea Dworkin, and Robin Morgan. Among contemporary artists who have dealt with issues of pornography are performance artists Karen Finley

and Annie Sprinkle, and photographers Cindy Sherman and Robert Mapplethorpe. (See PERFORMANCE ART.)

**POSITIONALITY**   In "Cultural Feminism Versus Poststructuralism: The Identity Crisis in Feminist Theory," Linda Alcoff contrasts cultural and structuralist feminist viewpoints (see CULTURAL FEMINISM). She offers an alternative to both the ESSENTIALISM believed characteristic of CULTURAL FEMINISM, which she regards as resulting from valorization of "positive attributes developed under oppression," and the paralyzing effects on social activism of POSTSTRUCTURALIST feminists, which she sees as resulting from the lack of a fixed position of self-IDENTITY from which the individual can act. Alcoff views CULTURAL feminism as limited by a definition of woman formed under conditions of oppression. This definition reinforces that which formed the basis for such oppression: the belief in an essential, innate womanhood to which all women must adhere. She views FEMINISM based on POSTSTRUCTURALIST THEORY as equally limiting because such FEMINISM "could only be a wholly negative feminism, deconstructing everything and refusing to construct anything" (p. 418). Alcoff believes that an effective feminist politics cannot be mobilized on such a negative basis: positive alternative for action must be offered in order to motivate people. Alcoff sees a feminist politics based on positionality, on the idea that individual SUBJECTIVITY is "an emergent property of a historicized experience," as offering a fruitful alternative (p. 431). Those holding such a view would recognize IDENTITY as a construction, but also as a point from which action can be taken. A positional definition of woman makes IDENTITY relative to ever-changing contexts and does not define "woman" by the possession of certain attributes, but instead defines her by the position(s) she occupies. These positions can be utilized as locations for the construction of meaning and IDENTITY and can become loci from which effective political action can be initiated.

**POSTCOLONIAL/POSTCOLONIAL DISCOURSE**   Those working in the area of postcolonial studies have taken as their task the subversion and APPROPRIATION for an oppositional purpose of COLONIAL texts that position the COLONIALIZED as OTHER. By recognizing and locating in COLONIAL art, writing, and other cultural productions the BINARY constructions (civilizer/savage, self/OTHER, and so on) that are the tools of the colonizer, postcolonial artists and writers have attempted to rewrite and subvert such TEXTS. JanMohamed addresses this strategy of resistance in "The Economy of Manichean Allegory," labeling the postcolonial writer's APPROPRIATION and subversion of the COLONIAL TEXT "writing back."

Postcolonial critics and writers generally agree that the most important issue in such theoretical WORK involves the problem of how the postcolonial SUBJECT may achieve agency (Bhabha, p. 9), which remains PROBLEMATIC. Homi Bhabha has offered HYBRIDITY as a possible strategy. He explains that HYBRIDITY challenges assumptions regarding cultural purity and authenticity. In challenging such cultural distinctions, it may operate as an effective form of subversion, because it makes visible the "necessary deformation and displacement of all sites of discrimination and domination" (Bhabha, p. 9). In her development of THEORIES of the SUBALTERN Gayatri Chakravorty Spivak has dealt

with social factors that are especially PROBLEMATIC for women in this CONTEXT. The work of Trinh T. Minh-ha, who as both a writer and a filmmaker deals with problems specific to women, has had a particularly strong impact on visual art.

**POSTFEMINISM**   In the postfeminist view, women's goals have been achieved, equality has been attained, and it is no longer necessary to advocate for social change. In *Feminism Without Women: Culture and Criticism in a 'Postfeminist' Age* Tania Modleski asserts that the MYTH of postfeminism stems from a major conservative backlash, which, while operating under the guise of a profeminist stance, is undermining what progress has been made by feminists. Modleski finds the origin of much postfeminist RHETORIC in the POPULAR media. She also sees it operating in recent scholarly DISCOURSE regarding GENDER, in what has become know as "gender studies," which forgoes issues that necessarily pertain specifically to women and thus, in her opinion, may simply be PATRIARCHY operating through a different VOICE.

**POSTMODERNISM**   According to some historians and theorists, we may be leaving MODERNISM and entering a different cultural epoch tentatively called postmodernism. Through the past two decades, however, there have been several conflicting definitions of the term. Early definitions of Postmodernism in art stressed a DIFFERENCE or even a straightforward opposition to the FORMALISM of "high MODERNISM." As a result, PERFORMANCE, figurative painting, photographic or video WORK, Earth Art, and mixed media objects and installations were seen as especially Postmodern. The situation was described as "PLURALISM," which indicated an acceptance of a DIVERSITY of styles, SUBJECTS, and FORMS.

In architecture "postmodernism" was defined in terms of style and exemplified in designs that include a mixture of past and present styles, a technique called "double-coding." This early definition of postmodernism as a style was so successful that its application quickly spread to the other visual arts and critics were eagerly trying to find double-coding in painting and sculpture. At the same time such an understanding so "set in concrete" the definition of postmodernism in architecture that when architectural designers and theorists turned to the works of Jacques DERRIDA, a new and distinct style called "DECONSTRUCTIVISM" had to be designated, while in the rest of the world of the arts and humanities DECONSTRUCTION was generally associated with postmodernism as a whole.

These early definitions of postmodernism have more recently been replaced with a view that does not concentrate so much on style and materials, but look for ways in which artistic production is both different from MODERNIST practice and shares some important similarities with POSTSTRUCTURALIST THEORY. Such an understanding of postmodernism is heavily influenced by recent THEORIES of language, CULTURE, GENDER, ETHNICITY, and history. For art, this has resulted in a concern with how visual forms function as a language that, in large part, shapes CULTURE, GENDER, and ETHNICITY, among other things. For art history, postmodern approaches have resulted in an investigation into the techniques and motivations of the INSTITUTIONS that produced MODERNISM. Postmodern art history, sometimes called REVISIONIST ART HISTORY, also investigates how art has functioned in the production of CULTURE, personal

IDENTITY, GENDER, ETHNICITY, and relationships of POWER in society. Art produced from this POSTMODERN viewpoint may not look any different than previous art, but its function or purpose is regarded as radically different. This is due primarily to a shift away from both the object and one's personal experience of the object to a POSTSTRUCTURALIST examination of the social and cultural processes of which art is a part.

**POSTMODERN WARFARE**  See RHIZOMATIC AND ARBORESCENT.

**POSTSTRUCTURALISM/POSTSTRUCTURALIST**  A term designating a general set of theoretical concerns occupying many intellectuals after STRUCTURALIST SEMIOTICS was problematized by critics such as Roland BARTHES, Michel FOUCAULT, and especially Jacques DERRIDA. As a result of an emphasis on the ARBITRARY nature of SIGNIFICATION, many theorists became concerned with the general processes by which meaning becomes established and controlled. In short, meaning was radically politicized through a series of demonstrations of the relationship of CULTURE and POWER.

**POWER**  The term power has come to be a central one in recent discussions on the arts and humanities, mostly due to a reappraisal of the notion of power by Michel FOUCAULT. Power is perhaps FOUCAULT'S least clear concept, yet it is a key to understanding his later WORK.

FOUCAULT'S conception of power is not simply negative and repressive. On the contrary, for FOUCAULT, power is "a making possible," an opening up of fields in which certain kinds of action and production are being brought about, using pleasurable techniques as often as repressive ones. For him, power is exercised rather than possessed, decentralized and dispersed rather than top-down. To FOUCAULT, DISCOURSE "makes possible" DISCIPLINES and INSTITUTIONS which in turn sustain and distribute DISCOURSES and the effects of power throughout a social system. DISCOURSE is linked to social INSTITUTIONS that "have power," in the sense that INSTITUTIONS are part of a wider control of bodies, actions, and understandings. As power is dispersed, it opens up specific possibilities; new domains of action, knowledge, and social being can be constituted, shaped by various INSTITUTIONS and DISCIPLINES. It is in these INSTITUTIONS and DISCIPLINES that the SUBJECT and IDENTITIES (of self or of others, social and national) are formed. We come to be whatever or whoever we are only within this set of discursive and nondiscursive fields.

FOUCAULT'S notion of power should not be taken fatalistically, however, for "to say that there cannot be a society without power relations is not to say," he cautions, "that those which are established are necessary."  TRUTH, according to FOUCAULT'S formulation, has an economy characterized by economic and political incitement, an immense diffusion and consumption, the production and transmission under the control of a few political and economic APPARATUSES, and the fact that it is the issue of political debates. Because of this, FOUCAULT does not examine a mere history of power, but develops a series of methods he generally calls "DISCOURSE ANALYSIS" for examining the TRUTH-effects of knowledges.

**PRACTICAL BODY**  See BODY.

**PRESCRIBE/PRESCRIPTIVE** Literally "to write in advance," an attempt to set rules, instructions, and standards of excellence or correctness in the arts and in the criticism of the arts.

**PRESENCE** The "metaphysics of presence," as it is called by Jacques DERRIDA, has been a central logocentric assumption in the European philosophical tradition since the ancient Greeks. Presence, especially as opposed to ABSENCE, has been considered an invariable point of reference and has had various names, including God, TRUTH, essence, existence, being, origin, and consciousness. These points of reference have been understood to exist outside human systems of meaning and have therefore been used as grounds for argument and understanding. An argument that is based upon one of these TRANSCENDENTAL reference points is assured to be a powerful one. As DERRIDA explains, however, one result of a DECONSTRUCTION is the exposure of these seeming absolutes as contingent human values.

**PRESENTNESS** According to the American art critic Michael Fried, the experience of true MODERNIST art is an experience of presentness. Presentness is an effect of that single, infinitely brief instant in which an artwork is experienced in all its depth and fullness. Since there is no duration in the experience of MODERNIST painting, MODERNIST painting "defeats" theatre (temporal duration is necessary to theatre, literature, and music). To Fried, all art forms aspire to the condition of MODERNIST painting, purified of THEATRICALITY, that is, of duration, exhibition CONVENTIONS, and mixed media, or what lies "in between" the arts. Fried is usually considered as having extended the FORMALIST ideas of Clement Greenberg.

**PROBLEMATIC** A term derived from the writings of Marxist theorist Louis ALTHUSSER and used to designate theoretical and/or IDEOLOGICAL formations. It can also be used to refer to rather large and wide-ranging belief systems, resembling Michel FOUCAULT'S *EPISTEME*. The term has come into wide usage among Marxist theorists, as well as CULTURAL STUDIES.

**PSYCHOANALYSIS** Psychoanalysis is an interpretive science of the human mind and human development founded by Sigmund Freud. The basis of its methodology lies in a THEORY of the UNCONSCIOUS, which, for Freud, is that part of the human psyche that is repressed and contains what does not reach the conscious level, but is instead expressed in the disguised form of dreams, FANTASY, FETISHES, art, and other SYMBOLIC forms. The repressive mechanism of the UNCONSCIOUS prevents its contents from being revealed to the conscious mind, allowing their expression only in disguised form (see UNCONSCIOUS).

Freud used his own observations of Western CULTURE, mostly literature, to formulate his ideas. Consequently, his WORK, in many ways, may be seen as an explanation and critique of Western cultural traditions. The most notable of his THEORIES of human development that draw on the Western literary tradition is the Oedipus complex. Using Sophocles' tragedy *Oedipus Rex* as his source, he theorized that the child desires the parent of opposite SEX and thus develops a ri-

valry with the parent who is of the same SEX as the child. Resolution of this rivalry is, in Freud's view, crucial to development of the child's SEXUAL orientation and personality. In psychoanalytic practice, the analyst serves as parental substitute while the person being analyzed reworks traumatic incidents revolving around the Oedipal conflict through his or her relationship with the analyst. The analyst's task is to use methods devised for accessing the UNCONSCIOUS so that its contents may be revealed to the patient. Thus drawn up to the conscious level, UNCONSCIOUS, conflicts may be resolved.

A number of artists have recently made PSYCHOANALYTIC THEORY the focus of their WORK, including Mary Kelly, Katy Campbell, Victor Burgin, and Sylvia Kolbowski. Mary Kelly critiques the foundations of psychoanalysis in *Interim*, an installation of 1984–89, through incorporation of psychoanalytic DISCOURSE and reference to early formulations of hysteria. She divides the *Corpus* section of her four-part installation, the section that deals with the BODY, into five sections: *Extase* (ecstasy), *Erotism* (eroticism), *Supplication* (supplication), *Menace* (menace), and *Appel* (appeal). These titles are drawn from the five "passionate attitudes" of hysteria identified by the nineteenth-century French neurologist and colleague of Freud, J. M. Charcot. Charcot, who was instrumental in forming psychoanalytic approaches to treatment of female patients, has been criticized for emphasizing the visual and theatrical manifestations of hysteria, reflecting a view of the female patient as object rather than SUBJECT.

**PSYCHOANALYTIC FEMINISM**   See FEMINISM.

**PSYCHOANALYTIC THEORY AND CRITICISM**   Psychoanalytic theory and criticism have been used as a tool of literary and artistic analysis for some time. Early forms of this use analysis consisted of an analysis of the artist's personality via their artwork, supplemented by whatever biographical information was available. Examples of such analysis include Freud's essay of 1910, "Leonardo da Vinci and a Memory of His Childhood." More recently, psychoanalytic theory has been used in one of two ways. Some, including Kate Linker in "Representation and Sexuality" and Laura Mulvey in "Visual Pleasure and Narrative Cinema," have used it as a tool to critique cultural practices of visual REPRESENTATION. Others, including Mary Kelly in *Interim* and Jana Sterbak in *Seduction Couch*, have employed a psychoanalytic method to perform a critique of PSYCHOANALYSIS itself and its reliance on the REPRESSIVE HYPOTHESIS, the "talking cure," and THEORIES of the female SUBJECT, including hysteria.

Contemporary artists have used psychoanalytic concepts as formulated by a number of individuals. FEMINIST FILM THEORY has drawn heavily on both Freud's and LACAN'S THEORIES regarding VOYEURISM, SCOPOPHILIA, and DESIRE; this THEORY has, in turn, influenced the WORK of a number of contemporary artists, including Victor Burgin, Sylvia Kolbowski, and Cindy Sherman. Julia Kristeva's THEORIES regarding the ABJECT and the MATERNAL BODY have recently received much attention have found their way into the WORK of Cindy Sherman, Kiki Smith, Robert Gober, Robert Mapplethorpe, Joel-Peter Witkin, and Andres Serrano. Melanie Klein's OBJECT RELATIONS THEORY has informed the WORK of a number of artists, including Katy Campbell.

**PUNCTUM**  See STUDIUM AND PUNCTUM.

# Q

**QUEER THEORY** A relatively new area of scholarly inquiry, commonly referred to as queer theory, has received increasing attention by artists and art critics since the mid-1990s. The central concerns of queer studies are GENDER and SEXUALITY. The issue of self-REPRESENTATION has become a prevalent strategic problem in the WORK of a number of lesbian filmmakers, artists and art writers, including Barbara Hammer, Harmony Hammond and B. Ruby Rich. The REPRESENTATION of gay male SEXUALITY has been a major theme in the writings of Craig Houser and Kobena Mercer.

Judith Butler's PERFORMATIVE THEORY of GENDER, as presented in *Gender Trouble: Feminism and The Subversion of Identity*, has been particularly influential in the field of queer theory (see PERFORMANCE/ PERFORMATIVE/ PERFORMATIVITY OF GENDER). In an interview with Liz Kotz that appeared in *Artforum* in 1992, Butler says that, when she began *Gender Trouble*, she was interested in questioning the heterosexist presumption of the a majority of feminist theorists. The book resulted, however, in a criticism of the IDENTITY politics of lesbian feminists. Butler perceived a too great investment in a fixed IDENTITY by gays, which replicated the social regulation operative in compulsory heterosexuality. She offers the theatrics of ACT UP and Queer Nation as exemplary of a strategic use of IDENTITY, "a certain performative production of identity" ("The Body You Want," 82–89). which is effective in resistance to cultural constraints. Queer studies, Butler feels, can offer a challenge to FEMINISM similar to that offered by women of color in the 1980s, which resulted in radical reformation of feminist studies.

**QUOTATION** The reuse in one WORK of a style (or stylistic technique) of another period. For example, Neo-Expressionism, as exemplified by George Baselitz, has general stylistic similarities with early twentieth-century German EXPRESSIONISM.

# R

**RACE/RACISM** Racial and racist discourses of Western CULTURE have formed the focus of the WORK of a number of contemporary artists. Through such works, artists such as Lorna Simpson, Robert Colescott, and Adrian Piper have examined common attitudes toward race, including the idea that cultural DIFFERENCE is the product of some "essence" possessed by individuals of common descent or heredity and the idea that this essence is observable in, and can be signified by, some visible characteristic shared by that group, such as skin color, head shape, hair texture, or posture. They have explored how racial DISCOURSE and REPRESENTATION have been used to justify European domination and how they have served to "demonstrate" the presumed racial superiority of Europeans. Taking a POSTSTRUCTURALIST approach, Lorna Simpson has dealt with the racist view that characteristics like skin color, hair texture, and so on are to racial "essence" as the SIGNIFIER is to the SIGNIFIED. Such a POSTSTRUCTURALIST approach also allows for a radical critique of racism.

**RADICAL ALTERITY** In the THEORY of Jacques DERRIDA "radical alterity" refers to the alienation of the SIGNIFIED from itself. Because a SIGNIFIER always requires a SIGNIFIED to function, it can never exist alone in a self-sufficient, self-referential state. DERRIDA explains:

The *representamen* [or signifier] functions only by giving rise to an *interpretant* that itself becomes a sign and so on to infinity. The self-identity of the signified conceals itself unceasingly and is always on the move. The property of the *representamen* is to be itself and another, to be produced as a structure of reference, to be separated from itself. (Derrida, *Of Grammatology*, pp. 49–50)

Recent POSTCOLONIAL critics, such as Gayatri Chakravorty Spivak, have used this idea on a larger scale to designate those peoples (for example, Hindu and Muslim in India) in semiological opposition to which the REPRESENTATION of the imperial SUBJECT (for example, the British) is constructed.

**RADICAL FEMINISM** See FEMINISM.

**READER**  In recent criticism of literary and artistic TEXTS, great attention has been placed upon the activity and role of the reader or viewer. This shift away from the artist as CENTER of the study of TEXTS and toward the reader is aimed at investigating the contributions of the reader to the meanings of TEXTS. This is part of a larger shift away from so-called "inherent" or "legitimate" meanings—meanings that "belong" to TEXTS as a result of AUTHORIAL actions—toward a study of "artificial" meanings—the meanings produced through consumption and circulation of SIGNS throughout social contexts.

**READERLY AND WRITERLY TEXTS**  Originally brought into common critical usage by Roland BARTHES, these terms describe the DIFFERENCE between two modes of writing and reading literary TEXTS. The readerly TEXT is a TEXT in which the READER and writer share a number of CONVENTIONS about TEXTS so as to allow for unproblematic and TRANSPARENT use of language. Writerly texts challenge readers through a number of devices aimed at DEFAMILIARIZATION, forcing them to become actively engaged in the process of writing through reading. These terms are also commonly used to indicate a WORK that lends itself to written commentary or lends itself to be read.

**READER-RESPONSE CRITICISM**  A type of criticism that takes the reader's response to a literary TEXT—or a viewer's response to a WORK of art— as the primary focus. This is in contrast to the more traditional approaches to texts and art objects that explore the qualities of the works themselves or the intentions of the artist. Reader-response criticism is not a formalized movement or school, but a set of concerns on the part of many critics from different and otherwise conflicting viewpoints. See also RECEPTION THEORY.

**REAL**  In LACANIAN terms, the Real is that which is in excess of the IMAGINARY and the SYMBOLIC. It is unrepresentable. (See IMAGINARY and SYMBOLIC.)

**REALISM**  The term "realism" has a number of different and sometimes conflicting meanings. It can be used to indicate a general quality of a WORK of art that seems to match our expectation of the visible world. In that sense realism strives to be mimetic REPRESENTATION, marshaling material so as to produce a "REALITY EFFECT." In film studies, realism refers to the ways in which an audience accepts certain modes of REPRESENTATION and NARRATIVE as "faithful to reality." This implies a belief in the SEMIOTIC TRANSPARENCY of the materials used in film and the use of various cinematic devices—authentic locations and details, long shots and lengthy takes, eye-level placement of the camera, a minimum of editing and special effects—that allow viewers to partake of the PLEASURE of film and forget that they are watching an arrangement of flickering shadows.

A second understanding of realism includes a number of literary and artistic CONVENTIONS that have their origin in the nineteenth century and deal with the social reality of their times. As such, realism is a political attitude that does not necessarily include a mimetic requirement.

**REALITY EFFECT**  According to Roland BARTHES, certain arrangements of SEMIOTIC material result in their seeming TRANSPARENCY and so allow mimetic reading. In other words, one can arrange material like paint so that the arrangement prompts the viewer to implicitly accept the depiction as "REAL."

**RECEPTION THEORY**  A position taken by a relatively small group of primarily German critics, such as Hans Robert Jauss and Wolfgang Iser, on the reception of WORKS by their consumers. With a special concern for the READERS of literary TEXTS, reception theorists study the ways in which WORKS have been received historically, as well as the ways in which the history of reception of TEXTS has shaped the production of writers. Reception theorists are especially concerned with a reader's "horizon of expectation," that is, the familiar ways in which WORKS are consumed, and how this horizon may expand.

**REFERENT**  See SEMIOTICS, SEMIOLOGY.

**REPRESENTATION**  This term has undergone great changes in recent years, especially in the visual arts, and has come to be one of the central issues in contemporary art theory and criticism. Traditionally, representation referred to TRANSPARENT and mimetic representation, that is, a WORK'S ability to "match" the visible qualities of its SUBJECT. More recently, however, our understanding of representation has been challenged by POSTSTRUCTURALIST THEORY. As a result, representation can indicate any usage of material that has the ability to refer to something else, actual or imagined, visible or invisible. This can include both traditionally "realistic" painting—with portraits, landscapes, and still-life as subject matter—abstract painting. All are seen to have the potential to represent in some way, if not strictly mimetically.

**REPRESSIVE HYPOTHESIS**  In *The History of Sexuality, Volume 1: An Introduction*, Michel FOUCAULT asserts that, since the advent of the Age of Reason, we have seen an incitement to SEXUAL DISCOURSE dispersed in multiple forms from multiple centers. He discusses the "speaker's benefit," explaining that, when SEX is repressed, speaking about it becomes a deliberately TRANSGRESSIVE act. Our DESIRE to rebel against oppression, he asserts, produces our need to see SEX as repressed. Rebellion against SEXUAL oppression (or repression) provides the opportunity to espouse a DESIRE for a "garden of earthly delights." FOUCAULT states that his goal is to explore the DISCOURSES that work to produce an impression of repression (which acts to produce DISCOURSES of SEXUALITY) and the will and intention that produce and support them. He wishes to explore not why we are repressed, but why we insist so vehemently and so profusely that we are repressed (thereby generating DISCOURSES of SEXUALITY).

FOUCAULT raises three doubts regarding the repressive hypothesis: (1) Is the repression of SEX actually historically established? (2) Does POWER in our society function through repression (through prohibition, censorship, and so on)? (3) Did critical DISCOURSE regarding repression function to obstruct the workings of POWER that was, up to then, unchallenged? Or is such critical DISCOURSE actually part of that same "historical network" as denounces and labels it as repression? FOUCAULT attempts to explore the "discursive fact" of

SEX and the manifold techniques of POWER. He states that his primary aim is to investigate the "will to knowledge" that functions as the support and instrument of such discursive productions. He wishes to locate and write the history of "instances of discursive production. . . of the production of POWER. . . of the propagation of knowledge" (*The History of Sexuality,* pp. 11–12). He tells us that, since the end of the 1500s, DISCOURSE regarding SEXUALITY has not been repressed but has, instead, "been subjected to a mechanism of increasing incitement." This has produced manifold forms of SEXUALITY; and the "will to knowledge" has constituted a "science of sexuality" (*The History of Sexuality,* pp. 12–13).

In order to control SEX and SEXUALITY, it became necessary to control its circulation in language, to "subjugate it at the level of language" (*The History of Sexuality,* p. 17). However, FOUCAULT points out, over the last three-hundred years there has been an explosion of DISCOURSE on SEX. There developed a profusion of discourses on SEXUALITY, "an institutional incitement to speak about it" explicitly and in great detail. Such DISCOURSE, propagated by the Church through the confessional, was intended to modify DESIRE (*The History of Sexuality,* p. 18).

SEX became something that was administered. It required management directed by analytical DISCOURSES. In the eighteenth century, governments became concerned with population problems. SEX became important because, through it, population increased or decreased. SEXUAL behavior came to be viewed as an appropriate point for state intervention to control population. INSTITUTIONS of the eighteenth and nineteenth centuries that produced DISCOURSES on SEX were schools, medicine, and the criminal justice system. The three CODES (canonical law, the Christian pastoral, and civil law) that, up until the end of the 1700s, controlled SEXUAL practice involved matrimony, sothat constraints on behavior (and thought) were mostly focused on marital relations. The system based on legitimized (marital) relations was modified in two ways by the "discursive explosion" of the 1700s and 1800s. First speech related to normative SEXUALITY became more discreet, quieter. Second, those whose behavior did not conform to the HETEROSEXUAL norm of reproductive SEXUALITY were compelled to confess their "unnatural" acts. Those who confessed to such acts were set apart, and this marking of DIFFERENCE, of the non-normative, the "perverse," worked (by distinguishing itself from the norm) to constitute what was regarded as "natural" behavior. It became necessary to separate such individuals, and this gave rise to techniques of separation and SURVEILLANCE that focused on the BODY (Foucault, *A History of Sexuality, Volume 1: An Introduction,* pp. 3–49).

One of a number of contemporary artists who draw on FOUCAULT'S ideas regarding the repressive hypothesis and incitement to SEXUAL DISCOURSE is Jana Sterbak. In *Seduction Couch,* a sculpture from 1987–88, Sterbak presents us with an object that is most meaningful when viewed within modern DISCOURSE on SEX and SEXUALITY as discussed by FOUCAULT. This sculptural installation consists of a chaise lounge constructed of perforated metal which, lit by a spotlight, casts an enormous and sinister shadow on the wall behind it. A Van de Graaff generator sits at the foot of the metal couch. Building up a charge from the electrostatic energy in its environment, the generator sends out an arc of blue light every so often when the charge crosses the gap to the metal couch. The generator, steadily building an electrostatic charge that is periodically and dramat-

ically released, acts as a TROPE for the buildup of energy deriving from SEXUAL attraction.

The conjunction of attraction and repulsion found in Sterbak's *Seduction Couch* is characteristic of seduction as an exercise of POWER. The one wielding the POWER of seduction controls both the attraction and the repulsion of the one being seduced. Sterbak's couch carries an electric charge. The thrill produced by anticipation of the charge seduces the viewer into touching it. The anticipated repulsion produces the attraction because it produces the thrill. Since, upon touching the couch, the viewer is repulsed by the electric charge, the attraction of repulsion is what causes the viewer to touch it.

The chaise lounge is associated with PSYCHOANALYSIS. It serves as the SITE for PERFORMANCE of Freud's "talking cure." It is the point at which the female SUBJECT is constructed in and through PSYCHOANALYTIC DISCOURSE. Through reference to both the psychoanalyst's couch and SEXUAL seduction, Sterbak clearly conveys that this piece is intended as a commentary on SEXUALITY, seduction, and DESIRE as conceived within PSYCHOANALYTIC DISCOURSE. Sterbak concerns herself with the central role PSYCHOANALYSIS has played in the production of SEXUAL DISCOURSE. PSYCHOANALYSIS is one of the primary DISCOURSES through which the repressive hypothesis FOUCAULT describes has operated. The core assumptions of PSYCHOANALYSIS are built upon the presumed existence of repressed SEXUAL DESIRE. Through the "talking cure," the psychoanalyst attempts to bring awareness of such repressed DESIRE to the conscious level. The patient is made to verbally express his or her DESIRE. The psychoanalyst's couch, thus, serves as the SITE of generation of DISCOURSE on SEXUALITY. It signifies those processes, through which the incitement to SEXUAL DISCOURSE and the deployment of SEXUALITY have operated, Sterbak shows us how DESIRE stimulates "the injunction to know" and lead us to believe that, through participation in SEXUAL DISCOURSE, we may liberate ourselves. Through incitement to DISCOURSE, through talking about SEX, we are provided the illusion of individual agency. We think we are liberating ourselves from a repressive social injunction; however, we are only serving to further generate what we seek to subvert.

**REPRESSIVE STATE APPARATUS (RSA)** See APPARATUS.

**REVISIONISM** See REVISIONIST ART HISTORY.

**REVISIONIST ART HISTORY** The terms "revisionist," "New Art History," or "New Historicism," when applied to historical matters, conjure up a Stalinesque scene of coconspirators in a dark room rewriting history textbooks. In the arts and humanities, however, these terms have come to be used in two interrelated senses. The first sense is derogatory, reminiscent of the Cold War days of "red-baiting" and perceived communist conspiracy. This first sense sees recent historical and critical research as far too influenced by Marxist thinking, too interested in so-called "extra artistic" matters like GENDER and ETHNICITY, and generally disturbing in its criticism of traditional and accepted histories. The second sense of the term is used by its supporters. Whether they call themselves revisionists or not, many critics, theorists, and historians have incorporated a wide variety of previously unused or seldom used theoretical positions in their writ-

ings, including SEMIOTIC, Marxist, POSTSTRUCTURALIST, FEMINIST, MULTICULTURAL or POSTCOLONIAL, and DECONSTRUCTIONIST positions.

As a result of incorporating various methodologies into their research, many historians and theorists have begun to question traditionally accepted ideas on such topics as INFLUENCE, EXPRESSION, ORIGINALITY, the idea of a direction of history, stylistic change, iconographic interpretation, and FORMALIST criteria. Radically different histories of the arts have been written, and sometimes disturbing (to some) critical positions on the arts have been taken. Art critic Hal Foster, for example, has used a combination of Marxist THEORY and POSTSTRUCTURALIST analysis to critique what he calls "the EXPRESSIONIST FALLACY." Other historians associated with the "New Art History" are Keith Moxey, Donald Preziosi, Norman Bryson, and Griselda Pollock. "New Museology" is the term assigned to the incorporation of THEORY into museological practices. An exemplary result has been the attention to the museum as a REPRESENTATIONAL medium with the POWER to write history and to shape the perception that individuals and groups have of themselves. "New Western History," which stems from new directions in the writing of the history of the American West has impacted art historical practices by providing some analytical tools for the investigation into the relationship of visual REPRESENTATION to the history of westward expansion, environmental degradation, and the near total genocide of Native Americans. A few of the historians writing in this vein are Richard White, Patricia Nelson Limerick, and Glenda Riley. One result of this renewed attention to the art of the West has been the controversial 1991 exhibition "The West as America," which paid special attention to historical topics not common to art exhibitions, and disturbing to many visitors.

**RHETORIC**  The way that a statement is put, especially as it differs from the sense or intentional meaning of the statement. Traditionally, the art of rhetoric examined the ways in which DISCOURSES were constructed in order to achieve certain effects. Rhetoric was traditionally regarded as a deliberate exploitation of eloquence for the most persuasive effect in speaking or writing. It included the study of the uses of FIGURES of speech—METAPHOR, METONYMY, simile, IRONY, synecdoche, personification, analogy, and so on—and the arts of memory, and oratory.

Rhetoric has been taken up again as an important field of study due to the widespread acceptance by many theorists, writers, and artists of the idea that the material aspect of REPRESENTATION is of utmost importance. Preoccupations on the part of recent theorists and critics with analyzing rhetoric often stems from an understanding of DISCOURSE as a form of POWER and DESIRE. One of the more important uses of rhetorical analysis has been its ability to look upon DISCOURSES with an eye to understanding how they produce certain effects, shape understanding, or maintain existing systems of POWER. One result has been to show that criticism, THEORY and knowledge are "interested," that is, "invested" in arrangements of POWER. Another result has been that rhetoric is now seen by many critics and theorists as an unavoidable instrument in the establishment of "TRUTH effects" and in the implementation of "TRUTH-values." In that vein, philosopher Jacques DERRIDA has called into question the attempt by some writers throughout history to separate rhetoric from philosophy. In DERRIDA'S view, it is rhetoric that gives statements their POWER to convince.

Ironically, however, it is sometimes the same rhetoric that undermines that statement's ability to convince, as DERRIDA explains in his writings on DECONSTRUCTION.

In the criticism of the visual arts, a great deal of attention has been paid to rhetoric as a strategy for artistic production. Critic Hal Foster, in his essay on EXPRESSION and the EXPRESSIONIST FALLACY, investigates the similarities of the rhetorical devices (or painterly techniques) used in early twentieth-century EXPRESSIONIST painting and in the Neo-EXPRESSIONIST painting of the late 1970s and early 1980s. (See EXPRESSIONIST FALLACY.)

**RHIZOMATIC AND ARBORESCENT**   Gilles DELEUZE and Félix GUATTARI use the terms "rhizomatic" and "arborescent" to distinguish between two modes of thinking. The arborescent mode is tree-like and refers to the traditional European disciplinary organization of knowledge based upon a "depth model," a vertical or HIERARCHICAL arrangement. This model includes branches of knowledge with its roots supplying a firm foundation. The rhizomatic mode is based upon the model of a horizontally spreading root system, like strawberries, bamboo, or mint. This model indicates a horizontal network organization, which is more dynamic, heterogeneous, and non-hierarchical than the arborescent. Rhizomatic thinking often affirms those modes of thought excluded from Western tradition, in an attempt to displace essentialized and totalized thinking and disciplinary organization. Horizontality can be a part of rhizomes, since they can have roots and stems that form "PLATEAUS." Rhizomes and PLATEAUS are connected to other rhizomes and PLATEAUS, and can therefore create wider rhizomes. Rhizomatic thinking is a form of "nomadic thought," as opposed to "state thought"; the application of nomadic thought in critiques of the state and state APPARATUSES is, for D&G, a form of "POSTMODERN WARFARE" (see Deleuze And Guattari, *A Thousand Plateaus*).

**RHIZOME**   See RHIZOMATIC AND ARBORESCENT.

**RUPTURE**   In Jacques DERRIDA'S THEORY of DECONSTRUCTION, a rupture is a moment in reading a TEXT when certain insurmountable conflicts are made obvious to a READER. For Michel FOUCAULT, a rupture is an EPISTEMIC BREAK, that is, a historical event in which whole systems of thought reveal themselves as artificial, inadequate, and so are replaced by other modes of thought.

# S

**SCHIZOANALYSIS** According to Gilles DELEUZE and Félix GUATTARI, a schizophrenic is someone who attempts to escape from IDENTITY-undifferentiation, in order to become a "NOMAD," for example, but is prevented from doing so by capitalist society. To DELEUZE and GUATTARI, schizophrenia is not an illness but a potentially liberatory process of becoming something else, something "OTHER." Schizoanalysis is the analysis of capitalism and the mechanisms by which it prevents or otherwise limits the possibilities of becoming. (See also BODIES WITHOUT ORGANS and NOMADS.)

**SCOPIC REGIME** See VISION/VISUALITY.

**SCOPOPHILIA** Feminist film theorist Laura Mulvey applies the Freudian concept of scopophilia to classic NARRATIVE film in her highly influential essay, "Visual Pleasure and Narrative Cinema." She describes scopophilia as one of the PLEASURES offered by cinema, where looking is the source of enjoyment. Freud develops this concept in *Three Essays on Sexuality* and defines it as an instinctual drive that is part of normal SEXUAL behavior. As described by Freud, scopophilia involves regarding of others as objects and making them the SUBJECT of a controlling GAZE. He associates it with pre-genital autoeroticism, with the PLEASURE of looking transferred to others at a later stage of the child's development. For Freud, normal scopophilic behavior is an active form of VOYEURISM. It may become so extreme, however, as to become a form of perversion involving the limitation of SEXUAL PLEASURE to situations in which looking functions as a controlling and objectifying behavior and finds expression in obsessive VOYEURISM and Peeping Tom behavior.

Mulvey sees mainstream film as characterized by scopophilic behavior. It produces a sense of distance in the viewer, thus providing a necessary condition for the satisfaction of voyeuristic DESIRE. The CONVENTIONS of NARRATIVE film provide the spectator with the sense that he or she is viewing a private world from the safe, obscuring distance and darkness of the movie theatre. Cinema satisfies this DESIRE for voyeuristic PLEASURE; at the same time, it provides the

opportunity for the exercise of the narcissistic aspect of VOYEURISM, which Mulvey finds in the viewer's identification with the film's protagonist. This identification recapitulates the narcissistic process of the MIRROR STAGE as described by psychoanalyst Jacques LACAN. During the MIRROR STAGE, which is pre-linguistic, the child perceives its own reflected image as superior to its BODY, because the reflected image appears more complete and perfect than the image of self produced by the child's experience of its own BODY. Recognition of this perceived superiority results in the formation of an ideal ego that is reintrojected, providing the basis for the child's future identification with other persons. Mulvey views film as similarly involving a simultaneous loss and reinforcement of the ego. It involves a reinforcement of the ego through a voyeuristic separation of the viewer from the objectified OTHER on the SCREEN, while, at the same time, it provides the conditions necessary for a narcissistic identification with the OTHER. It produces a tension between instinctual SEXUAL drives and the drive for self-preservation, which results in PLEASURE.

**SCREEN**  In his application of Ferdinand de Saussure's SEMIOTIC THEORY to PSYCHOANALYSIS, Jacques LACAN develops the idea of the screen. In LACAN'S explanation of the MIRROR STAGE of early childhood development, vision plays a major role in the attainment of individual subjecthood. In *The Four Fundamental Concepts of Psychoanalysis* LACAN discusses how the alienation of the SUBJECT from itself, which occurs through its awareness that it serves as the object of the GAZE of others is relevant to the visual arts. Asserting that humans assume masks so as to manipulate the GAZE of others, he explains that this process of manipulation operates through the screen. LACAN explains: "Man, in effect, knows how to play with the mask as that beyond which there is the gaze. The screen is here the locus of MEDIATION" (Lacan, *Four Fundamental Concepts*, p. 107). LACAN provides a schematic model for the operation of the screen, which consists of two intersecting triangles. The GAZE, as the visual version of the SYMBOLIC through which the SUBJECT locates itself, is found at the base of one triangle and the SUBJECT of REPRESENTATION lies at the other base. LACAN locates the "image screen" at the point of intersection of the two triangles.

In his discussion of LACAN'S idea of the screen, art historian Keith Moxey explains how the screen may also be seen as the WORK of art: "It can be regarded as the subject's personal mask insofar as it incorporates the unique qualities of his or her individuality in a form that can be reconciled with the impersonal otherness of the gaze, or it can be viewed as the way in which the artist expands or supplements the gaze's control of the real. . . by offering it that which it cannot see." The artist's individual SUBJECTIVITY, Moxey explains, "has the capacity to extend the gaze's power to define the real by offering it images or visions of that which escapes its purview, by developing means to capture that which the gaze cannot encode." The artist's image, thus conceived, seems to "transcend the visual CODES by which our approach to the real is mediated by the concept of the gaze." The visual image, as the artist's REPRESENTATION of what escapes the GAZE, "momentarily appeases its search for meaning" by providing a substitute for what always escapes it (Moxey, *The Practice of Theory*, pp. 52–54).

Theorist Kaja Silverman has developed and applied LACAN'S idea of the SCREEN to film studies. Visual artists who have used LACANIAN THEORY to explore how visual processes form individual SUBJECTIVITY include Sylvia Kolbowski and Victor Burgin.

**SCREEN THEORY** Another term for FILM THEORY written by various AUTHORS published in the British film journal *Screen*. The journal has been in publication for over two decades, publishing criticism and THEORY from various perspectives, including POSTSTRUCTURALIST, PSYCHOANALYTIC, Marxist, and FEMINIST positions. Perhaps the single best-known WORK appearing in *Screen* was Laura Mulvey's "Visual Pleasure and Narrative Cinema," published in 1975.

**SECOND-GENERATION FEMINISM** Second-generation feminist art and art writing originated in the early 1980s in the United States and Europe as an outgrowth of and a reaction to first-generation FEMINISM. It has extended into the present. Second-generation feminists reject their predecessors' presumption of a universal female experience and an identifiable feminine aesthetic. Their primary concern is with how visual REPRESENTATION influences the development and maintenance of GENDERED IDENTITY. They often incorporate TEXT into their WORK; they use images drawn from POPULAR CULTURE and often use POPULAR CULTURE venues to present their WORK; and many utilize electronic media in production and presentation of their WORK. First-generation feminists worked to unearth forgotten women artists of the past and to bring them and their contemporary counterparts to prominence by gaining them admission to either the art historical CANON or major art INSTITUTIONS such as museums and galleries. Second generation feminists have instead worked to change INSTITUTIONS that exclude women. For them, adding women to the CANON is not enough. One should first explore how INSTITUTIONS have functioned to exclude women and then work to change them. Second-generation feminist artists include Mary Kelly, Jenny Holzer, Barbara Kruger, Cindy Sherman, and the Guerrilla Girls. (See FEMINISM.)

**SELF-REFERENCE** See AUTONOMY and FORMALISM.

**SELF-REFLEXIVE** See AUTONOMY and FORMALISM.

**SELF-SUFFICIENCY** See AUTONOMY and FORMALISM.

**SEME** See SEMEME.

**SEMEME** In SEMIOTICS, the sememe is the smallest possible component of SIGNIFICATION. It can be a sound, a grunt, a brushstroke, a pencil mark, or a broken twig. STRUCTURALIST SEMIOTICS, especially in the linguistic paradigm, stresses the spoken utterance as the prime example of the sememe or seme. Roland BARTHES describes the sememe as being more or less interchangeable with the SIGNIFIER. Jacques DERRIDA had to invent his own equivalent to the seme for the written SIGN, which he called the GRAPHEME.

**SEMIC CODE** See CODE.

**SEMIOCLASM**   The literal or figurative activity of breaking apart something made of SIGNS. It can also be understood as a break in a chain of SIGNS brought about by an event such as a DECONSTRUCTION.

**SEMIOSIS**   According to SEMIOTIC THEORY, the process of SIGNIFICATION through the use of SIGNS.

**SEMIOTICIAN/SEMIOLOGIST**   One who practices SEMIOTICS or SEMIOLOGY.

**SEMIOTICS, SEMIOLOGY** From the Greek root *seme-*, meaning SIGN, a DISCIPLINE devoted to the study of SIGNS and the process of articulating and conveying meaning. Semiology or semiotics—depending on whether the particular approach is derived from the model of structural linguistics of Ferdinand de Saussure or from that of the American pragmatist Charles Sanders Pierce—studies the systems of SIGNS, the basic unit in the process of SIGNIFICATION, that enable human beings to communicate, to enter into discursive relations.

According to semiotic THEORY, all cultural utterances (in a broad sense, not just verbal utterances) are enabled as well as limited by systems or CODES that are shared by all who make and understand them. The goal of STRUCTURALIST semiotics is to describe the underlying patterns that structure those utterances. Semioticians study how SIGNS come to mean what they do and how they function in society, that is, the processes of SIGNIFICATION, or the material and social operations of the production of meaning. Strictly speaking, semiotics is not a method of interpretation.

According to Saussure's semiology, all SIGNS are made up of two parts, the SIGNIFIER (the material shape—sound, image—that carries meaning) and the SIGNIFIED (the concept SIGNIFIED, which in turn may refer to a potentially infinite number of referents). The SIGNIFIER can be an object, a mark, or a sound, and should be understood as separate from any possible meaning it may have. The SIGNIFIED, the conceptual component of the SIGN, is without FORM and independent or transcendent of any specific materiality. The REFERENT is that to which the SIGN, made of the combined SIGNIFIER and SIGNIFIED, refers. For example, the (spoken or written) word for the idea of rain in English is "rain," while in French it is "pluie." Both SIGNS refer to the same thing, which exists separately from the spoken or written words, but use different material terms to do it. In each case the sound or graphic component of the SIGN for rain is the SIGNIFIER, while the general idea of rain—the "essence" of rain, if you will—is the SIGNIFIED (see Saussure, *The Course in General Linguistics*, 65–98).

A semiotic analysis artificially splits the relationship of the SIGNIFIER and SIGNIFIED in order to show how the SIGNS and SIGNIFIERS differ from CULTURE to CULTURE, and to determine what transhistorical feature of CULTURES can explain those differences. The relationship of SIGNIFIERS to SIGNIFIEDS, as well as between SIGNS and REFERENTS, are "ARBITRARY," that is, not natural or necessary, but determined by CONVENTION. There are, however, some limits to the arbitrariness of SIGNS, some structures to language. One limit is that there is some "essential aspect" of the REFERENT that limits the usage of SIGNS. Another limit is the STRUCTURE of BINARY DIFFERENCE, that is, that at any one

point in time a SIGNIFIER relates to a SIGNIFIED due to the opposition of the SIGNIFIED to one other SIGNIFIED. For example, the SIGNIFIER "rain" signifies what it does in part because at one point in time, what is signified with "rain" is not what is signified with the signifier "shoe."

We could use Jacques-Louis David's *The Death of Socrates* (1787), as an example of a SIGN. The particular arrangement of stains of paint on a canvass, independent of their possible meanings, can be understood as a collection of SIGNIFIERS making up a larger SIGN. These stains signify human male bodies, clothing, furniture, architecture, a cup, and other objects. Taken as a whole, and on a strictly denotative level, the painting as a SIGN refers to a prison cell, due to its resemblance of human bodies in a space recognizable as a prison cell. On a connotative level, however, we can see the painting of human bodies in a prison cell as signifying something much more. Keeping in mind that the relationship of the SIGN to its REFERENT is determined by CONVENTION, and that the men in this painting were understood by David's French contemporaries to be Greek—Socrates and his followers in particular—the REFERENT of this painting-as-SIGN could be seen as self-sacrifice for the good of the State, or as a SIGN of revolution and progress.

In recent art THEORY and criticism, Saussure's THEORY of the SIGN has been far more discussed than that of Pierce. This is probably because semiotic THEORY did not enter the art world in any significant way (with the important exception of Roland BARTHES on photography) until the introduction of POST-STRUCTURALIST THEORY, which had as a primary concern the critique of Saussurean-derived semiotics. Nevertheless, Pierce's semiotic THEORY has received some attention, primarily by art historians. Pierce's THEORY consists of three types of SIGNS, INDEX, ICON, and SYMBOL, each distinguished by a particular relationship to its REFERENT. The INDEXICAL SIGN is caused by its REFERENT; for example, smoke is caused by fire. The ICON resembles its REFERENT in the way that a photograph shares some features of its SUBJECT. The relationship of a SYMBOL to its REFERENT is highly conventional and not at all natural; for example, the image of a light bulb has come to refer to an idea.

**SEMIURGY**   The process of constructing something from SIGNS. This notion of construction from SIGNS was propagated especially by the French sociologist Jean BAUDRILLARD.

**SEX/GENDER DISTINCTION**   In "A Critique of the Sex/Gender Distinction," originally published in 1983, Moira Gatens responds to an increased use in feminist scholarship of the distinction between SEX and GENDER. Prominent among those employing this distinction are Nancy Chodorow in *The Reproduction of Mothering*, Dorothy Dinnerstein in *The Mermaid and the Minotaur*, and Michele Barrett in *Women's Oppression Today*. Gatens's purpose in responding to this scholarship is threefold. First, she hopes to clarify the theoretical base of the distinction between SEX and GENDER. Second, she wishes to determine if the sex/gender distinction is a coherent and valid one. Third, she attempts to examine the political effects of the employment of the sex/gender distinction by groups of varied political persuasion.

Gatens tells us that the idea of GENDER has been found predominantly in Anglo-American feminist THEORY of the mid- to late-1980s. Theorists who favor

use of the category "GENDER" over "SEX" generally do so, she tells us, in order to avoid biologism or ESSENTIALISM. They argue that one must see GENDER as a social category and SEX as a biological one. She feels that, given the wide currency of the distinction by diverse groups in the 1980s (including Marxists, gays, and equity feminists, whom she calls "feminists of equality"), its use and "credentials" warrant critical reassessment.

Gatens asserts that SEXUAL DIFFERENCE—and thus SEXUAL politics—has been neutralized through the use of the sex/gender distinction. She takes issue with the assertion that the newborn's mind is a blank slate upon which CULTURE inscribes its norms, values, and so on, and that the BODY passively mediates such inscription. She wants to challenge the presumption of an ARBITRARY connection of femininity with the female BODY and masculinity with the male BODY, as well as the naive idea that, through re-education, the patriarchal CODES of one's CULTURE can be unlearned. What she posits as the "central issue at stake" and as "what appears to be one of the most burning issues in the contemporary women's movement" is the issue of "Sexual Equality vs. Sexual Difference" (Gatens, "A Critique of the Sex/Gender Distinction," p. 144). Gatens hopes to clarify the position of feminists who favor SEXUAL DIFFERENCE (a position that equity feminists commonly misrepresent) and to respond to and hopefully quash charges of ESSENTIALISM and biologism against DIFFERENCE feminists. Equity feminists, she contends, tend to position theoretical stances at one pole or the other of a BINARY OPPOSITION, regarding views as either constructionist or ESSENTIALIST. As she sees it, the task is to reopen the debate and argue for a politics of DIFFERENCE. This is her goal. But, first, she feels it necessary to critique the position of those who support "degendering."

Gatens proceeds with her critique via a short summary of the ideas of psychoanalyst Robert J. Stoller, author of *Sex And Gender* (1968). Stoller's project was to study nonnormative biological and psychological states to illuminate the relationship of SEX and GENDER. As a result of his research, he purports to have accounted for the origins of the behavior of transvestites and transsexuals. He views transsexualism as wholly the result of social forces, with the primary cause being the way that the mother relates to the child resulting in the inability of the male child to separate from the mother and develop a sense of his own individuality. The child identifies with the mother to such a degree that he comes to see himself as a woman trapped in a man's BODY. Gatens notes that a number of feminist theorists, including Kate Millet in *Sexual Politics* and Germaine Greer in *The Female Eunuch*, have used Stoller's research and conclusions as the basis of a social constructionist view that posits masculine behavior as arbitrarily ascribed to the biological male and feminine behavior as arbitrarily ascribed to the biological female. She finds the acceptance of Stoller's ideas unsurprising, given the liberal humanist CONTEXT of the late 1960s and early 1970s. However, by the early 1980s it had become increasingly less tenable to accept such assertions as based in scientific fact and more and more apparent that they were the products of a specific historical CONTEXT, that of eighteenth- and nineteenth-century liberal humanism.

In order to adopt the view that degendering is possible, Gatens contends that one must accept two assumptions. First, one must adopt the ahistorical rationalist view that the BODY has no influence on the formation of consciousness. The

BODY must be seen as "neutral and passive" and consciousness as "primary and determinant" (Gatens, "A Critique of the Sex/Gender Distinction," pp. 146–147). Second, one must think that, by changing the material practices of a CULTURE, "the important effects of the historical and cultural specificity of one's 'lived experience,' is able to be altered, definitively" (Gatens, p. 147). If these assumptions are accepted, she tells us, then one could claim that both the consciousness and the BODY it acts upon are initially neutral; and, further, one could contend that "masculine and feminine behaviours are arbitrary forms of behaviour, socially inscribed on an indifferent consciousness that is joined to an indifferent body" (Gatens, p. 147). Gatens then goes on to analyze these two assumptions.

Gatens contends that the sex/gender distinction is situated in the nature versus nurture debate (or, in her terms, "heredity vs. environment") and the "confused terminology" and concepts that characterize it (Gatens, "A Critique of the Sex/Gender Distinction," p. 147). Socialization theorists, she explains, understand the sex/gender distinction as a distinction between BODY and consciousness, thus committing themselves to a series of historically untenable assumptions. Theorists who adopt a mind/BODY distinction consistently align themselves with one side or the other of the equation. They adopt either a wholly social constructionist view or a wholly biologist orientation. Gatens points out that both positions "posit a naive causal relation between either the body and the mind or the environment and the mind which commits both viewpoints, as two sides of the same coin, to an *a priori*, neutral and passive conception of the subject" (Gatens, p. 147). This leads to a behaviorist conception of the human SUBJECT; and, as Gatens points out, there is no proof that the behaviorist concept of conditioning can be validly applied to human, as opposed to animal, SUBJECTS. A behaviorist model assumes a consistent response by a SUBJECT to a particular stimulus. PSYCHOANALYSIS, Gatens points out, "read as a *descriptive theory* of the constitution of subjectivity in (Western, industrialized) patriarchal society," does not support such a behaviorist view of the human as a passive SUBJECT consistently and predictably amenable to such conditioning (Gatens, p. 148). The PROBLEMATICS of mind/BODY interaction are one of the factors out of which PSYCHOANALYTIC THEORY arose. Freud's preoccupation with hysteria is given as evidence of his concern with this problem. What the behaviorist view does not account for is the non-passive nature of perception. Freud argues that perceptual processes are active rather than passive and cannot be equated wholly with either consciousness or the BODY. Further, most of what the individual perceives does not enter consciousness but exists, instead, at the UNCONSCIOUS level. The activity of perception is the activity of an individual SUBJECT and cannot be accommodated in the behaviorist's account. Gatens adds that, if behaviors and social practices are located in the SUBJECT, instead of in the BODY or in consciousness, "then this has important repercussions for the subject as always a *sexed* subject" (Gatens, p. 148). All of this leads Gatens to conclude that the behaviorist notion of a passive SUBJECT that is central to the idea of degendering "is demonstrably inadequate to account for human behavior and, in particular, the activity of signification" (Gatens, pp. 149–150).

**SEXUALITY/SEXUAL IDENTITY**   Recent feminist theorists have critiqued the necessary linking of SEX and GENDER. They have attempted to show how sexuality, or expression of one's sexual identity, is not a natural and neces-

sary expression of one's biological SEX. Noteworthy among such theorists is Judith Butler (see PERFORMANCE/PERFORMATIVE/PERFORMATIVITY).

**SIGN** See SEMIOTICS/SEMIOLOGY.

**SIGNIFICANT FORM** See AESTHETIC EMOTION.

**SIGNIFICATION** From the SEMIOTIC perspective, the construction of meaning through the use of SIGNS. These SIGNS can be spoken or written words, but can just as well be painting, sculpture, PERFORMANCE, photographs, or any of the materials or methods common to the visual arts.

**SIGNIFIED** See SEMIOTICS/SEMIOLOGY.

**SIGNIFIER** See SEMIOTICS/SEMIOLOGY.

**SIGNIFYING PRACTICE** Any activity that uses SIGNS and produces MEANING or significance on a cultural or interpersonal SCALE.

**SIMULACRA/SIMULACRUM** See SIMULATION.

**SIMULATION** A COPY or REPRESENTATION. In the mid 1980s, some critics were asserting that there was a style or movement in artistic practice called "Simulationism" or "Simulation Art." This activity, exemplified by the WORK of Peter Halley and Haim Steinbach, was influenced by the theoretical writings of French sociologist Jean BAUDRILLARD. To BAUDRILLARD, simulacra are COPIES, or REPRESENTATIONS. These COPIES are the result of the use of SIGNS in REPRESENTATIONS that are so convincing they threaten to replace that which they ostensibly represent.

**SITE** Another term for location, usually used figuratively in contemporary THEORY to indicate a set of particularly embattled themes or topics.

**SLIPPAGE** A term used to indicate the moment within a TEXT when the conventional relationships of SIGNS and REFERENTS become questionable and begin to appear conventional rather than natural and a matter of course. (See HINGE and PLAY.)

**SPEAKING SUBJECT** Building on the ideas of Freud, French psychoanalyst Jacques LACAN developed a THEORY of human development in which the acquisition of language is central to the development of individual SUBJECTIVITY. LACAN replaces the Cartesian privileging of thought, of man as thinking being, with the speaking SUBJECT, which is defined in and by language.

**SPECTACLE** In FEMINIST FILM THEORY, woman is the object of SPECTACLE in the classical Hollywood cinema. In "Visual Pleasure and Narrative Cinema," Mulvey theorizes that Hollywood CONVENTIONS of cinematic practice construct the GAZE as male. The female BODY acts as the FETISHIZED object of the MALE GAZE, and those in the audience necessarily take on the role

of masculine VOYEUR. Further, the combination of NARRATIVE and spectacle (the functions of showing and telling) reflect a system of SEXUAL imbalance in which the male is the active SUBJECT and the female is the passive object (see FEMINIST FILM THEORY).

**SPECULAR/SPECULARIZATION** The concept of the specular, or specularization, which literally referring to the properties of a mirror, has taken on a particular meaning in contemporary FILM THEORY and in feminist cultural DISCOURSE. It has come to denote the "to-be-looked-at-ness" of the woman in classical Hollywood cinema, who serves as the object of the dominating MALE GAZE (see FEMINIST FILM THEORY and MALE GAZE). Feminist film theorists often refer to the operations of the MALE GAZE and its male/female, ACTIVE/PASSIVE BINARY STRUCTURE, which works to produce and maintain GENDER distinctions as the "specular regime" of film.

Film theorist Kaja Silverman asserts in *The Acoustic Mirror: The Female Voice in Psychoanalysis and Cinema* that the history of film has "coincided with the ever-increasing specularization of woman." She states further that she "would argue that cinema has contributed massively to what might be called the 'revisualization' of sexual difference" (Silverman, *The Acoustic Mirror*, p. 24). This increased specularization of women, she asserts, was accompanied by a *de*-creased specularization of men. Silverman cites J. C. Flugel's assertion in *The Psychology of Clothes*, that this "Great Masculine Renunciation" involved more than apparel. It involved, as well, the collapse of CLASS distinctions and of visible designation of social rank and status. According to Flugel, such visible SIGNS of distinction were replaced by a SYMBOLIC order, through which POWER was more dispersed, less material, and thus less easily identified and located.

**SPIRITUAL FEMINISM** See GODDESS ART.

**STAR SYSTEM** The commercial and aesthetic exploitation of the charisma of POPULAR actors, combining the appeal of both their on-SCREEN and their off-SCREEN personas. The star system was developed in the United States and has been one of the pillars of the American film industry since the mid-teens.

**STEREOTYPE** In the late 1700s, a new printing process was developed called the stereotype. The process duplicated letters, numbers, and SYMBOLS onto a metal plate, bypassing the tedious process of "setting" moveable blocks of type. Soon "stereotype" came to mean anything in an edition, or a series of copies. In the nineteenth century the word acquired a meaning similar to the current one: an image that is repeated, fixed, perpetuated, or continued without change—a formula.

Producing and reproducing convincing images of ethnic groups is an unchallenged ability of the POPULAR media. Perhaps this is due to their technological nature: photography, film, and television are assumed to share a basic ability to directly and immediately "COPY" images from nature. But these media, whether in the service of science, advertising, or entertainment, have also provided us with numerous stereotypical representations of ethnic DIFFERENCE. The stereotypical image isolates prominent visual characteristics of its object and substi-

tutes those for the object itself. As such, the stereotype is a kind of one-dimensional COPY.

A vague resemblance to historical fact is an important aspect of all stereotypes. Just as the first stereotypes were copies of an original, media stereotypes of ethnic groups "resemble" their origins. The important difference is that these stereotypical representations of ethnic groups also have origins in the often unspoken and invisible political attitudes and historical events that belong to the populations producing and consuming these images. Stereotypes do not simply "reflect" African Americans or Native Americans as ready-made realities. In all categories of image production, whether "mass media" or "fine art," stereotypes also create meanings about what they are used to depict. To a great extent, the production and reproduction of stereotypical imagery are an expansion of the mechanisms of colonization, control, and social exclusion of particular ethnic groups. One ominous meaning produced by the stereotype is that the original, which it ostensibly depicts, is dispensable and can be erased by its COPY.

A number of contemporary artists have drawn on stereotypical images from the POPULAR media in their WORK. They include Native American artists Jimmie Durham, James Luna, and Harry Fonseca, African-American artists Betye Saar, Lorna Simpson, and Robert Colescott, and Chicana/o artists Ester Hernandez and Rupert Garcia.

**STRAIGHTJACKET STYLE**   The phrase "straightjacket style" was coined by Samuel Wagstaff to describe the controlled and contained nature of the female BODY as seen in Robert Mapplethorpe's photographs of body-builder Lisa Lyon. In her analysis of Mapplethorpe's WORK, Lynda Nead contends that such qualities as Wagstaff observes in the photographer's portraits of Lyon are typical of all of Mapplethorpe's WORK. She further observes that such images may be seen as examples of how REPRESENTATION can act as a form of regulation of the female BODY. Such contained, controlled images of women, Nead contends, pose no threat to patriarchal order and serve to reinforce a view that the female BODY must be constantly controlled (Nead, *The Female Nude: Art, Obscenity and Sexuality*, pp. 8–10).

**STRUCTURALISM/STRUCTURALIST**   See STRUCTURE, SEMIOTICS, and DECONSTRUCTION.

**STRUCTURE**   The notion of structure is not unique to STRUCTURALIST SEMIOTICS, with its insistence on certain operations that limit the arbitrariness of SIGNIFICATION. The term is also used more generally and loosely in a number of other contexts. Structure seems at times to indicate organization, as when we say that a painting's composition is achieved through the structure of the elements of visual FORM. Structure can also indicate some general force or law that limits and organizes a large number of cultural phenomena. As the term structure implies, this law or force is often understood to lie, figuratively, beneath the surface appearances or beyond the abilities of humans to perceive. Examples include the general notions of the subconscious and the UNCONSCIOUS, as well as the idea of a historical spirit. Any theoretical position that implies such a "depth model" can be loosely termed STRUCTURALIST. (See also SEMIOTICS, DECONSTRUCTION, and POSTSTRUCTURALISM.)

**STUDIO ERA**  The period (roughly from 1925 to 1955, but especially the 1930s and 1940s) when most American NARRATIVE films were produced under the auspices of the big studios, such as MGM, Paramount, and Twentieth Century Fox. (See also FILM THEORY.)

**STUDIUM AND PUNCTUM**  Roland BARTHES claims that our fascination with photographs stems from two distinct qualities of the photographic image: *Studium* and *Punctum*. *Studium* is that which is CODED in the photograph. It is that very wide field of unconcerned DESIRE, various interest, and inconsequential taste, exemplified by phrases like "I like it" and "I don't like it." *Studium* mobilizes a "half DESIRE," the vague, irresponsible interest one takes in people, entertainment, books, and clothes. *Punctum* is an element of surprise, the aspect of the photograph that "pricks" the observer, getting his or her attention. *Punctum* also produces a lingering impression, evoking a "subtle beyond" and causing us to speculate about the SUBJECT beyond the photograph.

**SUBALTERN**  The word "subaltern" is often used as a label for individuals who have been marginalized (see MARGINALITY, and RADICAL ALTERITY).

**SUBJECT/SUBJECTIVITY**  Recent use of the term "subject" refers to the individual's sense of self. With the questioning of the concept of AUTONOMY and of the liberal humanist conception of individuality in recent cultural THEORY, the term "subject," which designates one possessed of subjectivity, has come to replace "individual" and the accompanying term "individuality."

THEORY regarding the subject and subjectivity has arisen out of the ideas of ALTHUSSER and the WORK of other French philosophers, including Jacques LACAN, Michel FOUCAULT, and Jacques DERRIDA. Many of their concerns found their basis in Marxist THEORY and in existential philosophy as practiced by Jean-Paul Sartre and Simone de Beauvoir. Within this theoretical CONTEXT the subject is the product of INTERPELLATION, which is described by Marxist philosopher Louis ALTHUSSER as a process that operates through ideological mechanisms produced by the state (see INTERPELLATION). Using a BASE/SUPERSTRUCTURE model of Marxism, ALTHUSSER discussed the role of IDEOLOGY in the formation of individual subjects. He described the functioning of REPRESSIVE STATE APPARATUSES (police, the military, penal systems, and so on) and IDEOLOGICAL STATE APPARATUSES (the family, religion, the educational system, and so on) as mechanisms that work together to produce SUBJECTS who act in harmony with society.

Also important to the development of THEORIES of subjectivity have been LACAN'S psychoanalytically based THEORY, which takes the infant's establishment of a sense of self through recognition of its own mirror image as one of the central events of human development; and FOUCAULT'S conception of the individual as both subject to and subject of DISCURSIVE REGIMES of POWER. Particularly relevant to subject formation are FOUCAULT'S archaeological and genealogical methods, his conception of POWER as produced by SUBJECTS through self-SURVEILLANCE, and the role of the BODY as locus of POWER in such processes. DERRIDA'S critique of REPRESENTATION and his idea of

DIFFÉRANCE have also proved crucial to the development of such THEORIES (see DIFFÉRANCE).

A number of recent feminist theorists have made the processes of subject formation the focus of their WORK. Philosophers Judith Butler and Elizabeth Grosz have concerned themselves with the production of GENDERED subjectivity. In "Contemporary Theories of Power and Subjectivity," Australian philosopher Elizabeth Grosz argues that, if feminist theorists are to be effective in the strategies they develop and deploy, they need an understanding of how subjects are produced. This will necessarily involve an examination of how POWER operates in contemporary CULTURE because, if feminists are to use constructions of POWER against themselves and against each other, if they are to develop new THEORIES and methodologies regarding the operations of POWER, they must first understand how constructions of POWER are formulated and how they function to produce subjects. Feminist artists who have produced WORK that examines those processes of REPRESENTATION that go into the formation of subjectivity include Barbara Kruger, Jana Sterbak, and Cindy Sherman.

**SUBTEXT**   Based on the implicit spatial model in PSYCHOANALYTIC THEORIES of the relationships of the conscious and the subconscious, a subtext refers to the story or stories that may be implied in a TEXT in addition to the ostensible one.

**SUPPLEMENT**   One of Jacques DERRIDA'S main concerns is the habitual rhetorical operation in Western philosophy of opposing terms in an argument. According to DERRIDA, the terms are positioned in such a way as to suggest that the first term of the pair is ontologically prior to and philosophically preferred to the second term, which acts as a supplement to the first. He finds examples of this in important texts in European philosophy, such as the Socratic dialogues, where Socrates opposes speech and writing as part of his argument on his preference for speech over writing. To DERRIDA, the outcome of Socrates' argument is determined in advance by the opposition of speech and writing. Speech finds support in the argument, while writing is clearly not preferred, and in fact is seen as a mere supplement to speech. Other conceptual pairs of significance throughout European CULTURE include male/female, CULTURE/nature, good/evil, light/dark, and rational/irrational. In the visual arts, examples are figure/ground, positive space/negative space, linear/painterly, color/design, and, of course, FORM/CONTENT.

**SURVEILLANCE**   See DISCIPLINE.

**SUTURE**   In his explanation of human development, which relies on the pivotal concept of the MIRROR STAGE, Jacques LACAN uses the idea of suture, the stitching up of the sides of a wound, to describe the meeting of the IMAGINARY and the SYMBOLIC. (See MIRROR STAGE, IMAGINARY, and SYMBOLIC.)

**SYMBOL**   In the SEMIOLOGY/SEMIOTICS of Charles Pierce, a symbol is a SIGN that demands neither resemblance to its object nor an existential bond with it, but is ARBITRARY, UNMOTIVATED, and  operates by CONVENTION. In its more common, literary usage, SYMBOL refers to a figurative device or TROPE,

an image that means something more or something else, than its literal meaning, usually referring to something immaterial such as an idea or conception.

**SYMBOLIC** French psychoanalyst Jacques LACAN (1901–1981) revised Freud through SEMIOTIC THEORY by centering his THEORIES of the SUBJECT and PSYCHOANALYSIS on language. Since an analyst works with a patient's statements and repeated (ENCODED) behaviors, SIGNS are really all that is available to him/her. As a child develops the ability to use language (SIGNS), the child becomes socialized. In his "rewriting" of Freud, LACAN introduced several important concepts into PSYCHOANALYTIC DISCOURSE, which are useful to those interested in the processes of socialization, especially GENDER formation. One such concept is the Symbolic. The Symbolic is a linguistic stage of development. It includes social order and law, symbolically embodied by the father, and is characterized by a mediated experience of the world and development of an IDENTITY of the self that is separate from the mother. The development of the UNCONSCIOUS occurs during this stage, due to the repression of the sense of loss of the mother.

Mary Kelly is a contemporary artist who has used LACANIAN THEORY in her WORK. Most notable is her use of LACAN'S concepts of the IMAGINARY, the REAL, the Symbolic, and the MIRROR STAGE in *Post-Partum Document*, an installation that deals with the birth and early childhood of her son and her relationship to him.

**SYNCHRONIC** See DIACHRONIC AND SYNCHRONIC.

**SYNTAGMATIC AND PARADIGMATIC** According to Ferdinand de Saussure's SEMIOTIC THEORY, the relationships of SIGNS can be described using these two terms. A paradigmatic relationship describes the relationships of SIGNS that can replace one another in a sentence. For example, in the sentence "The girl kicked the ball," "girl" could be replaced with "boy," and "ball" could be replaced with "cat," with a significant change in the meaning of the sentence. A syntagmatic relationships describes the relationship of SIGNS in sequence and in combination. These relationships are sometimes understood in more visual terms as vertical (paradigmatic) and horizontal (syntagmatic). These relationships are handy in understanding film and video in SEMIOTIC terms, that is, as a series of image-SIGNS that have relationships to one another in a series and that can be substituted for one another to obtain different meanings.

# T

**TABLEAU SPACE** (from the French *tableau*, meaning picture, painting, scene). Historically tableau space refers to the conception of cinematic space prevalent in the so-called primitive period, before the invention of editing caused the image to be broken down into a series of shots varying in distance, height, and angle. Closest to the construction and perception of space in theater, thus usually a static long shot, this type of image contains everything that is relevant to the NARRATIVE, that is, a rather complex MISE-EN-SCÈNE.

**TELEOLOGY** Teleology is a variant of the older idea of a design or purpose, also called a *telos*, in nature. Any THEORY that sees history as progressing toward a particular point or goal as a matter of necessity is called a teleology. In the history and criticism of art, a particularly good example of teleology can be found in Clement Greenberg's understanding of art history, which he presents as gradually progressing toward "pure" modernist painting. The development and eventual dominance of abstract painting, then, is not simply a choice or preference of artists, but is seen by Greenberg and others as a matter of historical necessity.

**TELOS** See TELEOLOGY.

**TEXT** Traditionally, the term "text" refers to written material. However, largely as a result of the writing of literary theorist Roland BARTHES, the term has taken on new CONNOTATIONS with the application of SEMIOTICS to all manner of cultural production. The application of the word "text" to a WORK of visual art does not mean that the WORK of art is being "reduced to" a text, or is being seen as a text in any literal fashion. It simply means that the art object, once seen as a WORK—a term that stresses the materiality of the object and the hand of the artist—is now often seen as an organization of signifying material in the SEMIOTIC sense.

**TEXTUALIST** Having the character of a TEXT.

**THEATRICALITY** In the visual arts, this term has been associated almost exclusively with the writing of Michael Fried. In his "Art and Objecthood," published in *Artforum* in 1967, theatricality enters the DISCOURSE on contemporary art, along with OBJECTHOOD and PRESENTNESS. Fried used these terms to describe problems he saw with minimal art. Minimal art is theatrical, that is, it requires a "stage PRESENCE," more aggressively establishing its "public character" as art. This theatricality is produced by the size of the WORK relative to the viewer, or its scale. Large-scale WORK distances the viewer, creating a space in which it is not clear whether the artwork remains the CENTER of attention. As many critics, such as Hal Foster, later pointed out, theatricality also allows the relationships of art to INSTITUTIONS to be seen—literally and figuratively—more readily, thereby threatening notions of the AUTONOMY and SELF-SUFFICIENCY of art.

Fried also understood theatricality as a threat to the concept of artistic excellence. Excellence, in fact the very concept of art, is meaningful only within the individual arts. What lies between the arts is theatre, and art degenerates as it approaches the condition of theatre. Using minimal art as an example, monochromatic paintings constructed with very thick stretcher frames verge upon being seen as sculpture. Similarly, modular sculptural forms mounted on walls can be mistaken for paintings. The success of modernist art depends on its ability to defeat theatre.

**THEORY** In recent DISCOURSE on the visual arts, the term has come to designate any number of critical positions that may or may not be "theoretical" in a narrow sense. These positions include concepts from one or more disciplines such as GENDER THEORY, FILM THEORY, LITERARY THEORY, DISCOURSE ANALYSIS, POSTCOLONIAL DISCOURSE, CULTURAL STUDIES, BAKHTINIAN DIALOGICS, REVISIONIST ART HISTORY/NEW HISTORICISM, MARXIST LITERARY THEORY AND CRITICISM, and PSYCHOANALYTIC THEORY and CRITICISM.

**TOTALIZING DISCOURSE** A totalizing discourse is one that attempts to occupy the total ground of the argument, thereby eliminating the possibility of any opposition from those it excludes.

**TRACE** Jacques DERRIDA has used writing in general as an example of trace, although, strictly speaking, trace does not exist. As part of his critique of the preference in Western thinking for PRESENCE over ABSENCE, DERRIDA introduces "trace" as a way to argue that what seems to be PRESENCE is actually dependent upon ABSENCE. Extending Saussure's THEORIES on SIGNS, DERRIDA argues that no SIGN is fully present, since it is dependent upon the ABSENCE of that to which it refers. Although the SIGN, as exemplified by a brushstroke, is present, that PRESENCE is complicated by the fact that the SIGN is a only a trace of that which is absent, the artist.

**TRANSCENDENTAL SIGNIFIER/SIGNIFIED/SUBJECT** The term "transcendental" indicates something that it is thought to lie beyond REPRESENTATION. Two prominent examples of transcendental SUBJECTS are

God and nature. The term "transcendental" has developed another CONNOTATION, stemming from Jacques DERRIDA'S critique of STRUCTURALIST SEMIOTICS. To DERRIDA, SEMIOTIC THEORY depends upon the notion of the CENTER to stabilize any possible arbitrariness of the meaning of REPRESENTATIONS. This implies that the CENTER itself is not a mere REPRESENTATION, but transcends REPRESENTATION. However, as DERRIDA points out in his explanation of DECONSTRUCTION, this is a problem, since "CENTER," for all practical purposes, is itself first and foremost a REPRESENTATION.

**TRANSGRESSION**   Transgression involves surpassing the limits of oppositional thought. A transgressive strategy constitutes an attempt to "denaturalize," that is, to reveal the contingent foundations of what is culturally regarded as necessary and natural. An artist employing a transgressive strategy regards the art WORK as a TEXT that exists at the intersection of various DISCOURSES. Much recent visual art has taken as its task an analysis of those discursive STRUCTURES that have traditionally made up the culturally privileged category of fine art. These discursive STRUCTURES include traditional CONVENTIONS for REPRESENTATION of the nude, particularly the female nude. Such CONVENTIONS in Western art, like many other cultural CONVENTIONS, tend to reproduce a male/female polarity, constructing the viewer as active and male and the SUBJECT as passive and female. A transgressive act fails to align itself along this male/female, ACTIVE/PASSIVE, positive/negative axis. An example can be found in the WORK of contemporary photographer John Coplans, who portrays his aging male BODY in various characteristically "feminine" poses in his experiments with CONVENTIONS of REPRESENTATION of the female nude. For Coplans, the photographic REPRESENTATION of the BODY functions as a TEXT. The language he transgresses is the visual language constituted by the CONVENTIONS developed in Western art for REPRESENTATION of the BODY. Coplans denaturalizes these CONVENTIONS that serve to produce a naturalized female SUBJECT, a female SUBJECT that is necessarily and naturally "feminine."

Cultural theorists Peter Stallybrass and Allon White assert in *The Politics and Poetics of Transgression* that cultural IDENTITY is determined by limits: "[cultural identity] is always a boundary phenomenon and its order is always constructed around the FIGURES of its territorial edge" (Stallybrass and White, p. 200). They draw on the THEORIES of French philosopher Michel FOUCAULT, who describes a transgressive act as "an action which involves the limit, that narrow zone of a line where it displays the flash of its passage, but perhaps also its entire trajectory, even its origin; it is likely that transgression has its entire space in the line it crosses" (FOUCAULT, "A Preface to Transgression," pp. 33–34). However, FOUCAULT says further that transgression does not partake of the Hegelian dialectic, that is, it does not involve the opposition of one thing to another. According to FOUCAULT, in a transgressive act "what is in question is the limit rather than identity of a culture" (FOUCAULT, "Preface to Transgression," p. 33).

Stallybrass and White define a transgressive act as one that undoes the hierarchical and stratifying cultural DISCOURSES constructed by those in POWER as mechanisms of dominance and that function through the BODY as SITE of inscription. They say further that this "hierarchy of sites of discourse" must be challenged and control of such sites assumed if any cultural transformation is to

occur. Such contestation, they point out, usually comes from classes and groups in subordinate or marginal positions. In their argument, which is formed in terms of the THEORIES of Russian linguist and cultural theorist Mikhail Bakhtin regarding CARNIVAL, the carnivalesque (displayed in its many cultural forms, including Mardi Gras, medieval folk festivals, and numerous communal rituals of Western CULTURE) constitutes the SEMIOTIC realm of inquiry. The "GROTESQUE BODY" as displayed in CARNIVAL constitutes the SITE of DISCOURSE. Bringing the "low" (represented by the GROTESQUE BODY) high constitutes an act of transgression within the CONTEXT of CARNIVAL. Such a structural inversion, which subverts the HIERARCHY that establishes cultural order, effects an act of resistance.

**TRANSGRESSIVE STRATEGY** See TRANSGRESSION.

**TRANSPARENT/OPAQUE** When a REPRESENTATION is constructed in such a way that it draws little or no attention to itself as a REPRESENTATION, it is said to be "transparent." This especially useful in mimetic REPRESENTATION, when one is trying to produce a convincing duplication of a SUBJECT. When a REPRESENTATION is constructed in such a way that it draws so much attention to itself as a REPRESENTATION that it no longer functions well as a REPRESENTATION, it is said to be "opaque." These terms work through an implicit reference to a pane of glass in a window. The glass is usually not noticeable, unless it is constructed in such a way that it cannot be seen through. Opaque use of REPRESENTATIONAL devices is a key technique of DEFAMILIARIZATION.

**TROPE** A figure of speech in RHETORIC (e.g., METAPHOR, SYMBOL, synecdoche, or ALLEGORY); a connotative twist of meaning that relies on a tradition, a historical awareness of diction or, in painting and film, ICONOGRAPHY.

**TRUTH, IN THE** Michel FOUCAULT makes a distinction between "Truth" and "being in the truth." He does this to describe how INSTITUTIONS regulate discursive production by testing all utterances against sets of criteria commonly accepted in each DISCIPLINE. When a statement is acceptable to a DISCIPLINE, it may be said to be true. In such an event, the statement gains great POWER. To FOUCAULT, however, statements are not necessarily true; they are "in the truth," that is, they are acceptable to members of an INSTITUTION as valid statements, and so they take on the POWER of truth. FOUCAULT does not deny there is truth—at least not exactly—but affirms that truth is "of this world," a product of discursive DISCIPLINE.

# U

**UNCONSCIOUS** The unconscious is a common subject of discussion when viewing and interpreting visual art, since artistic expression is often seen as an expression of the individual artist's unconscious. Often at issue is the discrepancy between what an artist asserts is his/her conscious intent and what is produced. The artist's product may appear to the viewer to contradict the meaning the artist ascribes to the WORK. In a PSYCHOANALYTIC view, this discrepancy results from the fact that the unconscious is not under the artist's control; as a consequence, he/she may produce works that express unconscious feelings, drives, wishes, and so on.

For Freud, the unconscious is that part of the human psyche that is repressed, and does not reach the conscious level, but is instead expressed in dreams, FANTASY, FETISHES, art, and other SYMBOLIC forms. Building on Freud's ideas, French psychoanalyst Jacques LACAN developed his idea of the unconscious on a linguistic model. LACAN defined the unconscious as "that part of the concrete discourse, in so far as it is trans-individual, that is not at the disposal of the subject in re-establishing the continuity of his conscious discourse" (Lacan, *Ecrits*, p. 49). LACAN also used Claude Levi-Strauss's ideas regarding the unconscious as operating through a SYMBOLIC function and acting as a matrix through which CODED messages operate.

In *The Political Unconscious* Fredric Jameson applies the Freudian conception of the unconscious to an analysis of CULTURE as a system of SIGNS and as a system that exhibits the same features of the unconscious as the individual SUBJECT, such as censorship and repression. Jameson's work has influenced a number of artists who have been seen to express facets of POSTMODERN POPULAR CULTURE, such as Jeff Koons, Cindy Sherman, and Jenny Holzer.

**UNFOLDING** A term used by many theorists to indicate the qualities of a TEXT that allow one to access, enter, or "unpack it" in a figurative sense.

**USEFUL BODY** See DISCIPLINE.

# V

**VAGINAL ICONOGRAPHY** See CENTRAL VOID AESTHETIC.

**VISION/VISUALITY** In recent criticism and THEORY of visual REP-
RESENTATION a distinction has been made between vision and visuality. While
vision suggests sight as a physiological operation and visuality suggests a social
operation, the two are not opposed as Nature and CULTURE. Vision is also his-
torical, and visuality also involves the BODY. The use of these terms, however,
seeks to distinguish between the mechanism of sight and the data of vision on
the one hand, and the historical and discursive determinations of vision on the
other. Writing primarily about MODERNISM, philosopher Martin Jay developed
the concept of the "scopic regime" in his 1988 "Scopic Regimes of Modernity."
Each scopic regime seeks to eliminate the differences between vision and visual-
ity in order to place all socially produced visualities into one HIERARCHY of
natural sight. The ultimate purpose of this rhetorical activity in the European
tradition has been to produce powerful and persuasive REPRESENTATIONS—
REPRESENTATIONS based upon "the REAL." Jay points out many different
scopic regimes, with "Cartesian" perspectivalism being a particularly prominent
example. He speculates on the relationship of scopic regimes and IDEOLOGY,
suggesting that the "perspectivalist regime" may be complicitous with the bour-
geois IDEOLOGY of the isolated and self-sufficient SUBJECT, a SUBJECT that
fails to recognize both its INTERSUBJECTIVITY and its embeddedness in the his-
torical world of SIGNIFICATION. Based primarily on Michel FOUCAULT'S idea
of a DISCURSIVE REGIME, a "scopic regime" describes certain regularities of the
arrangement of materials within otherwise quite different forms of visual
REPRESENTATION. Just as an analysis of various DISCOURSES may reveal simi-
larities through the common uses of FIGURES of speech, and so be part of the
same *EPISTEME*, so the repetition of certain visual CONVENTIONS may be used
to link visual REPRESENTATIONS to the same *EPISTEME*.

**VOICE** The issue of how and under what circumstances those positioned as
OTHER by a DOMINANT CULTURE may be allowed a "voice" has become a cen-

tral concern of recent FEMINIST, MULTICULTURAL, and POSTCOLONIAL theorists. The concern is whether individuals who are members of oppressed groups are allowed to voice their opinions and communicate their needs to those in POWER. Also at issue is whether it is possible to rewrite the history of such groups, who have been effectively written out of history as formulated by the DOMINANT CULTURE. In "Can the Subaltern Speak?" Gayatri Chakravorty Spivak questions whether it is even possible for a SUBALTERN voice that is not an ESSENTIALIST FICTION to develop. Spivak's conclusion is that, since "the colonized subaltern subject is irretrievably heterogeneous," any unified voice representative of the SUBALTERN may prove impossible (p. 26). Related to Spivak's idea is the thorny question of whether the very value placed on voice is not ultimately a PHALLOGOCENTRIC value conferred by EUROCENTRIC CULTURE.

**VOYEURISM** In PSYCHOANALYTIC parlance, the voyeur is one who derives PLEASURE from looking. The PLEASURE derives from satisfaction of the SCOPOPHILIC drive which objectifies the one being watched (see SCOPOPHILIA, and FEMINIST FILM THEORY). In FEMINIST FILM THEORY, voyeurism is seen as a particularly masculine form of PLEASURE, because it enables dominance. The viewer's GAZE, which is constructed as male in the classic Hollywood cinema, allows the spectator the distance necessary to an empowering sense of control over the female who is being viewed. Christian Metz describes how the voyeur must maintain distance between himself and what he views, since a gap is necessary for the generation of DESIRE: "If it is true of all desire that it depends on the infinite pursuit of its absent object, voyeuristic desire, along with certain forms of sadism, is the only DESIRE whose principle of distance symbolically and spatially evokes this fundamental rent" (Metz, "The Imaginary Signifier," p. 61). Metz asserts that such "meta-DESIRE" is characteristic not only of film, but of other visual arts such as painting.

# W

**WORK**  See TEXT.

**WRITERLY**  See READERLY and WRITERLY TEXTS.

# SELECTED BIBLIOGRAPHY

Adorno, T. W. *Aesthetic Theory*. London and Boston: Routlegde & Kegan Paul, 1984.

Adorno, T. W. *The Culture Industry: Selected Essays on Mass Culture*. London: Routledge, 1991.

Alcoff, Linda. "Cultural Feminism Versus Post–Structuralism: The Identity Crisis in Feminist Theory." *Signs: Journal of Women in Culture and Society*, vol. 13, no. 3 (1988): 405–436.

Althusser, Louis. "Ideology and Ideological State Apparatuses." In *Lenin and Philosophy and Other Essays*, pp. 121–173. New York: Monthly Review, 1971.

Arnason, H. H. *History of Modern Art*. New York: Abrams, 1986.

Atkins, Robert. *Artspeak: A Guide to Contemporary Ideas, Movements, and Buzzwords*. New York: Abbeville Press, 1990.

Atkins, Robert. *Artspoke: A Guide to Modern Ideas, Movements, and Buzzwords*. New York: Abbeville Press, 1993.

Bakhtin, Mikhail. *Rabelais and His World*. Trans. Helene Iswolsky. Bloomington: Indiana University Press, 1984.

Baldick, Chris. *The Concise Oxford Dictionary of Literary Theory*. Oxford and New York: Oxford University Press, 1990.

Barrett, Michele. *Women's Oppression Today*: *Problems in Marxist Feminist Analysis*. London: Verso, 1980.

Barthes, Roland. "The Death of the Author." In *Image Music Text*, pp. 142–148. Trans. Stephen Heath. New York: Hill and Wang, 1977.

Bataille, Georges. *Documents*, vol. 1, no. 7 (December 1929).

Bataille, Georges. "The Big Toe." In *Visions of Excess: Selected Writings, 1927–1939*, ed. and with an introduction by Allan Stoekl, trans. Allan Stoekl, with Carl R. Lovitt and Donald M. Leslie, Jr., pp. 20–23. Minneapolis: University of Minnesota Press, 1985.

Bataille, Georges. *Georges Bataille, Visions of Excess: Selected Writings, 1927–1939*. Ed. and with an introduction by Allan Stoekl, trans. Allan Stoekl, with Carl R. Lovitt and Donald M. Leslie, Jr. Minneapolis: University of Minnesota Press, 1985.

Bauer, Dale M. and S. Jaret McKinstry. *Feminism, Bakhtin, and the Dialogic*. Albany: State University of New York Press, 1991.

Beauvoir, Simone de. *The Second Sex*, trans. and ed. H. M. Parshley. New York: Random House, 1952.

Bell, Clive. "The Aesthetic Hypothesis." In *Modern Art and Modernism: A Critical Anthology*, eds. Francis Franscina and Charles Harrison pp. 113–116. New York: Harper & Row, 1982.

Bernheimer, Charles and Claire Kahane, eds. *In Dora's Case: Freud–Hysteria–Feminism*. New York: Columbia University Press, 1985.

Bhabha, Homi K. *The Location of Culture*. London: Routledge, 1994.

Bhabha, Homi K. "Signs Taken for Wonders." In *The Post–Colonial Studies Reader*, eds. Bill Ashcroft, Gareth Griffiths, and Helen Tiffin eds., pp. 29–35. London: Routledge, 1995.

Bobo, Jacqueline. "The Color Purple: Black Women as Cultural Readers." In *Gender, Race, and Class in Media: A Text-Reader*, Gail Dines and Jean M. Humez, eds., pp. 52-60. Thousand Oaks, Calif.: Sage, 1995.

Bordo, Susan. "The Body and Reproduction of Femininity: A Feminist Appropriation of Foucault." In *Gender/Body/Knowledge: Feminist Reconstructions of Being and Knowing*, ed. Alison M. Jagger and Susan R. Bordo, p. 13–33. New Brunswick: Rutgers University Press, 1989.

Bourdieu, Pierre. *Distinction: A Social Critique of the Judgement of Taste*. Cambridge: Harvard University Press, 1984.

Bové, Paul. *Mastering Discourse: The Politics of Intellectual Culture*. Durham: Duke University Press, 1991.

Butler, Judith. *Gender Trouble: Feminism and the Subversion of Identity*. New York and London: Routledge, 1990.

Butler, Judith, "The Body You Want: Liz Kotz Interviews Judith Butler." *Artforum*, November 1992: 82–89.

Butler, Judith. *Bodies That Matter*. New York and London: Routledge, 1993.

Callen, Anthea. *Women Artists of the Arts and Crafts Movement, 1870–1914*. New York: Pantheon, 1979.

Chodorow, Nancy. *The Reproduction of Mothering*. Berkeley: University of California Press, 1978.

Cowie, Rosalind. "Fantasia." In *The Woman in Question*, eds. Parveen Adams and Elizabeth Cowie, pp. 149–196. Cambridge: MIT Press, 1990.

Creed, Barbara. "Horror and the Monstrous Feminine: An Imaginary Abjection." *Screen* 27 (January–February 1986): 44–71.

Daly, Mary. *Gyn/ecology: The Metaethics of Radical Feminism*. Boston: Beacon Press, 1978.

De Lauretis, Teresa. "Aesthetics and Feminist Theory: Rethinking Women's Cinema," *New German Critique* 34 (Winter 1985): 161–171.

Deleuze, Gilles and Félix Guattari. *A Thousand Plateaus*. Minneapolis: University of Minnesota Press, 1987.

Derrida, Jacques. "Structure, Sign and Play in the Discourse of the Human Sciences." In *The Structuralist Controversy*, ed. Eugene Donato and Richard Macksay, pp. 247–272. Baltimore: Johns Hopkins University Press, 1970.

Derrida, Jacques. *Of Grammatology*. Trans. Gayatri Chakravorty Spivak. Baltimore: The Johns Hopkins University Press, 1976.

Derrida, Jacques. "Plato's Pharmacy." In *Dissemination*, pp. 61–119. Chicago: University of Chicago Press, 1981.

Dinnerstein, Dorothy. *The Mermaid and the Minotaur*. New York: Harper and Row, 1977.

Doane, Mary Ann. *The Desire to Desire: The Woman's Film of the 1940s*. Bloomington: Indiana University Press, 1987.

Dyer, Richard. *Now You See It: Studies on Lesbian and Gay Film*. New York: Routledge, 1990.

Eagleton, Terry. *Walter Benjamin: Towards a Revolutionary Criticism* (London: Verso, 1981).

Eagleton, Terry. *Literary Theory: An Introduction*. Minneapolis: University of Minnesota Press, 1983.

Flugel, J. C. *The Psychology of Clothes*. London: L. and V. Woolf at the Hogarth Press, 1930.

Forte, Jeanie Kay, "Women's Performance Art: Feminism and Postmodernism." *Theatre Journal* , vol. 40, no. 2 (May 1988): 217–235.

Foster, Hal. "The Expressive Fallacy." *Art in America*, April 1983: 34–42.

Foster, Hal. *The Anti–Aesthetic: Essays on Postmodern Culture*. Seattle: Bay Press, 1983.

Foucault, Michel. "A Preface to Transgression." In *Language, Counter–Memory, Practice: Selected Essays and Interviews*, ed. Donald F. Bouchard, trans. Donald F. Bouchard and Sherry Simon, pp. 29–51. Ithaca: Cornell University Press, 1977. (First printed as "Hommage à Georges Bataille," in *Critique*, Nos. 195–196, 1963.)

Foucault, Michel. *The Archaeology of Knowledge and the Discourse on Language*. New York: Pantheon, 1972.

Foucault, Michel. *The Order of Things: An Archaeology of the Human Sciences*. New York: Vintage Books, 1973.

Foucault, Michel. *Discipline and Punish: The Birth of the Prison*. New York: Vintage Books, 1979.

Foucault, Michel. "What is an Author?" In *The Foucault Reader*, ed. Paul Rabinow, pp. 101–120. New York: Pantheon, 1984.

Foucault, Michel. *The History of Sexuality, Volume 1: An Introduction*. New York: Vintage Books, 1990.

Freud, Sigmund. "The Ego and the Id." In *The Standard Edition of the Complete Psychological Works of Sigmund Freud,* vol. 19, James Strachey, ed., in collaboration with Anna Freud, assisted by Alix Strachey and Alan Tyson. London: Hogarth Press, 1961.

Freud, Sigmund. "Fetishism." In *The Standard Edition of the Complete Psychological Works of Sigmund Freud,* vol. 21, James Strachey, ed., in collaboration with Anna Freud, assisted by Alix Strachey and Alan Tyson, pp. 152–157. London: Hogarth Press, 1961.

Freud, Sigmund. "Three Essays on the Theory of Sexuality." In *The Standard Edition of the Complete Psychological Works of Sigmund Freud,* vol.7,

James Strachey, ed., in collaboration with Anna Freud, assisted by Alix Strachey and Alan Tyson, pp. 130–243. London: Hogarth Press, 1961.

Freud, Sigmund. In *The Standard Edition of the Complete Psychological Works of Sigmund Freud,* vol. 14, James Strachey, ed., in collaboration with Anna Freud, assisted by Alix Strachey and Alan Tyson. London: Hogarth Press, 1961.

Freud, Sigmund. *Dora: An Analysis of a Case of Hysteria.* New York: Collier Books, 1963.

Fusco, Coco. *English is Broken Here: Notes on Cultural Fusion in the Americas.* New York: The New Press, 1995.

Gamman, Lorraine and Margaret Marshment, eds. *The Female Gaze: Women as Viewers of Popular Culture.* Seattle: The Real Comet Press, 1989.

Gatens, Moira. "A Critique of the Sex/Gender Distinction." In *A Reader in Feminist Knowledge*, ed. Sneja Gunew, pp. 139–160. London: Routledge, 1991.

Gouma–Peterson, Thalia, and Patricia Matthews. "The Feminist Critique of Art History." *The Art Bulletin*, vol. 69, no. 3 (September, 1987): 327–357.

Greer, Germaine. *The Female Eunuch.* New York: McGraw–Hill, 1971.

Hall, Stuart. "Encoding and Decoding." In *Culture, Media, Language*, eds. Stuart Hall, et. al., pp. 234–245. London: Hutchinson, 1980.

Hammond, Harmony and Jaune Quick–to–See Smith. *Women of Sweetgrass, Cedar, and Sage.* New York: American Indian Community House, 1985.

Hawthorn, Jeremy. *A Concise Glossary of Contemporary Literary Theory.* London: Edward Arnold, 1992.

Heath, Stephen. "Joan Riviere and the Masquerade." In *Formations of Fantasy*, eds. Victor Burgin, James Donald and Cora Kaplan, pp. 45-71. London: Methuen, 1986.

hooks, bell. *Art on My Mind: Visual Politics.* New York: The New Press, 1995.

Hughes, Robert. *The Shock of the New.* New York: Knopf, 1980.

Humm, Maggie. *The Dictionary of Feminist Theory.* Columbus: Ohio State University Press, 1990.

J. Laplanche and J.–B. Pontalis. *The Language of Psycho–analysis*, trans. Donald Nicholson–Smith. New York: Norton, 1973.

Jameson, Fredric. *The Political Unconscious: Narrative as a Socially Symbolic Act.* Ithaca, NY: Cornell University Press, 1981.

JanMohamed, Abdul R. *Manichean Aesthetics: The Politics of Literature in Colonial Africa.* Amherst: University of Massachusetts Press, 1983.

JanMohamed, Abdul R. "The Economy of Manichean Allegory: The Function of Racial Difference in Colonialist Literature." *Critical Inquiry*, vol. 12, no. 1 (1985): 59–87.

Jay, Martin. "Scopic Regimes of Modernity." In *Vision and Visuality: Discussions in Contemporary Culture no. 2*, ed. Hal Foster, pp. 3–23. Seattle: Bay Press, 1988.

Kelly, Mary. *Interim.* New York: New Museum of Contemporary Art, 1990.

Koch, Gertrud. "Ex–changing the Gaze: Revisioning Feminist Film Theory." *New German Critique* 34 (Winter 1985): 132–154.

Kolbowski, Silvia and Mignon Nixon, eds. *October*, A Special Issue: Feminist Issues, 71 (Winter 1995).

Krauss, Rosalind. "The Originality of the Avant–Garde: A Postmodern Repetition." In *Art After Modernism: Rethinking Representation*, ed. Brian Wallis, pp. 13–29. New York: The New Museum of Contemporary Art, 1984.

Krauss, Rosalind, Jane Livingston, and Dawn Ades. *L'Amour Fou: Photography and Surrealism*. New York: Abbeville Press, 1985.

Kristeva, Julia. *Powers of Horror: An Essay on Abjection*, trans. Leon S. Roudiez. New York and London: Columbia University Press, 1982.

Lacan, Jacques. "Some Reflections on the Ego." *International Journal of Psychoanalysis*, vol. 34, 1953.

Lacan, Jacques. *Ecrits: A Selection*. Trans. Alan Sheridan. New York: W. W. Norton, 1977.

Lacan, Jacques. *The Four Fundamental Concepts of Psychoanalysis*. London: Hogarth Press, 1977.

Lacan, Jacques. "The Meaning of the Phallus." In *Feminine Sexuality: Jacques Lacan and the École Freudienne*, eds. Juliet Mitchell and Jacqueline Rose, trans. Jacqueline Rose, pp. 83–85. New York: Norton, 1985.

Lentricchia, Frank, and Thomas McLaughlin, eds. *Critical Terms for Literary Study*. Chicago: University of Chicago Press, 1990.

Lippard, Lucy. "A Note on the Politics and Aesthetics of a Women's Show." In *Women Choose Women*, pp. 1–5. New York: New York Cultural Center, 1973.

Lippard, Lucy. *Mixed Blessings: New Art in a Multicultural America*. New York: Pantheon Books, 1990.

Makaryk, Irena R., ed. *Encyclopedia of Contemporary Literary Theory*. Toronto: University of Toronto Press, 1993.

Mapplethorpe, Robert. *Lady: Lisa Lyon by Robert Mapplethorpe*. Foreword by Samuel Wagstaff and essay by Bruce Chatwin. New York: Viking; London: Blond and Briggs, 1983.

Marcus, Steven. "Freud and Dora: Story, History, Case History." In *Representations: Essays on Literature and Society*, pp. 247–310. New York: Random House, 1975.

Metz, Christian. *The Imaginary Signifier: Psychoanalysis and Cinema*. Bloomington: Indiana University Press, 1982.

Millett, Kate. *Sexual Politics*. London: Abacus, 1971.

Modleski, Tania. *Feminism Without Women: Culture and Criticism in a "Postfeminist" Age*. New York: Routledge, 1991.

Moxey, Keith. *The Practice of Theory: Postsructuralism, Cultural Politics, and Art History*. Ithaca, NY: Cornell University Press, 1994.

Mulvey, Laura. "Visual Pleasure and Narrative Cinema." In *Art After Modernism: Rethinking Representation*, ed. Brian Wallis, pp. 361-373. New York: New Museum of Contemporary Art, 1984.

Mulvey, Laura. "You don't know what is happening, do you, Mr. Jones?" In *Framing Feminism: Art and the Women's Movement 1970–1985*, eds. Rozsika Parker and Griselda Pollock, pp. 127–131. London: Pandora, 1987.

Mulvey, Laura. "A Phantasmagoria of the Female Body: The Work of Cindy Sherman." *New Left Review*, no. 188 (July 1, 1991): 136.

Nead, Lynda. *The Female Nude: Art, Obscenity and Sexuality*. London: Routledge, 1992.

Nochlin, Linda. "The Imaginary Orient." *Art in America* (May 1983): 56–62.

Ortner, Sherry. "Is female to male as nature is to culture?" In *Women, Culture and Society*, eds. Michelle Zimbalist Rosaldo and Louise Lamphere, pp. 67–88. Stanford: Stanford University Press, 1974.

Owens, Craig, "The Allegorical Impulse: Towards a Theory of Postmodernism," part 2. *October*, no. 13 (Summer 1980): 59–80.

Parker, Rozsika and Griselda Pollock. *Old Mistresses: Women, Art, and Ideology*. New York: Pantheon, 1981.

Pierce, Charles Sanders. *Collected Papers of Charles Sanders Pierce*, 8 vols. Eds Charles Hartshorne and Paul Weiss. 8 vols. Cambridge, MA: Harvard University Press, 1931–1958.

Pollock, Griselda. "Modernity and the Spaces of Femininity." In *Vision and Difference: Femininity, Feminism and the Histories of Art*, pp. 50–90. London: Routledge, 1988.

Rich, Adrienne. "Compulsory Heterosexuality and Lesbian Existence." *Signs: Journal of Women in Culture and Society*, vol. 5, no. 4 (Summer 1980): 80–81.

Riviere, Joan, "Womanliness as a Masquerade." In *Formations of Fantasy*, ed. Victor Burgin, James Donald and Cora Kaplan, pp. 35–44. London: Methuen, 1986. (Originally published in the *International Journal of Psychoanalysis*, vol. 10, 1929.)

Russo, Mary, "Female Grotesques: Carnival and Theory." In *Feminist Studies/Critical Studies*, ed. Teresa de Lauretis, pp. 213–229. Bloomington: Indiana University Press, 1986.

Said, Edward. *Orientalism*. New York: Vintage Books, 1978.

Sarup, Madan. *An Introductory Guide to Post–structuralism and Postmodernism*. Athens: University of Georgia Press, 1989.

Saussure, Ferdinand de. *Course in General Linguistics*. Ed. Charles Bally and Albert Sechehaye. New York: Philosophical Library, 1959.

Schapiro, Meyer. "The Social Bases of Art." (1936) In *Art in Theory: 1900–1991: An Anthology of Changing Ideas*, ed. Charles Harrison and Paul Wood, pp. 506–510. Oxford, U. K. and Cambridge, MA: Blackwell, 1992.

Schilder, Paul. *The Image and Appearance of the Human Body*. New York: International Universities Press, 1978.

Selden, Raman. *A Reader's Guide to Contemporary Literary Theory*. Lexington: University of Kentucky Press, 1989.

Showalter, Elaine. "The Feminist Critical Revolution." In *The New Feminist Criticism*, pp. 1–12. New York: Pantheon, 1985.

Showalter, Elaine. "Toward a Feminist Poetics." *The New Feminist Criticism*, pp. 125–143. New York: Pantheon, 1985.

Silverman, Kaja. *The Acoustic Mirror: The Female Voice in Psychoanalysis and Cinema*. Bloomington: Indiana University Press, 1988.

Spence, Donald. *Narrative Truth, Historical Truth: Meaning and Truth in Psychoanalysis*. New York: W. W. Norton, 1990.

Spivak, Gayatri Chakravorty. "Can the Subaltern Speak?: Speculations on Widow Sacrifice." *Wedge*, vol. 7, no. 8 (Winter/Spring 1985): 120–130.

Stallybrass, Peter, and Allon White. *The Politics and Poetics of Transgression*. Ithaca and London: Cornell University Press, 1986.

Stoller, Robert J. *Sex and Gender*. London: Hogarth Press, 1975.

Suleiman, Susan Rubin. "Love Stories: Women, Madness, and Narrative." In *Subversive Intent: Gender, Politics, and the Avant–Garde*, pp. 88–118. Cambridge: Harvard University Press, 1990.

Tagg, John. "A Discourse (With the Shape of Reason Missing)." *Art History*, vol. 15, no. 3 (September, 1992): 342–368.

Tickner, Lisa. "Sexuality and/in Representation: Five British Artists." In *Difference: On Representation and Sexuality*, ed. Kate Linker and Marcia Tucker. New York: The New Museum of Contemporary Art, 1984.

Trinh, T. Minh–Ha. *Woman, Native, Other: Writing Postcoloniality and Feminism*. Bloomington: Indiana University Press, 1989.

Trinh, T. Minh–Ha. *When the Moon Waxes Red: Representation, Gender and Cultural Politics*. London: Routledge, 1991.

Tucker, Marcia. *Bad Girls*. New York: The New Museum of Contemporary Art; Cambridge: MIT Press, 1994.

Williams, Linda. "Provoking Art: The Pornography and Performance of Annie Sprinkle." In *Dirty Looks: Women, Pornography, Power*, ed. Pamela Church Gibson and Roma Gibson, pp. 176-191. London: BFI Publishing, 1973.

Williams, Linda. *Hard Core: Power Pleasure and the "Frenzy of the Visible."* Berkeley: University of California Press, 1989.

Williams, Raymond. *Keywords: A Vocabulary of Culture and Society*. Oxford and New York: Oxford University Press, 1976.

Women's Action Coalition. *WAC Stats: The Facts About Women*. New York: The New Press, 1993.

# INDEX

**About the Authors**

THOMAS PATIN is a historian and critic specializing in contemporary art. He has taught numerous courses in contemporary art history, theory, and criticism, as well as nineteenth- and twentieth-century art history. He has published extensively as an art critic and historian on topics ranging from architecture to Native American art to the teaching of semiotics in undergraduate art history courses. He is currently Assistant Professor of the History, Theory, and Criticism of Art and Visual Culture at Ohio University.

JENNIFER McLERRAN is an art historian and critic specializing in contemporary art and aging studies. She is a contributor to *Modernism and Beyond: Women Artists of the Pacific Northwest* (1993), co-author with Patrick McKee of *Old Age in Myth and Symbol: A Cultural Dictionary* (Greenwood, 1991), and author of numerous published articles on visual art.

ISBN 0-313-29272-8

HARDCOVER BAR CODE

## DATE DUE